W9-BVP-932

# JOHN THOMSON

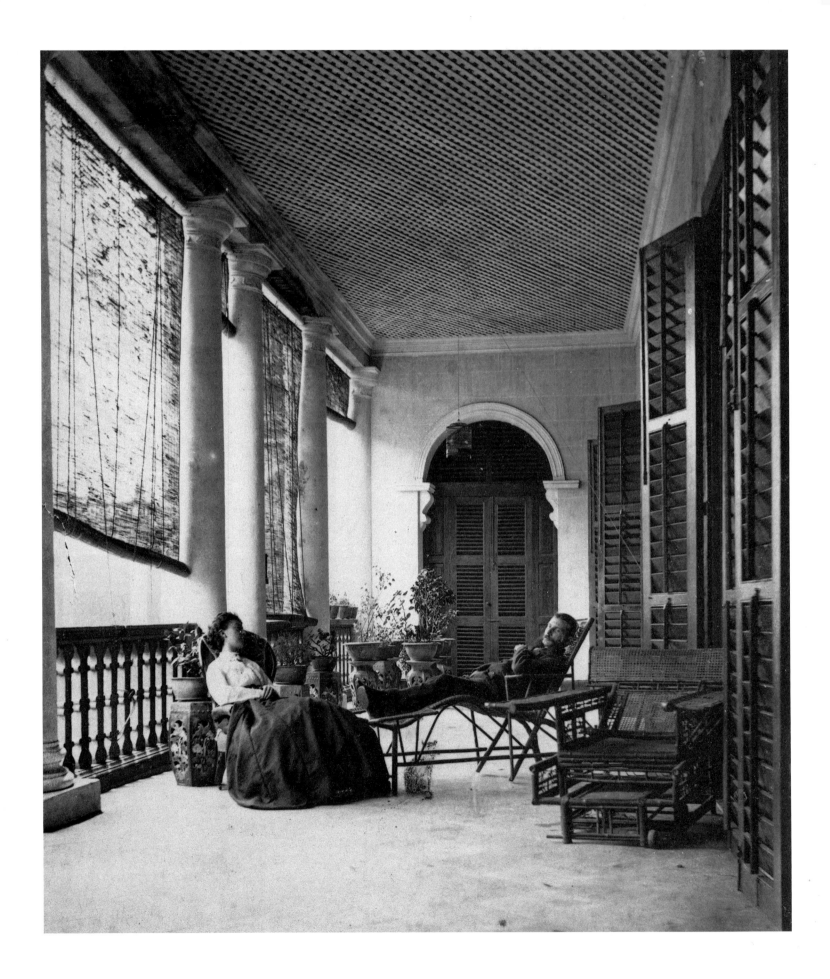

STEPHEN WHITE

# JOHN THOMSON
## *A Window to the Orient*

*Preface by*
*Robert A. Sobieszek*

with 173 illustrations, 161 duotone plates

THAMES AND HUDSON

*Major traveling exhibition of John Thomson's work*

1985

**International Museum of Photography**
at George Eastman House
Rochester, New York

**National Museum of Photography,
Film, and Television**
Bradford, Yorkshire

1986–87

**The Asia Society Galleries**
New York, NY

**Museum of Photographic Arts**
San Diego, California

**The Nelson-Atkins Museum of Art**
Kansas City, Missouri

*Frontispiece* John Thomson and his wife Isobel in Canton in 1869

First published in the United States in 1986 by
Thames and Hudson Inc., 500 Fifth Avenue,
New York, New York 10110

Library of Congress Catalog Card Number 85-51118

Printed and bound in Italy

# CONTENTS

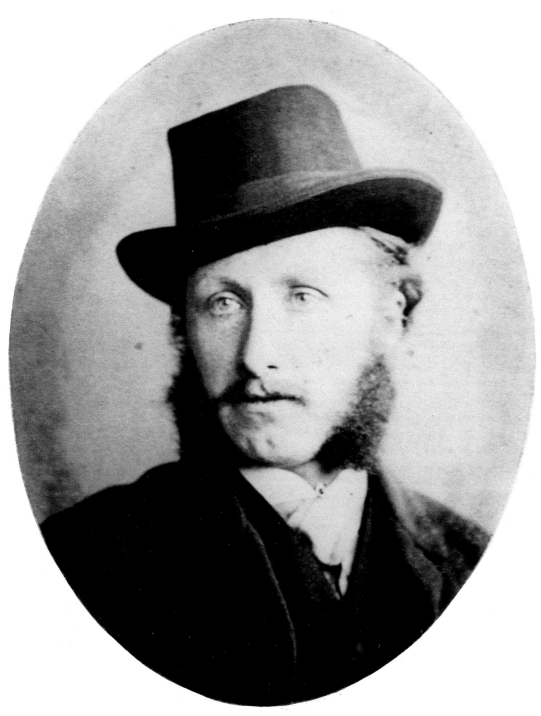

*A portrait of John Thomson taken in Edinburgh in 1866, shortly after his
return from four years in the Orient*

# PREFACE

THE SECOND HALF OF the nineteenth century was a period of compendia, concordances, encyclopaedia, and taxonomic analyses. Human knowledge and power would be furthered, it was felt, and progress maintained if enough particular data could be amassed and studied. Photography, born of this materialist age, was quickly inducted as the perfect tool for collecting global facts. Every racial type and facial expression, the façade of practically every major piece of accessible architecture, all known flora and fauna, nearly all the gaits of most bipeds and quadrupeds, and just about every conceivable object was photographed. After the ubiquitous portrait, the most photographed and disseminated kind of image was the topographic view, rendering famed and far-distant landscapes visible to the European and American public. A corollary of the topographic landscape, the ethnographic study of native cultures, was a natural by-product once the photographer journeyed the distance. From Poet's Lane in Torquay to Half-Dome in Yo-semite Valley, from the forests around Fontainebleau to the awesome reaches of the Himalayas, from the Hudson Valley just north of Manhattan to Nakhon Wat in Cambodia, from the native dress of Madagascar to social conventions in Japan, photographers began a steady assault on the known world, culminating over the decades in the greatest pictorial documentation ever achieved. Some of these photographers were associated with government surveys and geological explorations, others attended more quietly to the steady need for tourist souvenirs. Professional photographers and commercial distributors of such views – establishments that marketed tens of thousands of views each year – were at once both the result of the desire to 'see' as many sights as possible and the cause of much of our modern age's appetite for images.

A number of these early photographic pioneers have become famous – photographers like Francis Frith and Maxime Du Camp in Egypt, Désiré Charnay in the Yucatan, Félix Bonfils in the Near East, Samuel Bourne and Linnaeus Tripe in India, Timothy O'Sullivan and Carleton E. Watkins in the Western Territories of the United States. The names of most nineteenth-century topographic photographers, however, names like Scowen, Hammerschmidt, Zangaki, Kivork and Wichen Abdullah, and Félix Teynard, are simply that – names, known for the most part only because they are found inscribed on so many pictures. Yet were it not for their often tenacious ambition to photograph scenes that had never been recorded, we would be without the vast store of description that reverberated throughout the early years of our history. And were it not for so many photographers whose talents transcended the merely capable and attained the 'artistical' (to use a nineteenth-century term), we would not possess so many memorable and hauntingly beautiful images – images for the most part made in service of economics, colonization, and instruction.

'The camera should be a power in this age of instruction for the instruction of the age,' wrote the British photographer John Thomson in 1875. Two years later, he and the writer Adolphe Smith Headingly published the first major sociological text of British life to be illustrated by photographic documentation: *Street Life in London*, a volume of descriptive case-histories accompanied by thirty-seven Woodburytype prints from Thomson's negatives. Modelled upon earlier 'human science', reformist literature such as Henry Mayhew's *London Labour and London Poor* of 1851, which included

engravings from daguerreotype images, Thomson and Smith's study of the welfare-less urban poor of the British capital advanced the sense of immediacy and authenticity by photography – photographs that validated the author's written observations and argued each case by picturing it. As the authors wrote in the introduction to *Street Life in London*, 'the unquestionable accuracy of this testimony will enable us to present true types . . . and shield us from the accusation of either underrating or exaggerating individual peculiarities of appearance.'

So powerful was this single publication that Thomson's position as a significant nineteenth-century photographer was assured. Rarely has his other work been recognized, and only then in passing; and while there have been numerous examples of photographers who flowered suddenly for a moment and had their lesser creative labour remain in shadow, the case with Thomson has proved rather different. Slowly and discretely, the extent of John Thomson's photographic achievement has come to light during recent years, with the appearance of a few fine prints at auction and in various exhibitions and publications. Most of what was seen was made up of individual prints of exceptional strength and of exotic subjects, indicating that Thomson's career was much more worldly and prolific than had been assumed. Now, we are in the fortunate position to be able fully to survey and measure Thomson's achievement, thanks to the researches of the present author who has assembled a near-complete collection of Thomson's work, from which many of the photographs illustrated are selected. Seen from this broader perspective, Thomson is revealed as far more than a great social documentarian – although just how great is only now bountifully evident – he was also one of the finest exploratory, topographic, and landscape photographers of the last century.

The real surprise of Thomson's hitherto undisclosed photography is the work he did in the Far East – those luminous, exquisite prints portraying the wonders of the 'floating city' of Bangkok, the ancient temples of Cambodia, the tea-plantations around Foochow, the closed city of Peking, the mountain monastery of Yuan-fu, the rapids on the River Min, and the rich vegetation of Formosa. Here, too, we discover that Thomson's talent in depicting social types and cultural conventions of behaviour and costume – a talent he was to manifest so adroitly in *Street Life in London* – had been applied years earlier to a broad panoply of Asian locales and peoples. Thomson was the very first photographer to document many of these peoples, such as Siamese dancers, Peking itinerant barbers, Buddhist monks playing chess, Laotian natives and slum-dwellers in Canton, the Kings of Siam and Cambodia, the Anamites in Cholon, and the Pepohoans in southern Formosa. Everything fascinated Thomson, and he recorded much of what he encountered. His imagery ranges from strict documentary to the picturesque, from an elegant straightforwardness to a photographic lyricism. His eye was that of the quintessential Victorian traveller, an incisive *flâneur* wandering the streets of exotic lands, and an educated geographer. His motivation for photographing was to capture the essence of these unforgettable and never-before-photographed regions, and to obtain permanent records for visual delectation, instruction, and verification. 'The faithfulness of such pictures,' Thomson wrote, 'affords the nearest approach that can be made towards placing the reader actually before the scene which is represented.'

*International Museum of Photography*                         ROBERT A. SOBIESZEK
*at George Eastman House*
*Rochester, New York*

# LIFE AND PHOTOGRAPHS

## A WINDOW TO THE ORIENT

John Thomson decided to leave England to settle in the Far East in 1862, when he was twenty-five years old. In the previous year he had visited Singapore, where his elder brother had established himself working in the shipchandlery business.

Thomson was born in Edinburgh in 1837, one of three children of a successful tobacconist. Little is known about his early life, though a brief biography in a publication entitled *Our Contemporaries . . . 1897–1898* tells us that he attended school and university in Edinburgh, 'the Athens of the North'. There is no question that he received an excellent education, for his many interests ranged from micro-photography and chemistry to art, ethnography, history, geography and botany. How he acquired his considerable photographic skills remains something of a mystery, but there was a great deal of interest and experimentation in photography going on in Edinburgh at the time Thomson was growing up.

Thomson first decided to settle on the island of Penang. 'During the ten months I spent in Penang and Province Wellesley,' he writes in the only book that documents his early travels, 'I was chiefly engaged in photography – a congenial, profitable, and instructive occupation, enabling me to gratify my taste for travel and to fill my portfolio . . .'[1] He set up a studio where he photographed a broad variety of races, including 'descendants of the early Portuguese voyagers, Chinese, Malays, Parsees, Arabs, Armenians, Klings, Bengalees, and Negroes from Africa'.[2]

But Thomson soon discovered that the most interesting subjects for his photographs lay in the streets and countryside outside his studio. He began to visit the villages and various sites, recording the local people and Europeans in a more natural environment. Travelling about, he carried with him a small stereoscopic camera, making two small ($3 \times 4$ in) images at one time, as well as a variety of larger cameras, a practice he was to continue throughout his ten years photographing in the Far East.

The Chinese living in Penang provided a vital link between the European and Malay populations. Thomson's fascination with the Chinese grew as he observed them in Penang, then later on in Singapore and Hong Kong: 'The Chinaman out of his own country, enjoying the security and prosperity which a more liberal administration confers, seems to develop into something like a new being. No longer chained to the soil by the iron fetters of a despotic government, he finds wide scope for his energies, and high rewards for his industry.'[3]

Thomson encountered a number of problems and difficulties upon embarking on photography in a tropical climate (see pp. 37–8). His early work is extremely rare for that reason, and it is difficult to assess the overall quality of his Penang work, or even its extent.

His intentions became clearer when he moved to Singapore in 1863. Singapore, situated on a small island at the end of the Malay Peninsula, offered ready access by sea to China in the north, and westwards through the Straits of Malacca to both Ceylon and India. To travel from Singapore to Hong Kong by way of Saigon took eight days. Singapore to Galle harbour in Ceylon was a nine-day journey, and a few days more brought one to Calcutta.[4]

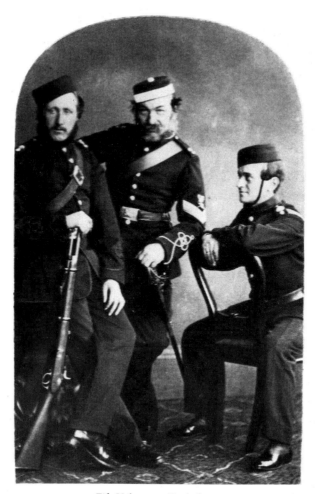

*Fife Volunteers, St Andrews.*
*Why Thomson (on the left) was a member of this unit is unknown*

Thomson set up a studio close to the thriving centre of the city, in Commercial Square, where most of the shops, banks, stores and offices were clustered under the control of Europeans. The studio was to be the basis of his income for the next two years. For a while Thomson took his elder brother William into the business. The logo on their card reads 'Thomson Bros'. But their partnership was short-lived; and after that, Thomson worked on his own until his children joined him in his London studio many years later.

Thomson trained two Chinese assistants in Singapore. Akum and Ahong were to remain loyal to him for as long as he worked in the Orient, travelling thousands of miles with him through difficult and often dangerous country.

Thomson came to know many of the European residents during his years in Singapore. Their life-style was a pleasant one: 'Fashion . . . demands that the carriage should be as costly a one, and the house as showy, as the owner's means will admit. After all, judging from the luxurious style in which the foreign residents live, we may discover, in some measure, how it comes that times are altered, and why magnificent fortunes are not piled up so easily nor so speedily as in former days.'[5]

In October 1864 Thomson set out by way of Ceylon for India. He was admitted to membership of the Bengal Photographic Society and photographed the devastation newly wrought in the area by a cyclone, before returning to Singapore in November.

By the beginning of the following year Thomson was growing impatient with his studio work. Portraiture and the settled life proved dull beside the challenge of taking his camera into the remoter areas of the Orient. He resolved to visit Siam 'with the object of making myself better acquainted with the country, its people, and its products, in consequence of the interest excited in me by reading the late M. Mouhat's *Travels in Indo-China, Cambodia, and Laos,* and other works to which I had access'. It was the description in Mouhat's book 'of the magnificence of the ruined cities which the author found in the heart of the Cambodian forests' that led Thomson to resolve 'to cross the country, and penetrate to the interior of Cambodia, for the purpose of exploring and photographing its ruins'.[6]

## Siam

It was late summer before Thomson managed to arrange his affairs to the point of being able to move on to Siam. He reached Bangkok on 28 September 1865 on the steamer *Chow Phya*, and encountered a city more exotic than any he had ever seen: 'When I use the term "floating city", I mean to say that the dwellings of the people are for the most part afloat on rafts, and it is impossible at first sight to determine where land begins, and where it ends.'[7] Thomson counted some sixty-five temples spread throughout the city, with a population of nine thousand priests. He soon set about arranging a meeting with the King of Siam. King Mongkut had spent more than thirty years secluded in a monastery before ascending the throne, and knew Sanscrit and Pali as well as his native language. He was interested in Western education, and had engaged an English governess for the Royal children. This lady, Anna Leonowens, later wrote a number of books about her experiences in Siam, and in recent years her life formed the subject of both a biography and a successful musical, *The King and I.*

Thomson became friendly with the King's astronomer, Prince Krum-mun-alongkot, a nobleman with a great if uninformed interest in photography, and when they were better acquainted Thomson was introduced to the astronomer's family circle. 'He had, I believe, sixteen wives, although I never saw more than twelve at a time; some of these were young and pretty, but no less timid in their behaviour, than unhappy in their looks. He told me it was a difficult task to keep his wives cheerful; they were modest and graceful ladies, and they expressed their surprise that a foreigner was after all a very harmless sort of animal.' While their embroidery 'displayed both beauty of design and skill', Thomson 'thought it a pity to see them smoking cigarettes, or chewing betel-nuts, the teeth blackened with the incrustation, and their mouths disfigured with blood-red juice; they had also a nasty habit of spitting into golden vases which their slaves held up dutifully for the purpose. As for the children, they seemed to be born with a cigarette in their mouths. I have actually seen a child leave its mother's breast to have a smoke.'[8]

A Royal audience was granted, the King appeared robed in spotless white, and Thomson, beckoned by his Majesty, was told that he wished to have his portrait taken as he knelt in an attitude of prayer. The scene was arranged, and Thomson was on the point of taking the photograph, when 'his Majesty changed his mind, and without a word to anyone, passed suddenly out of sight'. 'I thought this a strange proceeding,' wrote Thomson, 'and fancied I must have given him some offence; but it was possibly one of his practical jokes. I appealed to the Prince; but his reply was simply that, "the King does everything which is right, and if I were to accost him now he might conclude his morning's work by cutting off my head".'[9]

At length, the King reappeared in a French Field Marshal's uniform, and allowed himself to be photographed first in this and then in his court robes.

The King next invited Thomson to attend a great festival for the heir-apparent, Prince Chowfa Chul-along-korn. An artificial hill, Mount Khrai-lat, had been specially constructed for the ceremony in the palace grounds. Each afternoon a procession of nobles and slaves escorted the Prince three times around it. Thomson was amused by the parade of female slaves dressed in various European costumes complete with crinoline dresses.

Thomson remained in Siam for six full months, photographing the city and the countryside, the royal ceremonies and daily activities of the people. His intention to go to Cambodia remained firm, but there were obstacles to be overcome.

One problem was to find a travelling companion. Europeans considered the trip likely to prove a fatal one, and Thomson was met with such warnings as, 'you must en route pass the gold mines of Kabin; a fatal spot, some say it is fever, other assassins . . . Or, at all events go well armed, and never sleep both at the same time. Be warned by the fate of F – who was murdered in his own boat; and a third would say, Well after all I don't know that they have the natives so much to fear as the tigers that infest the forest and jungle, where, I am told, their perpetual nocturnal howlings effectually banish sleep, and want of sleep induces fever, which we all know is the traveller's worst enemy . . .'.[10] After some effort Thomson managed to find a young employee of the British Embassy, H.G. Kennedy, to accompany him.

*Cambodia*

'We had first intended to sail down the Gulf of Siam to Chantaboon, and thence to cross over the forest-clad mountains of that province to Battabong. But the Siamese government declined to grant a passport for that route, which they reported as dangerous and impracticable.'[11] Consequently the adventurers were forced to take the more difficult inland route. They left by river on 27 January 1866, 'in a long boat manned by eight stalwart Siamese, with Mohammed Ali, a Malay, a Siamese named Kut, and two Chinese men-servants, Ahong and Akum. Our way lay along the Klong Sansep, a creek cut some fifty years ago, and which penetrates east, till it emerges, after a course of fifty miles, in the river Bang Phra-kong.'[12]

The travellers had experienced some of the hardships of jungle travel even before they crossed the border from Siam. 'The first district of importance through which we passed was Sunsep, where every break in the luxuriant foliage that borders the creek revealed glimpses of the rich plains that, like a sea, stretch away vast and unbroken to the distant horizon . . . Every brush of our oars brought forth myriads of mosquitoes from the long grass growing within the banks. During the night our bloodthirsty assailants kept torturing us; they even swarmed in our mosquito nets, under which we vainly endeavoured to sleep.'[13]

Mohammed Ali fell into mud, and both Thomson and Kennedy became covered with leeches in rescuing him. The photographer's superstitious assistants several times tried to turn back, terrified by the violent jungle storms. A buffalo cart overturned in the rugged terrain, costing them much of their food supply. Thomson came down with malaria. The party was forced to halt. For three days the fever raged and Kennedy stayed by his side, administering doses of quinine every four hours. When the fever broke, Thomson was too weak to move for another two weeks.

Some days later the party encountered their first ruins, a shrine and two fragmentary 'idols'. 'But what shall we say of the stone cities and sculptured palaces which we were now approaching –

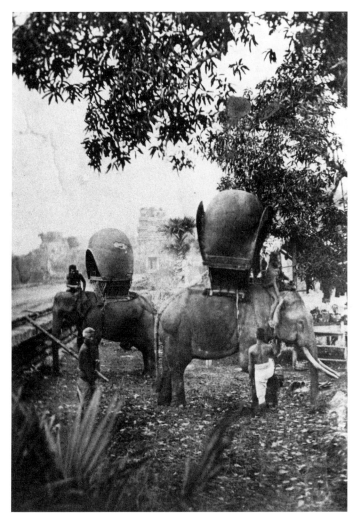

*Howdahs used by Thomson and Kennedy in Cambodia*

monuments of human labour with which even our greatest modern edifices can hardly be worthily compared?'[14] Thomson remarks that, even though these great buildings could only have been raised by the use of slave taskwork, 'we see a love of art in every line of ornament, which speaks of a master-sculptor glorying in his work'.[15]

Mohammed Ali had been sent on ahead to present the Governor with the passport letter from the King of Siam. Two elephants and five buffalo wagons were dispatched to meet the travellers and their baggage. 'My friend had had experience of elephant travel in Korat, but the sensation was new to me,' wrote Thomson. 'The elephant howdahs were dome-shaped, of a kind used only by persons of superior rank. The colossal, soft-eyed brute was requested, in Siamese, to give me a lift. Whereupon he bent his huge right fore leg, and then looked me over slowly from head to foot, before venturing to hoist me on to his back. I placed one foot firmly on his knee, and he then gently raised me until I could reach his neck, keeping me steady with his trunk until I had fairly scrambled into the howdah. This business finished, he then marches with a steady step onwards to his destination,

knowing, apparently, all about the country. On he goes through pools and marshes, but keeping an eye all the while on the spreading branches of the trees above; for somehow, with a marvellous exactness, he knows the howdah's height, and if a branch would barely clear it, he halts, raises his trunk, and wrenches it off before he ventures to proceed.'[16]

Many years later, addressing a meeting of the Royal Geographical Society, Thomson recalled his survey of the 'principal antiquities', the temple of Angkor Wat, of which he drew a ground-plan, the city of Angkor Thom, or 'Inthapatapuri', the capital of ancient Cambodia, and the ruins extending further north and south. 'Many of the ruins are important, and are linked together by stone causeways raised well above the autumn flood levels, and were evidently intended and used by the ancients for extensive traffic from city to city. Adjoining the causeways one finds great stone reservoirs which must have been designed for use during the dry season, when water is scarce. . . . The quarries from which the stone was obtained are thirty miles distant from Angkor Wat, and one can hardly conceive of any means by which they could have drawn the huge blocks over hilly ground to the capital. . . . When in Cambodia,' Thomson continues, 'the King of Siam sent a special envoy to request me to photograph the entire series, a request with which I was unable to comply. At the time the kodak was unknown, and one had to depend on the collodion wet plate process of photography. This entailed the constant presence of eight or ten porters to transport the necessary apparatus.'[17]

Thomson and Kennedy spent several days exploring and photographing the temple and walled city. Each of the sides of the city walls was five miles long, and each side had five large gateways, but Thomson was prevented from taking more than one successful photograph of the gates by the local monkey population, 'who persisted in shaking the branches of the trees every time they saw me emerge from my tent to expose the plate, and during the exposure . . . kept chuckling and dancing about the branches like black fiends'.[18]

Thomson and Kennedy later tried to reach the site in the Richi mountains where the stone had been quarried for the ancient city, riding their elephants bareback. However the jungle growth proved too thick to penetrate. They went on instead towards the capital of Cambodia, Penompinh. Thomson, who spoke Malay, was surprised to find settlements of Malayans living along the river banks.

After a month in the jungle, the capital city provided a welcome change. Cambodia, at that time, had just become independent from Siam through an agreement between the French and the Siamese. With a letter from King Mongkut, the travellers received much hospitality from the newly crowned Cambodian King. The French influence in the capital and the palace was strong; the King's chef was French, and the two explorers ate an enjoyable meal for the first time in weeks. Thomson photographed the King, who later provided them with elephants for a five-day journey to Kamput, a town on the coast at the southern end of the Gulf of Siam. There they encountered an old Malay chief who offered to lead them to a distant mountain where, he claimed, a ship of stone lay with a rope of stone still to be seen on its deck. As appealing as the adventure sounded, the two Europeans were exhausted by their travels; instead they hired a boat with six men and made their way along the Gulf of Siam, and so returned to Bangkok.

The King of Siam was delighted to see the two explorers again. 'He enquired kindly about our journey, said he was glad to know that we had got safely back, but could not forbear wondering why two Englishmen should undergo so long a journey, at the risk of being either devoured by wild animals, or carried off by jungle fever, only to see some stone buildings very much out of repair, and this more especially as he placed no restriction upon our looking at his own magnificent Wats in Bangkok.'[19] Thomson presented the King with a set of photographs of Cambodia, and these so greatly impressed the monarch that he offered gifts and a free passage back to Singapore in return. He

requested that Thomson promise to proclaim, 'verbally, in books and in newspapers' that the three provinces containing the Cambodian ruins were part of Siam, and had been so for the past eighty-four years. This Thomson agreed to do, and took his leave of the court.

*A year at home*

Back in Singapore in May 1866, Thomson made a selection of his work, left some of his belongings with his brother William, and set out for home, hoping by his visit to establish a reputation for himself in the circles he respected. He carried with him the first photographs ever made of the Cambodian ruins, as well as a selection of material from his other travels.

He had planned to stop off in Ceylon on the way home to photograph the ruins there with the idea of comparing them with those of Cambodia. But his malaria flared up on board ship and he was unable to accomplish that task.

He settled back in Edinburgh, where he submitted a paper on his Cambodian adventures to the Royal Geographical Society.[20] However, a paper by his former travelling companion Kennedy, more straightforward and less anecdotal, was selected for journal publication instead. Thomson's paper was placed on file, and he was accepted as a fellow in the same year. He also joined the Royal Ethnographical Society, to whom he presented a paper on the people of Cambodia. This was published in the Society's journal wrongly credited to George Thomson.[21]

The British Association met annually at various locations for papers covering the latest developments in different scientific fields. Thomson was invited to speak before the Geography and Ethnology section, which was part of the Nottingham conference in 1866. His Cambodian photographs were commended by a critic in *The British Journal of Photography*: 'A beautiful series of photographs was exhibited, illustrative of the paper. Apart from the consideration of the difficulties with which Mr. Thomson had to contend, viz. operating in a tropical climate far out of the range of modern civilization, and having to convey his instruments and chemicals so many hundred miles, sometimes on elephants, sometimes in carts, and at other times by unwilling natives, across rivers, prairies, and jungle swamps, and having to work the wet process at a temperature that made it to the operator the wettest of all processes, and in a country where at any moment he might have to contest the use of the focussing cloth with an ambitious rhinoceros or artistic tiger – apart from all these considerations, the pictures he exhibited are entitled to take a high rank in virtue of their intrinsic merits, their softness and delicacy being such as could not be surpassed even in our own country, operating in the coolest temperature, and with the most perfect appliances of tent, chemicals, and the other comforts to which photographers take so kindly when out for a day's pleasure with the camera.'[22]

Possibly encouraged by this appreciative response, Thomson found a publisher in Edinburgh for an album of the Cambodian photographs. The book was illustrated with original photographic prints, not reproductions, and came out in a small edition.[23]

Thomson also gave public lectures in Edinburgh, showing slides of the Cambodian and Siamese visits. It was at one of these he met the young woman who was to become his wife, Isobel Petrie. Isobel was the daughter of an explorer who had piloted boats in the South Seas in the 1820s and 1830s, and had fought in the Battle of New Orleans. Her family often visited Edinburgh where Isobel's aunt, Jessie Grindley, had married the Scottish surgeon and discoverer of chloroform, Sir James Simpson. Isobel's sister Christina had also married into the Simpson family. Her husband John Simpson was a nephew of Sir James. He and John Thomson shared an interest in chemistry, and were to remain close friends until Simpson's untimely death.

*Vietnam*

Setting off for the Far East again in the autumn of 1867, Thomson first went to Singapore, then spent three months in Vietnam before moving to Hong Kong early in 1868.

Thomson may have visited Vietnam earlier, on his way back from Siam to Singapore, for one of his Vietnam negatives at the Wellcome Institute in London bears the date 1866. However Thomson's dating – providing it is his own – is sometimes inaccurate. That there is no mention in Thomson's writings of more than one visit to Vietnam is not conclusive evidence either way, for he often combined the incidents and observations of multiple visits into a single account for the sake of clarity.

Thomson remarked on his pleasant impressions of European Saigon, where the French merchant 'seems to carry on his trade with a degree of polite ease and light but elegant deliberation'. Three miles away was the native portion of the town of Saigon, Cholon. During the cool months, it was the habit of European residents to take a constitutional along the Cholon road, described as 'A Morning Walk in Cochin China' in Thomson's first venture into journalism – a series of evocative articles written for *The China Magazine* in 1868. Setting out, the walker passes coolies drawing morning supplies of pure water for the town from a well, and the Chinese shops, already open, their inmates brushing their hair at the door. 'A pack of the pariah dogs that infest Saigon have rushed howling across the road, and, through the cloud of suffocating dust they have raised, there is just visible the outline of a Cambodian cart, drawn by a pair of bullocks, and laden with produce from the interior.' Bullock trains come into view, their wooden cart-wheels creaking hideously; gendarmes are seen conducting a small prisoner, apparently to execution, barefooted women make their way to market; and then one reaches the Plaine des Tombeaux, a burial ground covering an area of about twenty miles: 'We will ascend this tomb, which is the highest near the roadside, from whence you see the entire plain covered with tombs, away to the very horizon.' And so one enters Cholon, astir long ago, noisy and entirely Chinese, and on as far as the river-bank to see the floating village and the Anamese river-huts, the subject of the photograph accompanying the article (see pl. 49).

'The capitalist who constructs these huts has to expend about two-dollars-and-a-half for the building of each, he then lets them out to his poorer friends. The food of this class consists entirely of rice and fish, and when providence is extremely kind, a little pork fat, as a luxury. The fish is obtained by dropping a line over the front *verandah*, on which the pot stands ready to receive the prize, as it is taken from the river. Clothing is one of the most expensive items in the maintenance of such a family. To-day they are in full dress to have their portraits taken. The father, who is rather imperfectly dressed, has taken shelter behind two children. He claims the distinction of a parent by wearing a conical hat made of leaves and worth about a third of a cent. On ordinary occasions the children are allowed to run about "au naturel", until they reach the age of six or seven years. In front of the huts there is the family canoe used for fashionable calls, fishing, &c.'[24]

Half way between Saigon and Cholon, off the road and well hidden, lay the village of Choquan. The villagers, writes Thomson, love privacy: 'every prickle in the hedge that encompasses their dwelling is, as it were, a token that the family within would rather be alone.' Here Thomson visits a sorcerer whose hut is surrounded by a thick cactus hedge. 'There is only one way by which this curious retreat can be entered, and that is by ascending a tree which bends over the hedge, then walking along a branch, and dropping from it to the doorway of the hut. When we have got inside we find the doctor, soothsayer, and magician, bent over a volume. Strewn on the table before him are the herbs by means of which he works some of his potent spells.' Patients drop down on him for a cure for a broken head, or heart. 'But the branch of his profession on which he mainly depends to fill his cash-box is the exorcism of the devils, which find a home in the hearts of his countrymen. . . . When

called to a patient's bed-side, the doctor begins his operations by bleeding – not the sick man, however, but himself. Into his own cheeks he first fixes two small skewers having lighted candles attached to their ends; then bending over the bed, he recites the praises of the good spirit, Chau-xuong, and solicits its aid.'[25]

In another of *The China Magazine* articles Thomson describes the leisurely life of an Anamese Chief whom he photographs (pl. 44): 'The Anamese aristocrat, like his prototype of other and more civilised nations, generally exhibits in his physique and manners, the evidences of superior breeding. When nature has had fair-play, he is taller and more erect than the average type of his countrymen of the humbler orders, while they are infinitely his superiors in muscular development. He has never done a day's work in his life. His hands are small, well formed, and soft as a woman's, and, as an indication of their utter uselessness, the nails of his third and little fingers are allowed to grow, or rather cultivated, until they become like the claws of a vulture ...

'His life is one of utter indolence. When at home, he lolls on a couch, or is seated on a chair, with half-a-dozen attendants surrounding him; one probably hunting through the hair of his head for insects of an objectionable character, while another fans him, and a third, who is watching the inanimate countenance of his lord, anticipates a wish, lights a pipe or cheroot, and gently places it between the parted lips of his lordship. When a friend calls who wishes to converse with him, he immediately fills his mouth with betel nut which is probably meant as a polite intimation that anything like an animated conversation is not to be thought of, and only suited for the vulgar. The friend is then invited to partake of the betel and seerie, and when both have the nut sufficiently masticated, gurgling growls, emitted though the plash of mastication, are exchanged, and are only intelligible to the highly tuned ear of the polite Anamese.'[26]

On the first day of the Chinese New Year Thomson went by boat to Cholon for the festivities. The Chinese boatmen were 'the most jovial characters I have seen', although 'why such men should be merry is a question for a philosopher to speculate upon. They are a hard working race, and poorly paid; they have few comforts, and many of them no home shelter save what they can find beneath the verandah, or at the doorway, of the godown where they are employed. True they can go to sleep without the dread of being robbed, for what has one of them worth taking? – His bamboo pipe, his bamboo pole, the rag that does not cover him, or the two or three fragments of a hat that he keeps together with a turn or two of his tail.'[27]

In Cholon Thomson visited 'a grave Chinaman, perhaps the gravest I know', a prosperous merchant whose house is the subject of the photograph accompanying the article (see pl. 42).

By the time Thomson left Vietnam he had begun to formulate his ambition to portray the Chinese as they lived in their own country. He had already visited Hong Kong and Canton, and possibly Shanghai, but in 1868 he was beginning a phase of his work which would leave those earlier brief excursions far behind. For the next four years of his life, he would travel the far reaches of China to make one of the most important and complete photographic documents ever made of any people.

*South China*

When Thomson arrived in Hong Kong in 1868 it was a new beginning both in his life and his work. Behind him were six years of experience of photographing and studying various Far Eastern societies. His fascination with the culture of China, the immense size of the country, and the opportunity it offered him to chronicle unexplored regions, all intensified his desire to travel there.

Balancing this objective, with the dangers and expense it would entail, was his need to establish himself economically in order to ask Isobel Petrie to join him in the Far East and become his wife.

Thomson did not set up a studio immediately, as he had in Singapore, but instead set about earning a living in another way. In April 1868 a notice appeared in *The China Magazine* stating that: 'The conductor of "The China Magazine" begs to inform subscribers that Mr. J. Thomson, FRGS, FESL, has undertaken the photographs with which the Magazine will, in future, be illustrated. From the high character of Mr. Thomson's productions and from the approbation awarded to them in Europe, as well as in the East, the conductor believes that subscribers will have reason to be well satisfied with this change.

'Photographs of scenes in Hongkong, Canton, Siam, Cochin China, Cambodia, and the Straits of Malacca, chiefly from negatives by Mr. Thomson, will appear during the present quarter.

'In deference to the expressed wish of numerous subscribers, the photographs will, in future, be fewer in number and larger in size.'

During his first few months in Hong Kong Thomson went about making contacts that would be important for the future. He then set up a studio in the Commercial Bank building on Queen's Road. An advertisement in *The Daily Press* offers: 'Views of Hong Kong. J. Thomson, 40 views, 10 large (14 × 19), 26 small (8 × 10), and four of late Dragon Feast.'[28]

Thomson published a number of articles in *The China Magazine*, but by the midsummer issue a problem had developed that resulted in the following notice to the magazine's subscribers: 'Although we hope to enjoy the advantage of an occasional contribution of plates and articles by Mr. J. THOMSON, we have to state that his charge of the illustration department of the Magazine has terminated. The illustrations are now all printed and (when not otherwise stated) the plates taken by the Magazine staff.'

An additional subscriber-announcement gives a clue to the probable source of the conflict: 'The article on artistic photography entitled, *Three pictures in Wong-nei-chung*, the illustrations to which appear in the present number, was crowded out, and will be published in our next.' The editor had decided to split the photographs and text of Thomson's article on the art of photography (see pp. 39–41), a solution that Thomson is likely to have found intolerable.

In July 1868 Thomson issued an album containing photographs of the Taiping Rebellion taken around the town of Soochow in 1863. 'This album', he writes in the preface, 'is issued as an accompaniment to Mr. Andrew Wilson's work, published by the Messrs Blackwood, entitled, "The 'Ever Victorious Army'. A History of the Chinese Campaign under Lieut.-Colonel C.G. Gordon, CB, RE, and of the Suppression of the Tai-ping Rebellion." A number of Photographs of Soochow having been made when Colonel Gordon was investing that city, it has been thought that they would be acceptable to those who take any special interest in his Campaign, though the circumstances under which they were produced forbade their being specimens of the highest style of Photographic Art as it is practised under more favourable circumstances in quieter parts of the world; and to these have been prefixed the Cartes-de-visite of the principal persons who were connected with what the Chinese officially termed the "Ever Victorious Army".'[29]

There is no mention of who took the original photographs. Thomson had no other involvement with war photography, and published this album merely as a commercial venture.

With his studio prepared, Thomson sent for Isobel to join him in Hong Kong. He also brought his two Chinese assistants, Akum and Ahong, to join him from Singapore. And he made arrangements for his wedding. A notice in *The Daily Press* of 21 November 1868 announces: 'Married 19th, Rose Villa, John Thomson, Esq. to Isobel, daughter of Capt. P. Petrie.'[30]

Soon after the marriage Isobel was expecting her first child. She found the Far East a difficult and frightening place to live. There were financial pressures, also, for Thomson had been obliged to assume responsibility for the debts of his brother William, who was still living in Singapore.

Impatient to begin his travels in China, Thomson went with Isobel on a visit to Canton, less than a day's travel by boat. His short stay produced an impressive body of work. He also made a brief visit to Shanghai and the Snowy Valley, but his work there did not satisfy him, and he returned to both places in 1872, before leaving China for good.

Thomson's style had begun to reveal its strengths as early as the Siam work of 1865. Four years later, when he sent some of his Canton photographs to *The British Journal of Photography*, they were praised by the reviewer for the natural groupings of the various figures introduced into the pictures, for the 'faculty for easy and natural posing' they displayed, as well as for providing 'a sort of pictorial encyclopaedia' of Chinese manners and customs.[31]

In 1869 the European colony in Hong Kong buzzed with the excitement of a visit by the Duke of Edinburgh, who was coming ashore while on a cruise to the Colonies. Streets, buildings and boats were decorated in his honour. Thomson took a series of photographs, including a portrait of the Duke and numerous views of the festivities. Shortly afterwards a commemorative book was published in Hong Kong with a text by the Rev. Beach and seven original photographs by Thomson.[32]

Later in the year the photographer's first child, William Petrie Thomson, was born; and a few months afterwards, on 23 June 1870, Isobel and the baby set out on the long voyage home. 'The fact of my being so much stronger now makes the separation more bearable, and I have a kind of feeling', wrote Isobel, 'that if I had stayed in Hong Kong, either my own or my baby's life would have been sacrificed.'[33]

Finally free to travel, Thomson set out to explore the North Branch of the Pearl River, some forty miles above Canton. The party included three men from Hong Kong, porters to transport the photographic equipment and the assistants Akum and Ahong. 'I do not think Akum has yet been introduced to my readers,' wrote Thomson. 'He was a faithful servant, or boy as they are here called, about forty years of age, who had been in my employment in Singapore, and afterwards turning trader, had lost his small capital.' Thomson was gazing over some bamboo fields when Akum approached him: '"Well," he said, "what are you looking at, Sir?". "At the beautiful view," I replied. "Yes," he said. "I wish I had the smallest of these hills; I would settle there, on the top, watching my gardeners at work below, and when I saw one labourer more industrious than the rest I would reward him with a wife." He spoke to me often afterwards about this ideal hill on which he hoped one day to sit and reward the virtue of his servants.'[34]

Travelling some two hundred miles up the river the party reached the grotto of Kwan Yin, the goddess of mercy. The album of the journey, *Views on the North River*, was to be published in Hong Kong. It is perhaps the least successful of Thomson's productions, for, as he writes in the Introduction, 'With a few exceptions, the efforts to obtain bright photographs of distant objects were baffled by a continuance of bad weather casting a veil of mist over the distance, and shrouding in fleecy clouds the jagged peaks in the foreground of the pictures.'[35] Few copies of the book are known.

It is only through his wife's letters to him that we can learn something of Thomson's plans. His own letters are lost, and he seldom had much to say about his objectives in the books he later wrote on the Far East. We learn from his wife that he planned to visit America after completing his work in China. Having studied the Chinese in the Orient, he was curious to see how they adapted to life on another continent. There was a growing Chinese population in America, and Thomson had learned about conditions there from the Americans with whom he spent a good deal of time in the Far East.

Though unable to finalize the sale of his Hong Kong studio, to free himself from responsibility and provide funds for his journeys, Thomson decided to spend a year travelling in the various Chinese provinces. In just over twelve months, he visited Fukien province, went up the River Min, crossed to

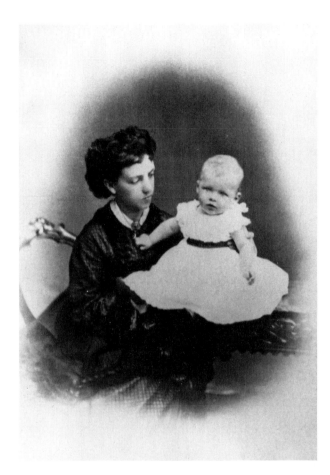

*Isobel and John Newlands Thomson, c. 1871.*
*Newlands, as the child was called, was born after*
*his mother's return from the Far East*

the island of Formosa, visited Shanghai, travelled far up the Yangtze, and went to Peking, Swatow, Amoy, Hankow, Nanking, Chefoo and Tien-tsin. Some of these places he had visited before, while others were an entirely new experience. With his two assistants and his dog, Spot, he moved on at a hectic speed from place to place, recording and photographing as he went.

Thomson was now at the height of his powers, and the work he produced during this year formed the basis for *Illustrations of China and Its People*, to be published in four volumes in London in 1873–74, two years after his return from the Far East.

The completed work did not, however, include a record of the Chinese in other parts of the Far East nor of those in California. By the time Thomson left China, the pressure to return to his wife and two children, the second of which he had not yet seen, was so great that he was unable to realize his ambition to return by way of the United States.

*Foochow and the River Min*

It was in the Fukien province Thomson reached his highest level of achievement since arriving in China. The success of his photographs exceeded even his own expectations. Believing they would prove popular with the European population of Foochow, Thomson decided he would publish a book about the area, to be sold by advance subscription to tea-planters, missionaries, and government officials. The book's dedication was 'to the Foochow foreign residents, as a lasting memento which will aid them, in future years, in recalling the scene and incidents of their life in one of the most picturesque provinces of China'.[36]

A high-point of the Foochow visit was a journey up a branch of the Min River to the monastery of Yuan-fu, in the mountains about thirty miles above Foochow. After two days passed 'amid a ceaseless diversity of grand river and mountain scenery', on the third morning, 'at a short distance above the first rapid, we landed to make the journey to the monastery. My friends had brought their sedans and bearers with them; as for me, I hired one at the nearest village; my dog, as was his custom, at once scrambling inside, and stowing himself comfortably beneath the seat . . . At one spot there is a flight of 400 steps (I had the curiosity to count them as our progress was slow), and this brought us to the entrance of the ravine overlooked by the monastery, which was also perhaps the most romantic bit of scenery to be encountered there. Above these steps, the path winds beneath a forest, and around a rich undergrowth of ferns and flowering shrubs, and finally, seems suddenly to terminate in a cave. This cave in reality forms the passage through which the dell is approached. A small idol stood at the foot of the rocks, on the right of the entrance, and there was incense burning before its shrine.'[37]

A path cut into the rock-face gave a view of the monastery 'propped up on the face of a precipice 200 feet in height, and resting above this awful abyss, on nothing more durable than a slender-looking framework of wooden beams'. Thomson stayed on in the monastery for a few days instead of returning straightway to Foochow.

There is another impressive subject of the Foochow photographs besides the scenic. Thomson's personality was marked by an unusual degree of sensitivity to the lives and misfortunes of others. He had an ability to judge situations individually, without recourse to the racial stereotypes normally adopted by Englishmen living abroad at that time. While many of his photographs, including the earliest ones in Penang and Singapore, had depicted the lives of peasants as well as the wealthy and prominent, it was in Foochow that Thomson made his first deliberate series of photographs portraying the different social elements that made up the town. Many of his photographs depict criminals, 'detectives', lepers, beggars and beggar chiefs.

'In China', wrote Thomson, 'poor law is known, and the only plan adopted to palliate the evil [of destitution] is to tolerate begging . . . and to place [the beggars] under the jurisdiction of a responsible chief.' Thomson describes his visit to the home of such a head-man: 'His eldest son received me at the entrance, and conducted me into a guest's chamber; and while I was seated there two ladies, dressed in silks and with a certain degree of refinement in their air, passed the door of the apartment in order to steal a glimpse at its inmate. These were the chief and the second wives of this Lord of the Lazaroni, who was himself unfortunately absent on business.'

The method these chiefs adopted was 'to make an agreement with the business men of the streets in their respective wards, under which they levy a kind of poor-rate for the maintenance of themselves and their subjects. A composition thus entered into exempts the streets or shops whereon the chief has placed his mark from the harassing raids of his tattered troops. Woe betide the shopman who has the courage to refuse his dole to these beggars! The most loathsome and pertinacious specimens of the naked tribe will be dispatched to beset his shop. Thus, while walking along one of the best streets in the city, I myself saw a revolting, diseased, and filthy object carried on the shoulders of another member of the fraternity, who marched into a shop and deposited his burden on the polished counter, where the tradesman was serving customers with ornaments for shrines, and food for the gods. The bearer, with cool audacity, proceeded to light his pipe and smoke, until he had been paid to remove the cripple.'[38]

Worse, even, than these, was a class of beggars 'who own allegiance to no prince or power on earth – and these were the men whom I visited and found dwelling in the charnel-houses in a city of the dead. Many of the little huts in this dismal spot were built with brick and roofed with tiles. They contained coffins and bodies placed there to await the favourable hour for interment, when the rites

of Fengshui might be duly performed, and the remains laid to rest in some well-situated site, where neither wind nor wave would disturb their sacred dust. But poverty, death, distress, or indeed a variety of causes, not unfrequently intervene to prevent the surviving relatives from ever choosing this happy site and bringing the final ceremonies to a consummation; and thus it comes to pass that the coffins lie forgotten and moulder into dust, and the tombs are invaded by the poor outcasts, who there seek shelter from the cold and rain, creeping gladly to slumber into the dark corners of a sepulchre, and then most happy when they most imitate the dead . . .

'Passing on to a tomb where I could hear sounds of mirth, I found four inmates inside, the members of a firm of beggars. I visited them again next morning, and came upon the group at breakfast . . . One, the jester of the party, was seated astride a coffin, cracking his jokes over the skull of its occupant. The repast concluded, they had to adjust their counterfeits of disease and deformity, and to map out their pilgrimage for the day.'

'After visiting the beggars,' Thomson continues, 'I thought I might as well see what the detectives are like. These men are commonly known as the "Maqui" or "Swift as horses", and are attached to the yamens of the local authorities, receiving a small stipend out of the government supplies, but obtaining the bulk of their earnings from persons who seek to recover stolen goods, or even from the thieves themselves.'[39]

When a house had been robbed, the owner contacted the detective to offer him a reward of half the property recovered. The detective then approached the thief with the offer. If the thief refused to return the property he ran the risk of being tortured or imprisoned, or both. Thomson photographed 'a thief who had just escaped from gaol . . . an unprofitable burglar [who] was accordingly triced up by his thumbs until the cords had worn away the flesh and left nothing but the bone.' If the thief turned out to be an amateur, the detective might be unable to locate him. When this happened, the detective was whipped. Then he would whip his subordinates, and they in turn would whip the thieves. 'Should this plan fail,' wrote Thomson, 'it is reported that the police have been whipped, and that the stolen property cannot be found.'[40]

Since the detective earned his income by the success of his thieves, he was not eager that his charges should reform: 'It was told of this detective, who might more appropriately be called the chief of the thieves, that he, one day, fell in with an old thief whom he had known and profited by in former times, but who was now respectably clad, and striving to lead an honest life. He at once had the man conveyed to prison, and there, in order to impress upon him the danger to which he exposed himself in falling into honest ways, suspended him by the thumbs, stripped off his clothes, and discharged him with one arm put out of joint.'[41]

Thomson visited a village of more than three hundred lepers near Foochow. The poorer of the lepers received a nominal annual sum from the government, enough to support them for perhaps one month out of the twelve, and for the rest, they were forced to beg. Yet the streets of the leper village were pleasant and clean, as were many of the houses. 'The most surprising feature in the whole village,' Thomson commented, 'was the wonderfully cheerful aspect of a considerable portion of its occupants.'[42]

An important contact for Thomson was Justus Doolittle, a missionary who had spent sixteen years in the area, who was editor of *The Chinese Recorder* as well as the author of a book on the *Social Life of the Chinese*.[43] When Thomson had the opportunity to borrow the yacht of a wealthy English merchant he invited Doolittle to accompany him on a trip up the far reaches of the Min. Together with a large number of servants and Thomson's assistants they made their way up-river on a journey that provided Thomson with some of his greatest landscape opportunities. From Doolittle's account in *The Chinese Recorder* we learn how small was the number of photographs taken on the trip, an

example of Thomson's ability to make each photograph significant. 'In December the editor accompanied Mr. Thomson on a trip of over two weeks up the Min as far as Yen-pin-fu, nearly 150 miles. Mr Thomson, who travels as an artist, took 50 or 60 photographs of the most striking and beautiful scenes, of which about one half were stereoscopic, and the rest were of a much larger size.' Doolittle also reported that 'it is his design soon to visit some of the ports North of this place in China, including Hankow, Peking, &c. In the Fall he proposes to spend some time in Japan on his way to the United States.'[44]

The early part of the journey passed with little incident. 'Sunday we spent quietly at a place called 'Teukkai', or Bamboo Crags. Here I had a walk ashore with my boy Ahong, and stopped for awhile to rest on a green mossy bank, whence our boat could dimly be made out through a sheet of mist, that rose above the river, like the steam from a cauldron's mouth. This vapour crept onwards up the mountain in a number of grotesque shapes, here and there forming beautiful vignettes out of the clumps of giant pines, and in a moment blotting out the picture again as it rolled waywardly along the woody steeps. These mists were a phenomena of daily occurrence, caused, I suppose, by the difference of temperature between the water and the air.'[45]

Along the way, the party encountered people who had never before seen a European. At Shui-kow they changed from the yacht to a riverboat to take the rapids. 'Our captain was Cheng-Show, or rather his wife, a lady who had a great deal to say both for him and herself too; who stood no more than four feet high, and yet talked about half as much again as any other woman twice her size. Of a truth she was the wonder of her sex, the great female phenomenon of the modern Chinese age!'[46]

'As for the rapids, their tumultuous cataracts alternate with great basins of smooth water slipping glassily onward from shoal to shoal. In some rapids the channel was so thickly bestrewn with rocks as to be concealed from view at but a very short distance off; while in the great Yen-ping rapid my ears were deafened by the roar of the boiling torrent, and my sight bewildered by the wide expanse of leaping and foaming water. Here, as we ascended, the ancient mariner Cheng flung his pipe down in a moment of peril; shouted out to the trackers on shore; and, snatching up a pole, planted it on a sunken rock to ease the strain that threatened to snap the cable by which we were being tracked from the bank, and send us to destruction on the rocks. It was an instant of intense excitement and danger; the power of the rushing water seemed to baffle the efforts of the crew, till all hands were at the poles, and with one combined effort we moved slowly up the current; the old man prostrating himself, and preparing a burnt offering of paper in honour of the sailors' protecting goddess.'[47]

Arriving in Shui-kow, Thomson wondered at the strange silhouettes of the inhabitants of the area, many of whom appeared deformed, 'due to the small charcoal furnaces which they carried concealed beneath the dress, and used to keep their bodies warm. As there are no fireplaces in the houses, these portable furnaces prove very convenient substitutes.' A last-moment peril occurred when: 'As I walked through the streets of Shui-kow on my way back to the boat, I lost my dog "Spot," who had been my constant companion; but recollecting a door in a wall that had been suddenly opened and shut, I felt certain my pet had been there caught up and taken in, as his white silken hair was much admired by the Chinese. Back I trudged to the door; and as, when I whistled, I seemed to hear a whining response, I commenced a vigorous assault on the entrance. My knocking soon collected a crowd, to whom my difficulties were explained; when, after a knock and a push more dangerous than the rest, my dog was quietly handed over the wall to me, and we turned our backs upon the place to descend to Foochow, and to photograph the points of interest on the route.'[48]

From Foochow Thomson went to Amoy, spending two or three weeks in the wealthy city-port before crossing to the island of Formosa on 1 April 1871, accompanied this time by a medical missionary named Maxwell who was well known on the island.

*Formosa*

At the time Thomson visited Formosa only half the island was under the control of the Chinese. Much of the eastern part of the two hundred and fifty miles length was controlled by various tribes of aborigines, including some practising cannibalism. These tribes were often responsible for massacres of shipwrecked European or American travellers.

From Taiwan, Thomson, his assistants, Dr Maxwell, and bearers carrying the photographic equipment, set out on foot to visit the Pepohoan villages. The Pepohoans were a half-civilized tribe occupying much of southern Formosa. Thomson, an excellent linguist, noted that 'they resembled the Laotians of Siam both in features and costume, while their old language bore undoubted traces of Malayan origin,'[49] and that they were 'a fine simple-looking race, and had a frank sincerity of manner which was refreshing after a long experience of the cunning Chinese'. Walking between villages, Ahong developed severe blisters, and the party suffered exhaustion from the excessive heat of the island. They lived in the most primitive of conditions along the way. The huts in which they slept had large rats running through the rafters. The Pepohoans trapped the animals, for rat-dinner was considered a great delicacy. At every village the missionary-doctor spent his time tending the sick. On their return to Taiwan it was Dr Maxwell who fell ill, directing Thomson on how to treat him with quinine.

After his return to England, Thomson used the photographs and notes of Formosa for an illustrated lecture given to the Royal Geographical Society in 1873.[50]

*North China*

Having completed the sale of his studio, which had delayed him for much of the summer, Thomson immediately set out for Shanghai. He had first visited the city two years earlier, and now it became his base in North China. A traveller contemporary with Thomson described Shanghai as 'belonging to Europeans and Americans, in so much that the Chinese have nothing to do with its government. The foreigners have their own Municipal Council, and make their own laws. The town is beautifully laid out with macadamised roads, and the buildings are quite palatial, reminding one of the marble palaces of Genoa.'[51]

Thomson's arrival was not without incident. As he reported in a letter to Isobel, and later described in one of his books: 'The Chinese have a superstitious belief that bad luck will attend their voyage, if they fail, at starting, to cross the bows of a vessel as she sails across their track; and so, as we steamed on, we perceived a native trading-boat making frantic efforts with sails and sculls to pass under our bows. The whistle was plied, but in vain. On they pulled to their own certain destruction. . . . The engines could not be backed amid such a crowd of shipping, and I was gazing helplessly over our bulwarks when we came crashing through the timbers of the fated craft. There was a yell of despair, and the wreck was next seen drifting down the stream. A number of the crew had been projected by the shock some distance into the water; others clung to their property until it was submerged; but fortunately none of them perished, as a number of boats had seen the incident and had put off to their assistance at once.'[52]

Thomson stayed only briefly in Shanghai, noting the splendour and sumptuousness of the foreign settlement, the picturesque form of taxi known as 'the Shanghai wheelbarrow' and the many temples of the old walled city. He continued on to Peking, reaching the city in early September 1871.

*Peking*

The capital city of China was divided into two parts, the Tartar or Manchu quarter and the Chinese settlement, joined by a wall more than twenty miles round. The city had remained unchanged in this respect since the Manchus seized power some two hundred years prior to Thomson's arrival. 'The old walls of the great city', Thomson wrote, 'are truly wonderful monuments of human industry. Their base is sixty feet wide, their breadth at the top about forty feet, and their height also averages forty feet.'[53]

'But let us hasten our steps, and enter the gate to behold this great metropolis. A mighty crowd is pressing on towards the dark archway, and we betake ourselves again to our carts, feeling sure that our passports will be examined by the guards on duty at the portal. But after all we pass through unnoticed in the wake of a train of camels laden with fuel from the coal-mines not far off. There is a great noise and confusion. Two streams, made up of carts, camels, mules, donkeys, and citizens, have met beneath the arch, and are struggling out of the darkness at either end. Within, there is a wide thoroughfare, by far the widest I encountered in any Chinese city, and as roomy as the great roads of London.'[54]

Inside the walls Thomson witnessed sights such as he had seen in no other place in China. 'I have not space to relate a tenth of what I beheld or experienced in this great capital, how its naked beggars were found in the winter mornings dead at its gate; how a cart might be met going its rounds to pick up the bodies of infants too young to require the sacred rites of sepulture; how the destitute were to be seen crowding into a sort of casual ward already full, and seeking permission to stand inside its walls, so as to obtain shelter from the wintry blast that would freeze their hearts before the dawn. There are acres of hovels in Peking, in which the Imperial bannermen herd, and filth seems to be deposited like tribute before the very palace gates.'[55]

Though the thoroughfares were wide, a 'cartway runs down the centre of the road, and is only broad enough to allow two vehicles to pass abreast. The causeway in the middle is kept in repair by material which coolies ladle out of the deep trenches or mudholes to be seen on either side of it. Citizens using this part of the highway after dark are occasionally drowned in these sloughs.'[56]

The Peking shops, by contrast, Thomson found 'very attractive objects. Many of their fronts are elaborately carved, and painted and gilded so beautifully that they look as if they ought to be set under glass cases, while as for the interiors, these are fitted up and finished with an equally scrupulous care, the owners ready for business inside, clothed in their silks, and looking a prosperous, supremely-contented tribe.'[57]

Walking proved treacherous there. 'As in the Commercial Road in London crowds congregate in front of the tents and stalls of the hawkers, while the shopkeepers spread out their wares for sale so as to monopolise at least two-thirds of the pavement, so also in Peking, in yet greater numbers and variety, the buyers and sellers occupy every dry spot. Sometimes one can only get through the press by brushing against the dry dusty hides of a train of camels as they are being unladen before a coal-shed; and one must take care, should any of them be lying down, not to tread on their huge soft feet, for they can inflict a savage bite.'[58]

Much of the entertainment of the city centred in the streets. 'Jewels, too, of no mean value, are on sale here as well, and there are peep-shows, jugglers, lottery men, ballad-singers, and story-tellers; the latter accompanying their recitations with the strummings of a lute, while their audience sits round a long table and listens with rapt attention to the dramatic renderings of their poets. The story-teller, however, has many competitors to contend against, and of all his rivals the old-clothes men are perhaps the most formidable tribe. These old-clothes men enjoy a wide celebrity for their humorous stories, and will run off a rhyme to suit the garments as they offer them to the highest bidder. Each

coat is thus invested with a miraculous history which gives it at once a priceless value. If it be fur, its heat-producing powers are eloquently described. "It was this fur [Thomson here is quoting the old-clothes hawker] which, during the year of the great frost, saved the head of that illustrious family Chang. The cold was so intense that the people were mute. When they spoke, their words froze, and hung from their lips. Men's ears congealed, and were devoid of feeling, so that when they shook their heads they fell off. Men froze to the streets and died by thousands; but as for Chang of honoured memory, he put on this coat, and it brought summer to his blood. How much say you for it? ." '[59]

'The foregoing', writes Thomson, 'is a rendering of the language actually used by one of these sellers of unredeemed pledges.'

Thomson stayed for three months in Peking, living in a hotel run by a Monsieur Thomas. Accommodation was often a problem for the travellers in China, and without contacts it might be impossible to visit a particular town or city. Thomson's hotel in Peking was barely tolerable: 'The mud floor, indeed, was matted over, but the whitewashed walls felt sticky, and so did the bed and curtains; a close, nasty smell, too, pervaded the whole apartment, and on looking into a closet I discovered a quantity of mouldy, foreign apparel. This, as I found out next morning, had been left there as plague-stricken by a gentleman who, some days previously, had nearly died of small-pox in this very room.'[60]

Thomson purchased a small Mongolian pony, which he used to explore the city and surrounding area. He photographed many of the famous sights of the city; the university with its astronomical instruments, the Confucian temples, and he visited the Ming Tombs, and of course the Great Wall.

Again relying on contacts, Thomson met a number of Europeans while staying in the city. Among them was a Dr Martin, president of the Imperial Tungwen College, who introduced him to the powerful Prince Kung, uncle of the Emperor, as well as to a variety of high government officials. Thomson photographed the Prince, who presented him with silks. Another of the men Thomson met, a member of the Grand Council named Wen-siang, was 'one of the foremost ministers of his age'. Thomson quotes a reply he made to a foreigner who asked him about the slow pace of progress in China: 'Give China time, and her progress will be both rapid and overwhelming in its results; so much so, that those who were foremost with the plea for progress will be sighing for the good old times.'[61]

Thomson also had the opportunity to meet wealthy Chinese. Among them was a Mr Yang, a member of the Public Works board, who invited Thomson to his home, an occurrence unusual in China. In one of his books Thomson explains the reason: 'A second difficulty arises from the strong dislike entertained by the people against admitting strangers into the inner court of their dwellings; for these they hold to be sacred and inviolate. To such an extent, indeed, has this idea of privacy and family isolation been carried, that Chinese homes have for ages been constructed, on all occasions, after a model which seems to aim at perfect family seclusion from relatives even, and friends, no less than from strangers.' Thomson adds that: 'I enjoyed exceptional advantages for gleaning information about the inner life of the Chinese wealthy classes, and the arrangements of their households, inasmuch as I never let slip an opportunity of volunteering to take family portraits, in order that while thus engaged, I might obtain for myself such groups and interiors as those which I have here represented.'[62]

### Shanghai and the Yangtze

With a satisfactory body of work from the capital, Thomson returned once more to Shanghai, this time intending to explore the Yangtze River. But first he stayed in Shanghai for about two months,

visiting friends and giving a lecture to the Shanghai branch of the Royal Asiatic Society. His work received favourable review in *The North China Herald*: 'I was delighted to see such good notices about your photos,' wrote Isobel. 'Such encouragement must be very gratifying to you.'[63]

Thomson made his final preparations for the dangerous journey up-river to the remote region of Szechuan. He was already growing homesick. 'I thought your previous letter was rather despondent,' Isobel wrote in February. 'As you say patience is a good thing to preach but not as easy to practice it, especially when the exercise of it keeps two loving hearts apart. I, like you, become more & more impatient as the time draws near.' She reported that Thomson's Formosa friend, Dr Maxwell, had used some of his photographs in a medical lecture in Edinburgh, and that there were two subscriptions for the anticipated work on Foochow.[64]

Still, Thomson knew that he had to make the journey in order to fulfil his goal. He set out with his two assistants, and porters for the equipment, travelling the first six hundred miles by steamer to the town of Hankow. There Thomson met the ruling Taotai, and was issued a passport allowing him to travel further.

The party embarked for the next stage in two hired native boats, with a pair of American passengers and an interpreter and secretary named Chang, 'a small compact man, full of Chinese lore and self-satisfied complacency'. Captain Wang and his wife were in charge of the boats. 'We left Hankow about mid-day on January 29, 1872, but as there was no wind, we had to pole our way through thousands of native boats, and anchor for the night at Ta-tuen-shan, only ten miles above the town. A hard frost set in during the evening, and it seemed quite impossible to keep the intense cold out of our quarters.

'To make matters worse, the skipper and his spouse smoked stale tobacco half through the night, and the fumes came through the bulkhead and filled my sleeping-bunk ...

'The boatmen were a miserably poor lot. They neither changed their clothes nor washed their bodies during the entire trip; and "Why should they?" said Chang the secretary; they could only change their garments with one another. They have but a single suit apiece, and that too, some of them, only on loan for the winter months. Their clothes were padded with cotton, and formed their habiliments by day and their bedding by night. Poor souls, how they crept together, and huddled into the hold! and what an odour rose from their retreat in the morning, for they had smoked themselves to sleep with tobacco, or those of them who could afford it, with opium.'[65]

Mrs Wang was in charge of rousing the crew. 'She shakes those sluggards from their rest with her strident tones; she stamps in her cabin and 'slings slang' at them, like the foulest missiles. At last, at about seven o'clock, they might be seen unwillingly turning to and hauling up the anchor ...'

The journey began with a monotonous succession of fights between the captain's wife and the crew, morning meals and evening meals, river-charting and a scenery of mud-red water and low side-walls that did not seem to change for days on end. Only Chang, the interpreter, was content. He read the ancient classics and enjoyed all the wine and cheroots his employers would provide.

At Shang-chai-wan, where they stopped to find coal, few of the inhabitants 'had ever set eyes upon a genuine white man before, and all made numerous good-natured enquiries about our relations, and our clothes; one old man even suggested that our faces and hands had only acquired a pale colour through the use of some wonderful cosmetic, and that our bodies were black as sin. I bared my arm to refute this calumny, and its white skin was touched by many a rough finger, and awoke universal admiration. Not knowing exactly what our barbarous views of decency might be, we were kindly recommended by an unwashed, but polished member of the community, not to gratify vulgar curiosity by stripping entirely, as we had already completely satisfied the more intelligent members of the crowd.'[66]

At Kiang-kow, far up the Yangtze, the crew wanted to go ashore for wine, and demanded money from the passengers to pay for it. The Captain pleaded with the men to return to work, but in vain, until, as a last resort, he threatened to turn his wife loose upon them. The strike came to an abrupt end.

At a small town called Ichang the party hired a boat to ply the rapids, leaving Captain Wang and his crew to await their return. 'We had a crew of twenty-four men at the sweeps,' Thomson wrote, 'who worked to the tune of a shrill piping song, or rather yell, and under their exertions it was not long before Ichang had been passed and the mouth of the first gorge was before us. Here the river narrows from half a mile to a few hundred yards across, and pours through the rocky defile with a velocity that makes it difficult to enter. The hills rose on each side from 500 to 2,500 feet in height, presenting two irregular stone walls to the river, each worn and furrowed with the floods of ages, and showing some well-defined water markings seventy feet above the winter stream, up which we were now toiling our way. The further we entered the gorges the more desolate and dark became the scene.'[67] The only inhabitants of this region appeared to be a few fisherman, whose huts, or caves, could be seen perched high among the mountains.

At a village called Kwang-loong-Miau the crew paused for half a day to celebrate the Chinese New Year, drinking, setting off fire-crackers, quarrelling and gambling, and – as became apparent next morning – selling off a portion of their clothing to give the new year a fair start. But 'they soon got heated, as we had cleared the first gorge and were now ascending a rapid. It was the first, but by no means the least dangerous. The bulk of the men were on the bank, attached to a tracking-line. Off they sped, yelling like fiends above the roar of the water; while the boy, to add to the din, lustily beat a gong, and the cook a small drum, for the purpose of stirring the men to put forth their full strength. At about the centre of the rapid there was a dead halt, just as if the boat had stuck fast on a reef, though the trackers were straining to their utmost with hands and feet planted firmly on the rocks. The skipper stamped, danced, and bellowed to his crew; and they, responding with a wild shout, a desperate tug, and a strain, at last launched our boat into the smooth water above.'[68]

The passengers had counted nine wrecks by the time they reached the third rapid, Shan-tow-pien. Thomson paused at a village to take a photograph, but his intrusion there was met with a rain of sods and stones. 'No doubt these villagers, some of them, had heard the popular fiction that pictures such as mine were made out of the eyes of Chinese babes. I narrowly escaped a stroke from an oar as I took refuge in a boat; but the blow was warded off with a force that sent its author spinning headlong into the stream . . .'[69]

Further up-river they visited a desolate area filled with coal mines. 'There every household is employed entirely in the trade, the children making fuel by mixing the coal with water and clay, and then casting it in moulds into blocks which weigh one catty (1 lb. $\frac{1}{3}$rd) a-piece.'[70]

The last of the great Gorges, Wu-shan Gorge, was more than twenty miles long. 'The officers of a gun-boat stationed at the boundary which parts the provinces of Hupeh and Szechuan, warned us to beware of pirates, and they had good reason for so doing. We came to anchor at a place where the rocks towering overhead wrapped the scene in pitchy darkness; and it was nearly 10 p.m. when our skipper sent to say we had better have our arms ready, as pirates were prowling about. One boat had just passed noiselessly up alongside, and its occupants were talking in whispers. We hailed them, but they made no reply; so we then fired over their heads. Our fire was responded to by a flash and a report from some men on the bank, not far off. After this we kept a watch all night, and at about two in the morning were all roused again to challenge a boat's crew that was noiselessly stealing down on our quarters. A second time we were forced to fire, and the sharp ping of the rifle ball on the rocks had the effect of deterring further advances from our invisible foe.

'On another night, in this gorge, I was summoned by my boy, who appeared in the cabin with a face of blank terror, and told me that he had just seen a group of luminous spirits that were haunting the pass. It was evident that something unusual had occurred, as I had never seen the boy in such a state of clammy fear before; so we followed him on to the deck, and, looking up the precipice about eight hundred feet above our head, we then saw three lights on the face of the rock performing a series of the most extraordinary evolutions. My old attendant declared, the cold perspiration trickling down his face the while, that he could make out sylph-like forms waving the lights to warn wayfarers off from the edge of the abyss ...

'The true explanation of the phenomenon lay in the fact, perhaps, that in this very gorge there are hapless beings, convicts immured in prison-cells cut in the face of the rocks, into which they are dropped by their gaolers from above, and from which they can never hope to escape unless to seek destruction by a plunge into the river below.'[71]

Thomson had travelled thirteen hundred miles above Shanghai to Szechuan, and could ascend the river no further. It took the party eighteen days to return the seven hundred miles to Hankow, where the journey had begun.

In April 1872, before finally leaving Shanghai, Thomson returned to the town of Ningpo and the famous Snowy Valley with the monastery high in the mountains. A monk led Thomson along a path that led to the 'thousand fathom precipice', where he could look down on the river, far below.

Returning to Hong Kong for the last time, Thomson sorted out his negatives, leaving many behind, taking only those he felt would be most useful in his future writing, probably less than twelve hundred.[72] The rest remained in Hong Kong, where they became part of the The Firm.[73] He said goodbye to his two assistants, who had so faithfully served him for almost ten years. Then in summer 1872 he boarded ship for England, to face an uncertain future.

*Years at home 1872–77*

With his return home in 1872, Thomson's life took a new and different direction. The nomadic existence of the past two years was replaced by the sedentary responsibilities of a man with a growing family, little money and a desire to bring out a series of books recording his recent experiences. His first project, after settling with his family in the Brixton area of London, was to publish the Foochow book, which had been sold by subscription. In order to make the photographs permanent he chose the Autotype Company of London to do the printing.[74] Each plate was numbered by hand to correspond with the letterpress titles.

The book was to be Thomson's most impressive, as well as his rarest, work. It was published in an extremely small edition, the exact number printed being unknown.

Before *Foochow and the River Min* was completed Thomson had already begun the process of compiling his great visual encyclopaedia of China and its people. The book was a complex project, requiring difficult decisions about which photographs should be included to create a balanced account of the architecture, people and topography of China. Thomson also wrote the text for the book, a series of sometimes elaborate essays linked to particular photographs, much as for *The China Magazine* in Hong Kong many years before. This work was published in four folio volumes, in 1873 and 1874, under the title *Illustrations of China and Its People*. Sampson Low were the publishers, the first of many collaborations between the photographer and this company.

Two hundred and eighteen photographs were reproduced by means of the collotype, or Albertype, process. Like the carbon process used in the *Foochow* book, the collotype process was permanent, although it was less aesthetically satisfying. Until permanent printing processes were

developed, fading was a common problem in the photographically illustrated books of the nineteenth century (see p. 42).

The exact number of copies printed is unknown. It was difficult to print large editions of photographically illustrated books, consequently editions were often of one thousand copies or less. Four years later, the four folio volumes were still being advertised for sale (in the pages of a book Thomson had translated) at the then expensive price of three pounds, three shillings, a volume.[75]

The *Pall Mall Gazette* gave a lengthy review to the four volumes. 'One fault only we have to find with the book as a whole – the illustration is somewhat in excess of the literary material. In the case of a country like China there is very much about which we seek information, and although this information may possibly be gained from various sources, it would have been more convenient if Mr Thomson had enlarged the scope of his literary labours and given us a fuller account of the subjects of his illustrations.' 'But whatever may be the judgement on its method,' the reviewer continues, 'Mr. Thomson's book is in substance a most valuable assistance to the understanding of its subject. No picture of Chinese manners at once so full and so vivid has yet been attempted; for, admitting the many artistic faults of photography, there is assuredly no other process by which we are set in such intimate relation with facts remote from us in point either of place or time.'[76]

Thomson soon seized an opportunity to 'enlarge his literary labours' in the travel-chronicle *The Straits of Malacca, Indo-China, and China, or Ten Years' Travels, Adventures and Residence Abroad*, which appeared a year after the four-volume work. The illustrations were wood-engravings made from Thomson's photographs. The text follows Thomson's travels from his arrival in Penang in 1862, through Siam, Cambodia and Vietnam, and to all the places he visited up to his departure from China in 1872.

The response to *The Straits of Malacca* was not universally favourable. *The Saturday Review* found the incidents to be mainly those of *China*, 'considerably enlarged upon, and not always to their advantage'.[77] While the four-volume set had cost more than twelve pounds, however, the new work cost only twenty-one shillings, and was therefore accessible to a far wider public.

Early in 1875 Thomson gave three lectures in Liverpool on 'The Traveller in China'. A reviewer commented that: 'They [the photographs] are apart from their value in connection with the descriptive matters of the lecture, real works of art, and they won universal admiration when they were presented for the first time last evening to a Liverpool audience.'[78]

Later in the same year, Thomson attended the International Geographical Congress in Paris, where four of his photographs were exhibited, besides the *Illustrations of China* volumes. Thomson received a second class medal for his work – greater recognition than he received in his own country. A French edition of *The Straits of Malacca* appeared in 1877.

Thomson's family was growing – by 1878 he had three daughters and two sons. The family moved four times in seven years, always remaining within the Brixton area. Thomson had no staple means of gaining a livelihood. He occasionally sold some of his photographs of the East, but more important were the articles he submitted to various journals, and his translations. He continued to write his own books at the same time. Of the three books he translated in 1875–76, only one, the translation of Gaston Tissandier's *History and Handbook of Photography* for which he supplied notes, had any connection with his own field of interest.

In 1876 Thomson produced another book on his Far Eastern travels, *The Land and People of China*, published without photographs by the Society for the Promotion of Christian Knowledge. He also wrote as a contributor, for instance to his friend Walter Woodbury's *Treasure Spots of the World*, published in 1875, which included three illustrated articles by Thomson.

## STREET LIFE IN LONDON

Almost four years were to elapse before Thomson embarked on another photographic project. When he did so, it was one that made full use of his years of experience in the East and his fascination with the way people lived. The result was one of the great classics of Victorian photographic books, and the best known of all Thomson's works. It explored the lives of the people living in the streets of London, the city's poorest citizens, as if they were a subculture within their own society.

An English journalist, Adolphe Smith Headingly, who wrote under the name of Adolphe Smith, worked with Thomson on the project. Whether the firm of Sampson Low brought them together, or whether one of the pair chose the other, is not known. Smith was something of a reformer as well as a 'professional reporter and writer through whose strangely miscellaneous works there ran the one dominant note of indefatigable concern for the worker and the quality of working-class life. More than just writer and observer, Smith was an activist as well, serving as the official interpreter at the International Trades Union Congresses from the first large-scale meeting in 1886 to 1905.'[79]

*Street Life in London* first appeared in twelve monthly episodes, starting in February 1877. Each instalment had three stories and a photograph to accompany each story. Most of the text was written by Smith, though undoubtedly there was collaboration. Thomson is credited with two episodes and ten others are left uncredited. The subjects of the studies are generally hard working, honest individuals, prevented by their station in life from further advancement. Some chapters deal with various trades and professions of the poor: Covent Garden workers, street-doctors, public disinfectors, and a remarkable man who tried to help ex-convicts to get a fresh start.

In the preface the authors refer to Henry Mayhew's *London Labour and London Poor*, 'still remembered by all who are interested in the conditions of the humbler classes'. They point out that the facts and figures of that work were necessarily out of date, and offer as further justification for their own study: 'nor, as our national wealth increases, can we be too frequently reminded of the poverty that nevertheless still exists in our midst'.

With social problems gaining increased attention in the 1870s through the work of such men as Charles Dickens and the founder of homes for destitute children, Dr Barnardo, these vignettes of survival among the poor proved popular with the public. The hopes and aspirations, values and needs of those portrayed were recognizable to readers of other classes. The photographs added a graphic realism to the stories. Through his China work, Thomson had become so adept at posing people in a natural way that the scenes appeared entirely spontaneous.

The work was described in a newspaper review as providing 'a large amount of important information, worthy of study by those residing in densely populated districts'.[80]

The twelve sections were collected as a book in 1878, and the volume sold sufficiently well for an abridged version, entitled *Street Incidents*, to be published in the following year.

Thomson's two signed essays are entitled 'London Nomades', describing an itinerant worker and telling the story of a murder he related, and 'Street Floods in Lambeth', in which Thomson describes the trail of misery left behind in a poor area by the annual overflowing of the River Thames.

## THROUGH CYPRUS WITH THE CAMERA, 1878

The year of Thomson's visit to Cyprus was also the year of the birth of his sixth child, a son. Despite the success of *Street Life in London*, economic pressures were constant. Thomson's publisher Sampson Low may well have advanced money to finance the trip.

The entire Cyprus journey proved a difficult and even unpleasant experience for the photographer. In a talk he gave to members of the Royal Photographic Society Thomson told how, overburdened with equipment, he arrived at his Cyprus hotel to find 'a number of disconsolate Englishmen, whose only occupation apparently was asking each other after their health, whether they had had fever, whether they liked the place, how long they were going to stay, when they were going back, why they had come to such a place, and altogether the reception was rather dispiriting'.[81]

As his guide Thomson engaged an Arab shopkeeper whose business was slow. 'Indeed [a reviewer reported] the dragoman had an important object in joining Mr Thomson, which was to call upon his customers in the different towns, and remind them of the stock of macaroni, soap, and matches he had got in his store at home.' The weather proved a problem, as it had years earlier on the trip up the North River. There was a heat haze, and, on the summit of Mount Olympus, one of the most terrible storms Thomson had ever witnessed.

The Cyprus visit was to be Thomson's last excursion in the type of visual reportage that had made peculiarly his own. But his career in photography was far from over.

## THE SETTLED LIFE, 1879–1921

It may have been after his return from Cyprus that Thomson finally realized he would have to return to studio work to provide a steady income for his family. He accordingly set out to establish a place for himself in London society, using his foreign travels as an entrée.

Left, *William Petrie and John Newlands Thomson, c. 1881, taken at their father's studio in Buckingham Palace Road.* Above, *Beatrice Thomson with her puppy, c. 1881. Beatrice was Thomson's eldest daughter. She worked in his studio for some years*

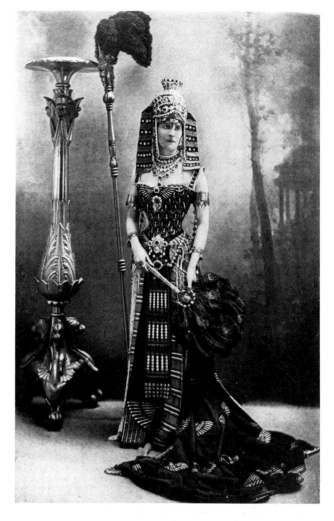

*Mrs Arthur Paget as Cleopatra. One of the great events of the late Victorian period was the Diamond Jubilee Fancy Dress Ball held at the Devonshire House on 2 July 1897. Thomson was one of several photographers chosen to photograph those who attended. The album with the photographs reproduced in photogravure was presented to the Duchess of Devonshire*

His first step was to get himself elected to the Royal Photographic Society, and he became a member in 1879. The second was to open his first English portrait studio. This he did in 1881, showing a considerable number of photographs in the annual exhibition of the Photographic Society in the same year. Among the prints exhibited were portraits of royalty, including Queen Victoria herself, and a series of 'At Home' photographs.[82] Thomson received a Royal Warrant in that year, entitling him to print the words 'By Special Appointment to H.M. Queen' on his photographic mounts. A photographer must have supplied photographs to the Royal Family for three years in order to qualify for this distinction, and forty-seven photographers were so honoured during Queen Victoria's long reign.[83]

Thomson's first studio was in Buckingham Palace Road, London, and he was to remain there about two years. A Victorian portrait studio such as Thomson's was lit solely by daylight, and was glass-roofed and glass-walled. 'Moveable blinds and curtains enabled the operator to adjust both the quantity and distribution of light to accommodate different sitters at different times of the day. There was a range of backdrops on rollers, various properties ranging from imitation masonry to toys for children, and posing chairs. Head rests were generally employed to support the sitter's head during the long exposure. They might be free standing, concealed, often imperfectly, behind the sitter, or be part of the posing chair. To make the customer feel relaxed, the studio often contained much of the paraphernalia of the Victorian drawing room – potted plants, paintings, furniture and so on.'[84]

Thomson's portraits were of the highest quality, and soon he opened a new studio in Grosvenor Street in fashionable Mayfair. He continued to work at this address until his retirement, around 1910.

Shortly after moving to Mayfair Thomson was commissioned to photograph the art-treasures, houses and furnishings of the English branch of the Rothschild family. It had become fashionable for the great families to produce illustrated books of their collections. The Vanderbilts in New York were having a nine-volume photographic record produced in the same year.

The first six photographs were platinum prints of the principal rooms of Seamore Place; the remainder, some two hundred in number, illustrated the painting collection, furniture, and other rare art-objects. Rothschild commissioned the best book-binders in Europe to finish the sets in uniform royal blue and gold. Thomson was also commissioned by the family to produce an album of their Halton estate.

Many years later Thomson photographed the famous Wallace Collection, today still intact, and open to the public.

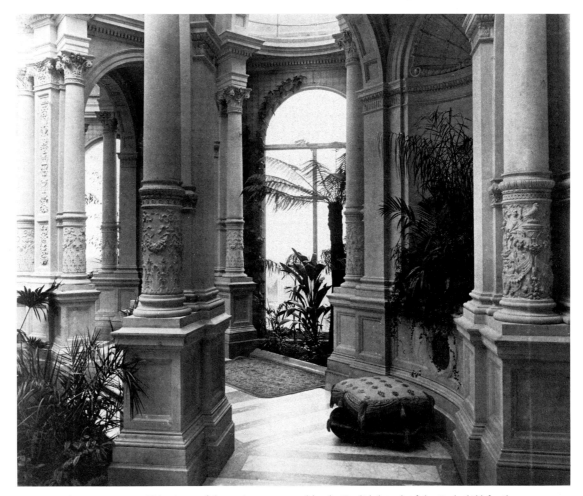

*A passage-way at Halton, one of the great estates owned by the English branch of the Rothschild family, photographed by Thomson c. 1884*

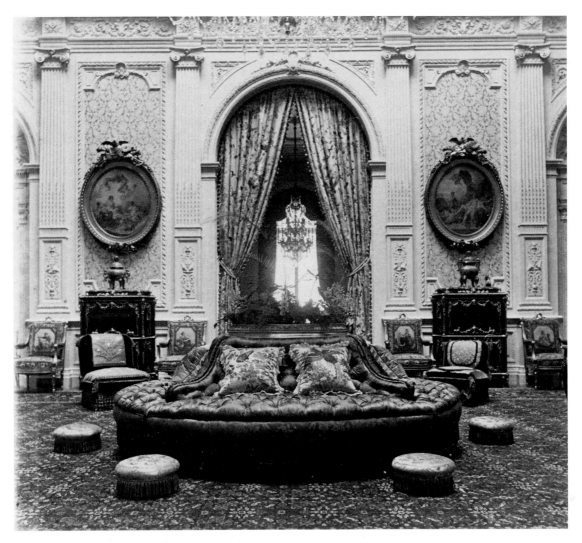

*Drawing Room at Halton, photographed by Thomson c. 1884*

Thomson's interest in exploration remained strong, and was expressed in his involvement with the Royal Geographical Society.

Photography had never to that time been fully appreciated as an important recording tool by the Society's members. But Thomson continued the challenge. In 1875 he had written to the Secretary of the Society asking that *Illustrations of China* and four photographs be included in the collection of the Royal Geographical Society exhibited in Paris: 'My large work on China illustrated with photographs is the only one of the kind in Europe . . .'[85]

A decade later Thomson was offered a part-time position as photographic instructor for the Society. He answered that his fee for teaching 'including use of instruments, chemicals, and all other materials required could be ten shillings', or 'five shillings for one hour's lessons, excluding chemicals'.[86]

A year later: 'I have just offered to Mr. Stanley to post up any officer of his expedition (free of cost). P.S. I have been very successful with my pupils.'[87] Thomson did not always find his relationship with explorers rewarding, for 'it is too often supposed by the traveller that the art may be picked up in an

afternoon, and that it is quite fitting that its study should be left to the last moment, as anyone can take a photograph! This is an error I have been combatting for years without success.'[88]

Thomson continued work in his studio until well after the turn of the century. John Newlands, his second son, worked with him for many years, and when the studio moved to New Bond Street in 1905 he was listed as one of the owners. Thomson's daughter, Beatrice, was also employed in the studio doing retouching and colouring of photographs.

From time to time Thomson received recognition for his pioneering work in the Far East. In 1866 he received a Queen's gold medal. In 1908 the French gave him a medal for the Cambodian photographs done in 1866.

Toward the end of the 1890s, interest in China was renewed because of the problems developing there. The old China experts, explorers and missionaries, seized the opportunity to publish books on their various experiences, and Thomson was no exception. 'Some parts of this volume have been published in a more costly form,' Thomson wrote in 1898 in the introduction to *Through China with a Camera*. 'In the present instance the photographs have been reproduced and transformed into printing blocks by a most effective half-tone process,[89] so that nothing in the original plates is lost. The letter press has been carefully revised and brought up to date and in part re-written. I have kept myself "au courant" with the course of events in "further Asia".' Thomson expressed it as his own view that 'Western civilization, with its aggressive activities, appears to be opposed to the genius of the people, who fain would be left alone to follow their time-worn methods social and political.'

The work was popular enough to be reprinted in a second edition a year later. At almost the same time a condensed version of *Illustrations of China and Its People* was issued.

Thomson's eldest son, William, became a successful stockbroker, and it was he who kept the family together, looking after his three spinster sisters. The youngest child, Arthur, was sick much of his life, and died at the age of thirty-eight in 1916.

John and Isobel Thomson spent much of their time in Edinburgh in old age. Thomson used to entertain his young grandchildren with stories of his travels. He became increasingly deaf as age closed in on him, but remained active and involved until the end.

In 1917 Thomson tried to resign from the Royal Geographical Society. 'Owing to my advanced years,' he wrote, 'and stress of the times, I have decided to discontinue my long fellowship in the Society. I was appointed instructor in photography to the Society in January, 1886, and have been engaged for over fifty years in promoting geographic photography by instruction and illustrating my own published books. I may note that, in the early days I urged, eventually with success, the use of lantern slides at the evening meetings. From Sir H. Stanley onwards the leading explorers sought my instructions so enabling them to insure excellent photographic records of their routes.'[90]

The council of the Society moved into action, and within a week Thomson had been voted a Life Fellow, 'in consideration of the valuable geographical work you have done during your long connection with the Society'.[91]

Thomson also tried to find an archive for his beloved negatives. He contacted Henry Wellcome, an American who had gained great success in England with a pharmaceutical firm. Wellcome expressed an interest, and the last two years of Thomson's life were spent trying to arrive at a price for the collection. After Thomson's death in 1921, his son agreed on a price, and the negatives were in Wellcome's library (later at the Wellcome Institute, London), to stay.

Thomson was returning from a meeting at the Royal Society the night he suffered a fatal heart attack near his home. He was eighty-four years old. *The British Journal of Photography* announced his death on 7 October 1921. Much of the information in the obituary was wrong, including Thomson's age at the time of his death.

## PHOTOGRAPHIC METHODS AND OBJECTIVES

John Thomson's methods of working evolved through the years of experience in the Far East. First, the technical problems had to be overcome; and second, there was the problem of the inaccessibility – sometimes even hostility – of the subjects he wished to record. Thomson's great success as a photographer came in part from his artistic interests and his natural eye, but equally from his ability to enter a new environment and draw the most from it within a limited period of time.

Many photographers contemporary with Thomson travelled great distances to make important series of photographs. Examples include Roger Fenton in Russia and the Crimea, Francis Frith in the Middle East, Linnaeus Tripe in India and Burma, and the team of Robertson and Beato in the Crimea, Turkey and India. But Thomson – to a greater extent, even, than these – desired more than fine photographs from his travels. His interests ranged from art to botany, from chemistry to languages and social customs, history and geography. He had an inveterate curiosity, a quick wit, and a charm that allowed him to make new friends at a rapid pace. As he began to learn how to use his social talents he found himself capable of accomplishing great tasks in a brief period of time.

But first Thomson had to master the difficult techniques required to work effectively in the Far East, where photographic materials were always in short supply, and new photographic problems could be solved only by ingenuity.

During the period of Thomson's Far East travels the method of making photographs was the wet collodion process, or wet plate process, so called because of the need to make an exposure from the glass negative before the collodion with which it had been coated could dry. While the process offered many advantages over its predecessors, the daguerreotype and calotype, it was laborious and time-consuming. First the collodion syrup was applied evenly to a precut piece of glass, and the coated plate was dipped in a mixture of chemicals to attract the light, then the negative was placed in a holder to be inserted into the camera. The entire operation had to be performed in total darkness. Once the plate had been exposed it was removed, again in darkness, and developed. It could then be stored for future printing. This method offered the photographer the advantage of knowing instantly whether he had achieved the image he wanted, but forced him to set up his entire paraphernalia, including his darkroom tent, every time he wanted to expose even a single negative. It also required him to travel with large quantities of spare equipment, as the loss of the simplest element in the process could result in long delays while a replacement was sent for.

In 1866, during the year Thomson returned to Scotland from the Far East, he wrote a series of six articles for *The British Journal of Photography* entitled 'Practical Photography in Tropical Regions'. He had by then run a studio in Singapore for two years, as well as visited Penang, Siam, Cambodia, Vietnam, and some parts of China. His advice covered a variety of photographic subjects, from equipment to posing to lighting.

'In any part of the East where I have travelled,' he wrote in the first article, 'I have generally found the early morning to be the best time for photographic purposes.' It is the 'early operator' who will be able to 'apply the most delicate manipulatory skill' and 'a nice artistic discernment' to the broad lights on the palm leaves and the deep shadows in the masses of foliage, which are 'softened down to a dreamy indistinctness by the mist', while 'the foreground stands out in well-defined relief'. Thomson adds: 'There are cloudy days occasionally, when a fine sky may be obtained and good photographs taken at any hour.'[92]

In the second article Thomson offered some insight into the frustrations of tropical photography. 'Glass plates have been a fertile source of annoyance to me while in the East. On one occasion I was anxious to have at once a number of patent plate glasses for a very important purpose. To save time I

ordered them from a chemist's in Calcutta. When I opened the box I found every glass rusted and useless; and very frequently plate glass, when sent round the Cape from England, arrives in this condition, and there is no cure for it, as the rust destroys the polished surface of the glass.'[93] Thomson offered a solution – that the photographic dealer should clean each plate and coat it with a mixture of alcohol and whiting to prevent rust occurring. Even with the strongest apparatus – Thomson describes his well-made frames, tripod, and stereoscopic and larger cameras – 'when one takes into account the average number of times a buffalo cart breaks down in a week', the photographer 'will be fortunate to get to his journey's end without accident'.

The next article explains the way in which Thomson made his cotton darkroom tent, and his method of securing his plate box from the curiosity of 'semi-savage tribes', as when 'a Coolie, of artistic taste and oily fingers, had opened a plate box during my absence, and lifted out each negative to examine its points. The firm hold he had taken of the plates left two indelible greasy thumb-prints on each, which came out (on account of the presence of animal matter) with great intensity when the pictures were developed with pyrogallic acid.'[94]

In the same article he discusses the photographer's chemicals, advising that 'the judicious addition of an excess of alcohol to your collodion is of the greatest importance when the collodion is to be used in a hot climate. The quantity to be added must be determined to a certain extent by the strength of the alcohol. If the alcohol be weak an excess would precipitate the gun cotton. By the addition of alcohol a structureless film is obtained, development facilitated, better half-tone produced, and the time of exposure shortened. By using a collodion of this kind I have been enabled to develop some of my best photographs of bas-reliefs after exposing the plate for half-an-hour in a dark interior, where the thermometer stood at 98 Fah.; and with the same collodion I have obtained instantaneous effects.'

As early as 1865, Thomson was producing 'instantaneous' images that are remarkable for their time. While in Siam, for example, he was able to make exposures standing in the crowd, and so give the viewer a sense of being in the middle of the ceremony (pl. 17). In Vietnam, he was able to show a cloudy sky with one exposure (pl. 52). While the majority of his subjects are posed, the shorter exposure-time allowed Thomson to transcend the stiffness so common in the photographs of his contemporaries, and achieve a 'natural' look – even a journalistic quality – almost sixty years before camera technology evolved to the point where a photographer could capture subjects in what we today call the 'photo-journalistic' style.

Thomson's sixth and last article was devoted to the construction of a glass house (studio) for the making of portraits. Glass walls and roof were a necessity to provide natural light, but a house-wall might give shade until the sun reached the meridian, and faint blue oil-paint and moveable blinds reduce glare. An 'intense softness' could be achieved by stopping the light from the west, admitting only sufficient to illuminate a reflecting screen placed on the right of the sitter.

Thomson took all his portrait work seriously: 'If a practical photographer in the tropics has Englishmen to deal with, he will find that portraiture forms an important branch of his business, and one in which he ought to excel; for an inferior portrait may be productive of the most painful results to a sitter, who in an unthinking moment has staked his future happiness upon a *carte*.'[95] And in another article: 'Every portrait, so far as the work of the photographer is concerned, should be a work of art. No matter how rough or uninteresting the face he has to deal with, he ought to start with the conviction that there is something good in it, some redeeming characteristic which may be brought out by his manner towards, and his treatment of, the sitter.'[96]

The Chinese had a different idea of artistic portraiture, as Thomson relates in an article entitled 'Hong Kong Photographers': '"You foreigners," says A-Hung, "always wish to be taken off the straight or perpendicular. It is not so with our men of taste. They must look straight at the camera so as

*Persian boy, Penang, c. 1862. By using a classical backdrop of the kind found in the typical European studio, Thomson reveals his early experience of traditional portraiture. He soon moved away from this stilted treatment into fresher and more naturalistic forms of portraiture*

to show their friends at a distance that they have two eyes and two ears. They won't have shadows about their faces, because you see, shadow forms no part of the face."' It is characteristic that while Thomson avoids any critical comment on the other European photographers working in the Far East, he singles out for praise the work of a Chinese photographer, 'who has exquisite taste, and produces work that would enable him to make a living even in London'.[97]

Although it is Thomson's China work that most clearly defines his ideas and methods of working, by the time he came to live in Hong Kong he had developed both a strong individual style and a way of achieving his objectives. He rarely expressed any view about the aesthetic values of his photographs, but in just one unsigned article published in *The China Magazine* in 1868, he reveals his aesthetic views, and suggests the influences that had helped to form his unique photographic perceptions.

He writes as if he were a visitor to Hong Kong, asking a photographer to take pictures of his favourite area, Wong-nei-chung or 'Happy Valley', a lovely spot, 'a little plain, whereon the Race Course is built, surrounded by hills that have been the burial grounds of the Hong Kong people for many a long year'.

'I often longed for something to remind me of Wong-nei-chung when I should be far away, something that would arouse in me the same feeling of delight and gratify my sense of beauty as it was gratified when I looked upon that pleasant vale itself. I thought I should like to have it photographed,

but to photograph *all* its beauties would require that at least a hundred plates should be taken; nevertheless, I was glad enough to have an opportunity of obtaining only a small percentage of that number, and went in high glee with a photographer to take three pictures in Wong-nei-chung.

'"You want three views of the valley," said he, "but you needn't have three unless you like. I've got a wide-angle lens that'll take it all at once. Look here!"

'He had fixed his camera on Morrison hill which is, as you know, at the mouth of the valley, and I looked into it to see his picture. There was the valley – the whole of it – all that I could see in nature by looking first before me, then below me, then on the right side, and then on the left, was presented at a glance upon the camera screen. In the foreground was a black mass that was incomprehensible to me, but then came the bridge and the smooth vale, there were the cemeteries with trees waving their mournful plumes over the graves, above them the great hills rose, in the middle was the Stanley road winding up among the trees into the hills – everything was there, but – '. It was not at all what the visitor had had in mind, rather, 'a wonderfully exact CHART of the valley, but not a picture'.

Thomson hoped to make his reader understand that photography offered potential for more than a mere reproduction or chart of a place. He pointed out that since the time of Niépce (one of the discoverers of photography), 'fascinated by the absolute accuracy with which the sun paints his pictures, photographers have sought to produce distinct but lifeless charts of the mechanical proportions of nature, leaving out altogether the feeling, the ideality, the soul with which all nature is flooded. They care nothing for the grandeur of a lofty hill, for the peaceful light that sleeps upon its forehead, for the solemn chastened gloom that slumbers at its base; they do not value one atom the softened sweetness of those other hills waning in the distance, they cannot see the contrast which the dark sharp distinctness of the adjacent tree makes with the far off woods, so cloudily so mysteriously beautiful, all these things – and all such things – can be dispensed with if only a presentment be produced whereon you may count the posts in the Race Course railing!'[98]

Thomson, on the contrary, sought to capture the essence, whether in the simplest portrait or the most complex juxtapositions in a landscape. While there is no evidence that Thomson was directly influenced by Taoist teachings, his best work follows the precepts of the Taoist landscape painter Kuo Hsi (AD 1050), who wrote that, 'In painting a scene, irrespective of its size or scope, an artist should concentrate his spirit upon the essential nature of his work. If he fails to get at the essential, he will fail to present the soul of his theme. Discipline should give his picture dignity. Without dignity depth is impossible. Diligence and reverence will make his work complete. Without diligence it will remain incomplete.'[99]

Thomson's aesthetic influence comes from the West. 'Let us hear very briefly what Mr Ruskin says of composition,' he writes in the same article, 'and try to see how far we can carry out his principles in taking our three pictures of Wong-nei-chung. "Composition means, literally and simply, putting several things together, so as to make one thing out of them; the nature and goodness of which they all have a share in producing. In a great picture, every line and colour is so arranged as to advantage the rest.

'"The great object of composition being always to secure unity, that is to make out of many things one whole, the first mode in which this can be effected is by determining that one feature shall be more important than all the rest, and that the others shall group with it in subordinate positions. But the observance of the rule is often so cunningly concealed by the great composers, that its force is hardly at first traceable; and you will generally find they are vulgar pictures in which the law is strikingly manifest."'

Thomson adds that 'I have arranged a picture in the camera and, as far as I am able, I have arranged it in accordance with these principles. Do not misunderstand me! My share in the composition is very

very small indeed; I have only permitted nature to do what she is always willing to do, if photographers do not stand in her way.'[100]

Here we have an indication of Thomson's view of what makes a successful photograph. Not mere accurate depiction, nor the highlighting of one feature of the composition blatantly in relation to the rest.

He invites the viewer to search for the 'principal subject' in the second picture of his three taken in Wong-nei-chung: 'Is it the village ... ? Scarcely so, I think ... The village then is subordinate to something else. Is that something else the hill in the background? Look carefully, again and again, and by degrees you will come to see that everything in the picture, from first to last, unites to convey to you an idea of the grandeur and the grace of that great hill.' The outline of the hill, Thomson points out to the viewer, is echoed in a line of trees in the foreground, and these again are echoed by a bush, whose curve is continued by a hedge. The village '*nestles*', and the trees in front 'hold themselves just high enough to let you peep at it, but no more'. 'Rising above all, nobler than all, greater than all, calmer than all', the hill 'looks down upon the landscape of which it is the king, and in token of its kingship wears a crown of golden light upon its forehead, placed there by the moving sun'.

But if the picture's focus were too blatant it would defeat the objective and destroy the unity Thomson aspired to in his photographs.

'We want something in the foreground [of his third photograph] which shall be interesting but not striking, and which shall break without hiding the monotonous sweep of the plain. A chair and coolies is the most natural thing in the world, but the group must be inactive, the chair upon the ground and the coolies doing nothing particular, otherwise they will be too prominent in the picture.'

The placing of a person at the centre of a landscape photograph or painting reflects a traditional Western view of nature as subordinate to man. Thomson's own view of the relation of man and nature is more Eastern than Western. In seeing himself as the medium or interpreter of a scene to be photographed, he does not set himself above his subject.

In his photographs of people, the poorest farmer, or simplest beggar, has a dignity which he seeks to capture. Thomson portrays his subjects just as they lived in their own worlds, not only acquainting the viewer with their daily lives, but allowing his subjects to feel at ease by being posed in their own environments.

The first body of work clearly to show the effect of his ideas was done during his visit to Siam in 1865. In these photographs, particularly, Thomson makes the viewer conscious of the interrelationship of the Siamese people and their environment. Often the photographs were composed in a way that leaves the viewer scarcely conscious of the separation of people and landscape.

Thomson continued this approach in the series of Vietnam photographs. Here various props are used to balance the natural elements in the composition, as in the photograph with Thomson's assistant standing on the road to Cholon, pointing an umbrella (pl. 45). Thomson would often use his two assistants in this way, posing them to shape a composition; or he might use poles, tools, trees, flowers, reflections in water, shadows – anything that would provide the balance and unity he sought. His use of diagonal shadow as an element of composition is particularly dramatic and successful in his magnificent photograph of the Great Wall of China (see pl. 137).

Despite his many successes, Thomson felt some frustration with the limitations of the medium. While on Formosa, he wrote that 'we halted awhile to admire the intense loveliness of the mountain gorge, and to obtain a photograph of the scene, regretting all the time that the picture on glass would, after all, give us but the bare light and shade, with none of the varied tints of the hoary bearded rocks,

their mossy nooks and crannies, the colours of the pendant climbing plants, or the play of the bright sunshine through the canopy of leaves, and among the dark rocky masses beneath.'[101]

Thomson was not the first to use photographs to illustrate his published articles and books. But few others had made such a deliberate effort to frame a photograph in a descriptive context. He used photography as an integral part of his explorations. He kept notes on how people lived, and on the social and economic fabric of the society he set out to examine. His work was directed not so much to the curiosity of the armchair traveller as to the scientist, explorer, and student of ethnology. One of the more curious aspects of Thomson's personality is that he sought little recognition for the unique qualities of his photographs, preferring instead to seek respect for his contributions to general knowledge.

Thomson appears never to have made a conscious attempt to seek recognition among his fellow-photographers. When he returned to England in 1872, bringing a selection of his finest work, and with rich, subtle prints from his last series on Peking, he made no attempt to exhibit them. Nor did he join the Royal Photographic Society, until prompted to do so by economic necessity. His desire was to gain recognition from the Royal Geographical Society, and to promote the use of photography as a guide for explorers. It was therefore only through publication of his photographs in books that a portion of his work became known to the public.

Most people familiar with Thomson's work today have seen it in modern reprints, or in reproductions published in Thomson's lifetime. While these books reveal the control Thomson had over his subject-matter, they are inadequate to convey the impact of the original print.

At the time when Thomson was working, the inclusion of photographs added a major expense to the production of books, and albumen prints (such as those in the Cambodia album) often faded. The problem of fading led as early as the 1850s to a search for methods of photographic reproduction, and by the 1870s photo-mechanical processes had begun to replace the use of original photographs. These early processes, though they produced durable prints, were no less costly than original photographs. In addition, the popular carbon print, the collotype or Albertype (as used for *Illustrations of China and Its People*) and Woodburytype (as used for *Street Life in London*) could not be printed together with the text. Photographically illustrated books were therefore usually printed in small editions, and remained rare until the half-tone came into use in the 1890s. The half-tone (as used for *Through China with a Camera*) could be printed together with the text and so allowed more profuse illustration, but provided less faithful reproduction.

Thomson's preference was for the carbon process, as used for his rare album *Foochow and the River Min* (1873). He wrote that 'The carbon process, in its most recent forms, has attained to that degree of perfection, certainty, and facility of manipulation which renders it a most formidable rival to silver printing. Photographers have not been slow to acknowledge its superiority over all other processes in the production of the most delicately beautiful enlargements from small negatives.'[102]

One of the few surviving copies of *Foochow*, Thomson's own, contains an additional section on Formosa. Here we find his prints of some of his beautiful studies of the island. The rich blacks in the carbon printing give a depth to the work which is only partly offset by limitation in the middle ranges. While the tones could not match the full range of the albumen, they have great visual power. A comparison between two complete volumes of *Foochow* reveals some variation in the print quality from image to image, indicating a certain lack of consistency in the process at the time of publication of Thomson's book. Carbon's dark tones accentuated the power of Thomson's River Min images – a power that is all the more astonishing when we remember that according to his companion at that time, Justus Doolittle, Thomson made his selection from fewer than thirty large photographs taken on the journey.

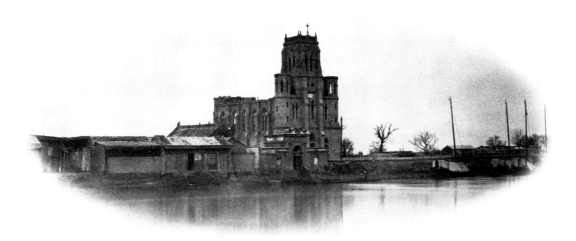

*A European church in China, c. 1872. An example of Thomson's use of vignetting to achieve an artistic effect. In a footnote to a book he translated, Thomson explained that the simplest method of vignetting was to cut an oval aperture in a piece of opaque cardboard, about one third of the size of the finished picture. A piece of tissue paper was then placed over the aperture, and the resulting screen was placed outside the glass of the frame. The sun's rays passing through the tissue paper were diffused to give a delicate, shaded vignette of the required dimensions*

Apart from Thomson's achievement as a landscape photographer, he had set out to accomplish something new in photography. He set out to record a people – what these people were, how they lived, and why they mattered. Everywhere, as Thomson photographed, he attempted to capture the individuality of each of his subjects, whatever their race or social class. His work with peasants in Vietnam or Siam is just as meticulous as his work with kings or princes, reflecting his own social values and awareness of individual identity. In *Street Life in London* as with the beggars in Foochow, he clothed each individual in dignity, as he showed the various occupations and ways of living among the very poor.

A small item in an Edinburgh newspaper throws a side-light on Thomson's character and the approach to people that we find in the photographs: 'SALE OF CHINESE AND JAPANESE ARTICLES: It will be remembered that last year at the approach of the Christmas season the manager of the Blind Asylum received a consignment of fancy articles from China and Japan. The sender was Mr John Thomson, a gentleman who was then travelling in those countries, who thought that the asylum might realize a handsome sum by the profits on the goods. The success which then attended the speculation induced the manager, Mr Wm. Martin, to order a lot of finer and more varied articles for the present season . . . '[103]

Thomson's methods of working in the Far East involved organization, elaborate preparations, and a flexible approach to the problems that he encountered as he attempted to achieve his ambitious goals. He worked under pressure of time, travelling heavily encumbered with equipment, with assistants and teams of bearers, but essentially alone. After his wife and young son had left China, he travelled through much of central and northern China, staying in large towns and venturing into remote areas, achieving in little more than a year perhaps the best work of his entire lifetime. The work at Foochow was accomplished in just a few brief months.

In his introduction to *Illustrations of China and Its People* Thomson refers to the difficulty and dangers he had to overcome in places where he was regarded with fear; where 'there were many who had never yet set eyes upon a pale-faced stranger; and the literati, or educated classes, had fostered a notion amongst such as these, that, while evil spirits of every kind were carefully to be shunned, none ought to be so strictly avoided as the "Fan Qui", or "foreign devil", who assumed human shape, and appeared solely for the furtherance of his own interests, often owing the success of his undertakings to an ocular power, which enabled him to discover the hidden treasures of heaven and earth.'

The photographer 'frequently enjoyed the reputation of being a dangerous geomancer, and my camera was held to be a dark mysterious instrument, which, combined with my naturally, or supernaturally, intensified eyesight gave me power to see through rocks and mountains, to pierce the very souls of the natives, and to produce miraculous pictures by some black art, which at the same time bereft the individual depicted of so much of the principle of life as to render his death a certainty within a very short period of years . . . The superstitious influences, such as I have described, rendered me a frequent object of mistrust, and led to my being stoned and roughly handled on more occasions than one. It is, however, in and about large cities that the wide-spread hatred of foreigners is most conspicuously displayed.'[104]

As Thomson travelled, he sought out a key contact in each place of interest. The key person opened doors for him, allowing him to establish himself quickly in a community. At Foochow, he found Justus Doolittle, a missionary who had lived there for sixteen years at the time of Thomson's arrival in 1870. When he moved on to Peking, Thomson wrote that, 'I had the good fortune while in the metropolis to be introduced to Prince Kung and the other distinguished members of the Chinese government and they wisely availed themselves of my presence to have their portraits taken at the Tsungli-yamen, or Chinese Foreign Office.'[105] The desire for portrait-photographs provided an entrée for Thomson into circles which must otherwise have remained closed. In Formosa Thomson travelled to remote villages with the medical missionary Dr Maxwell. Adolphe Smith played much the same role for Thomson in the poor areas of London as had his friends throughout the Far East.

When one sets Thomson's achievements in social documentation beside modern photography, when visual reportage and 'the decisive moment' are within reach of any photographer able to operate a 35mm camera, his work maintains its freshness and quality, its immediacy and authority.

Thomson's powerful, subtle and innovative landscape photography, only now gaining full recognition, takes its place alongside the truly great nineteenth-century photographic achievements.

# I
# PRELUDE

1862–1864

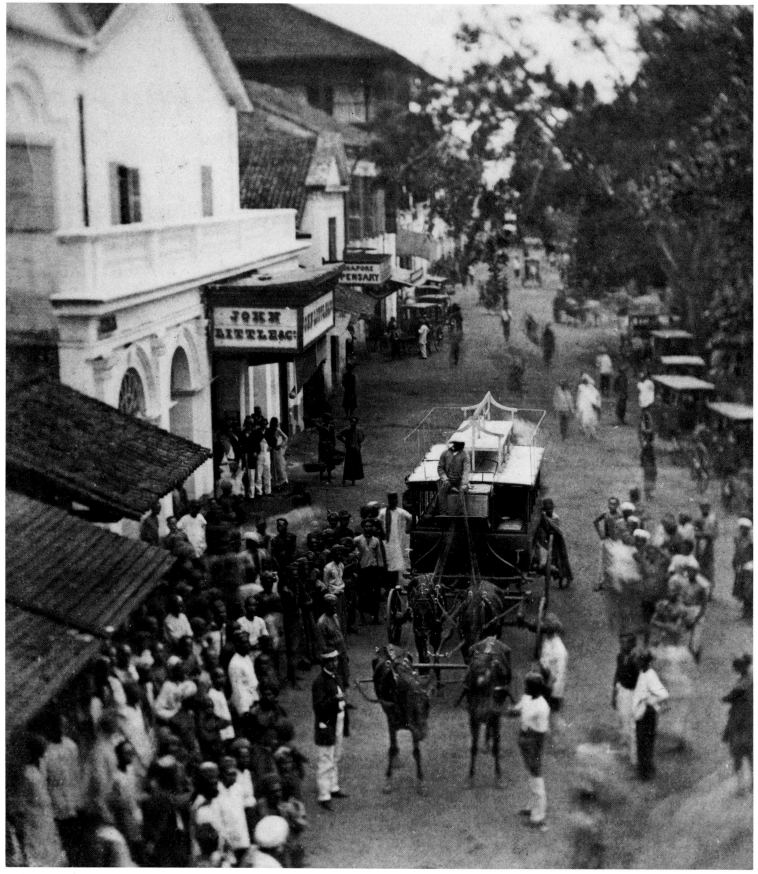

1  Commercial Square, Singapore, *c.* 1864

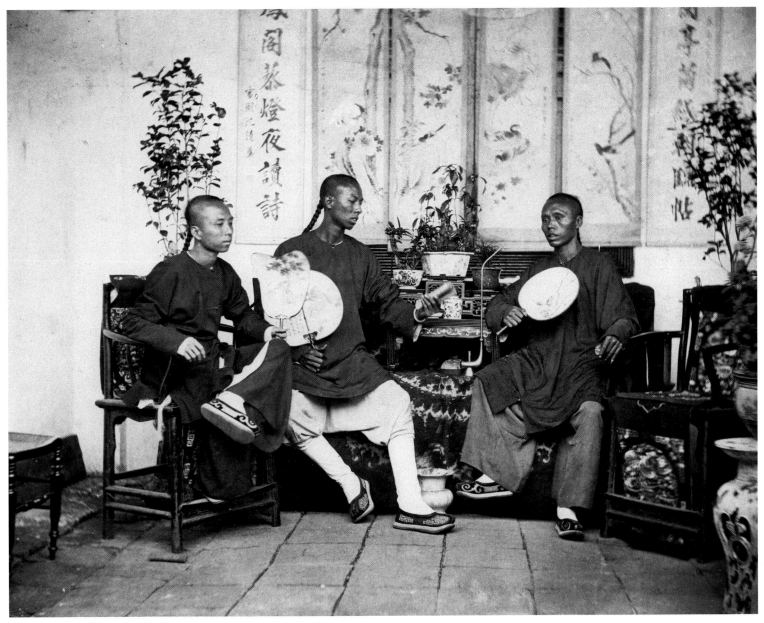

2 Chinese merchants in Singapore, *c.* 1864

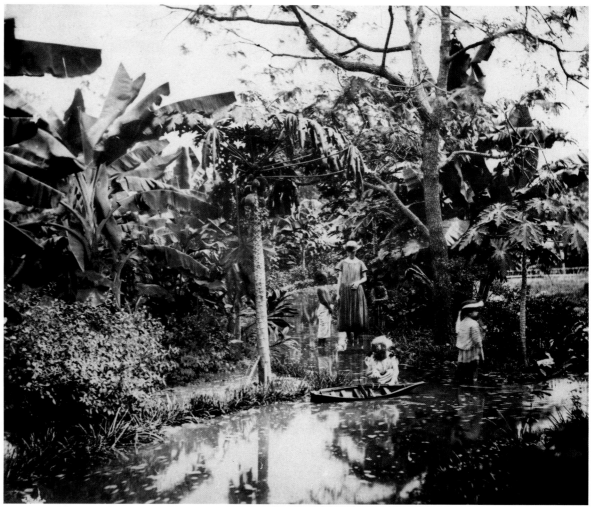

3 Annual inundation of 'our garden', Singapore, *c.* 1864

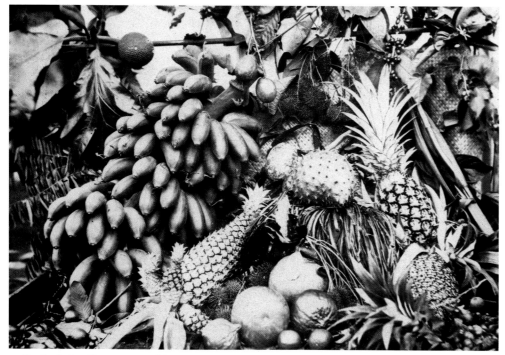

4 Straits fruits, Singapore, *c.* 1864

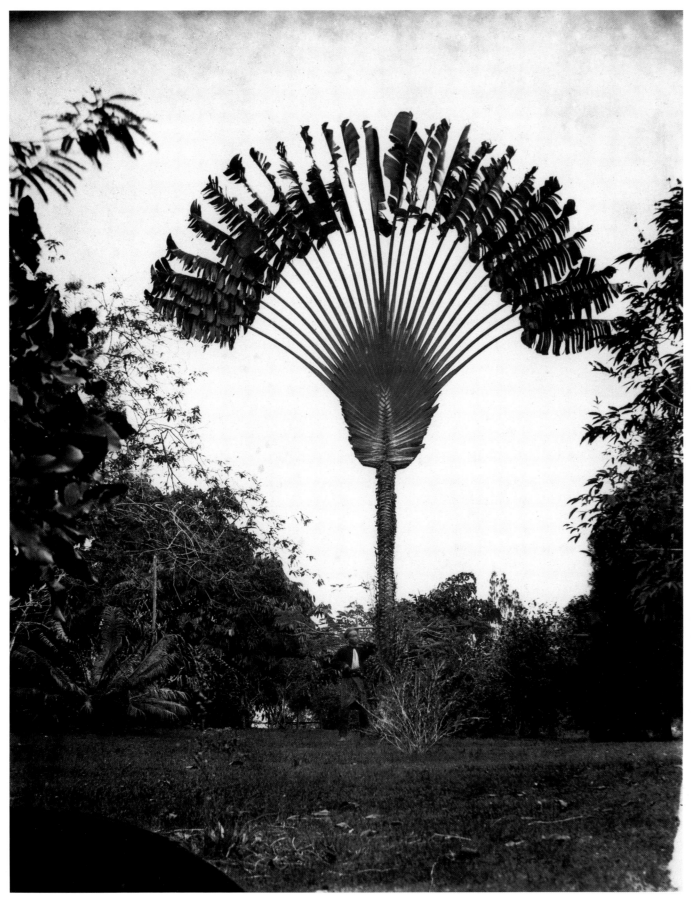

5 'Travellers'' palm, Singapore, c. 1864

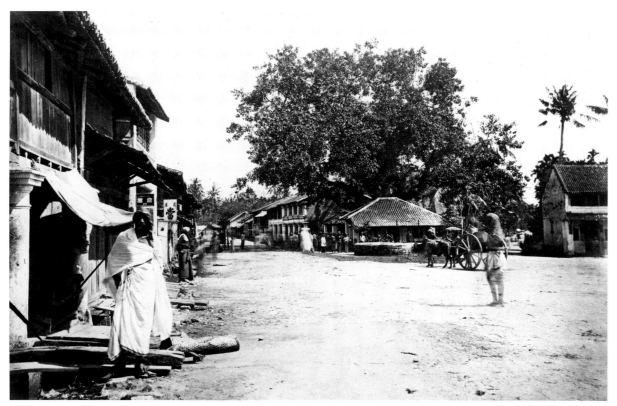

6  Main Street, Penang, *c.* 1862

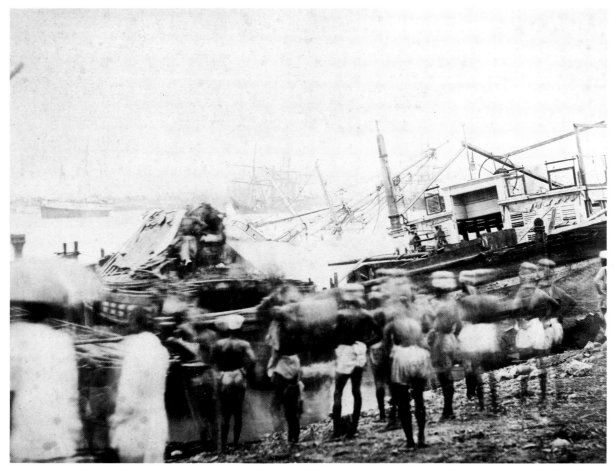

7  Cyclone, Calcutta, October, 1864

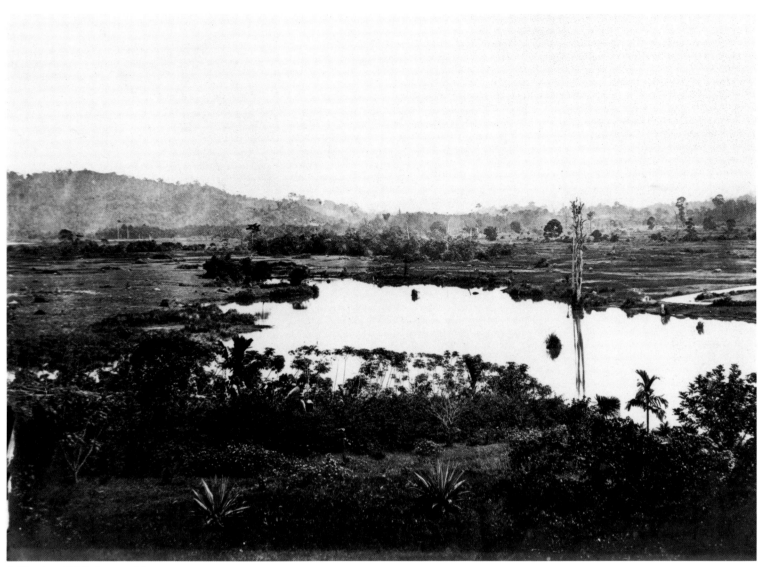

8 Province Wellesley, *c.* 1863

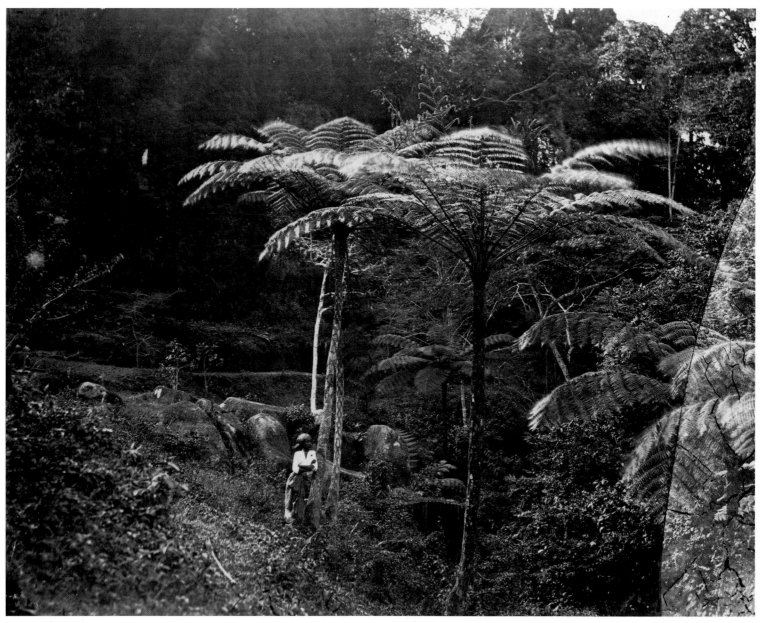

9 'Tree ferns', Penang Hill, Penang, *c.* 1862

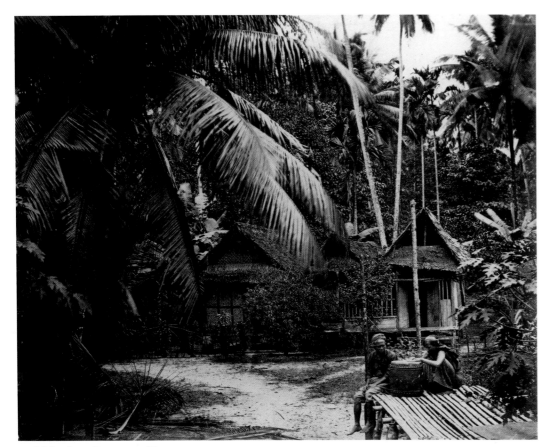

10 Malay huts, Penang or Singapore, *c.* 1862–64

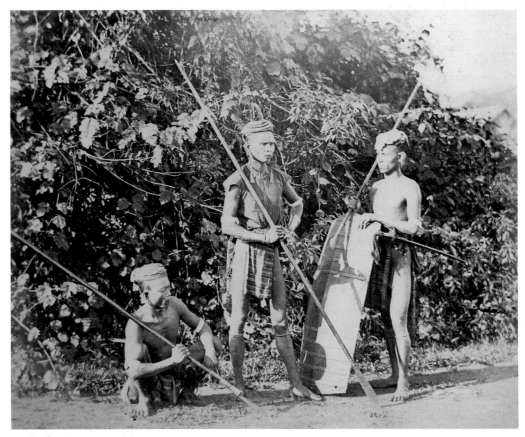

11 Dyaks, Borneo, *c.* 1864

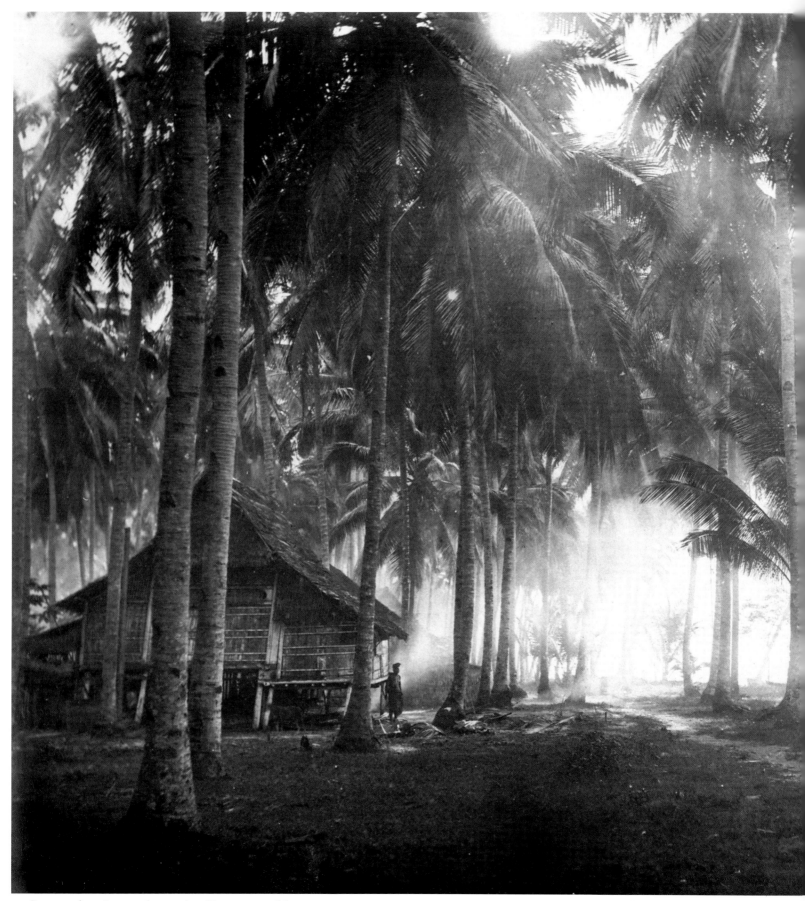

12  Coconut plantation – early morning, Singapore, *c.* 1864

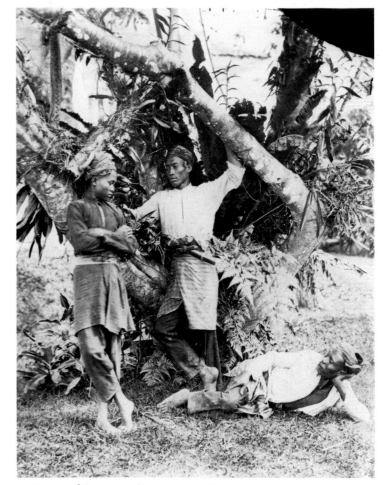

13 Group of Boyamese, Singapore, *c.* 1864

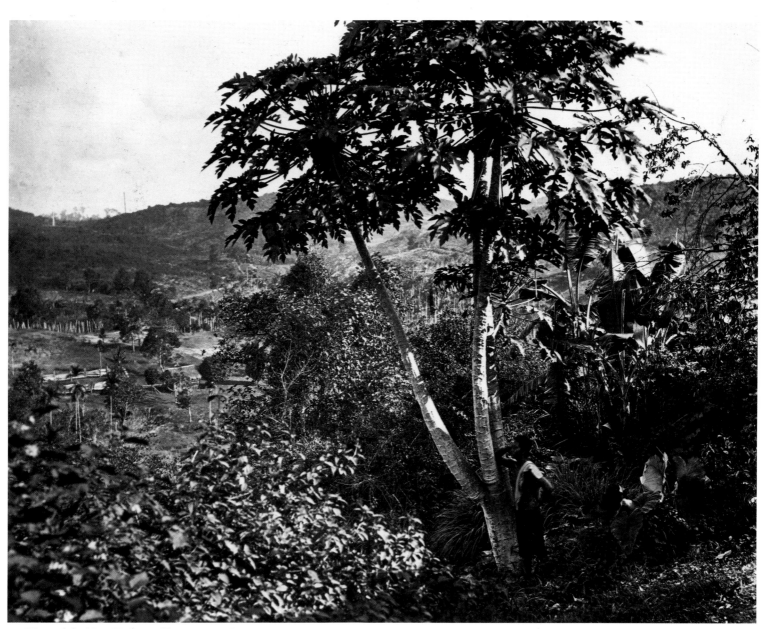

14    View of the New Harbour, Singapore, c. 1864

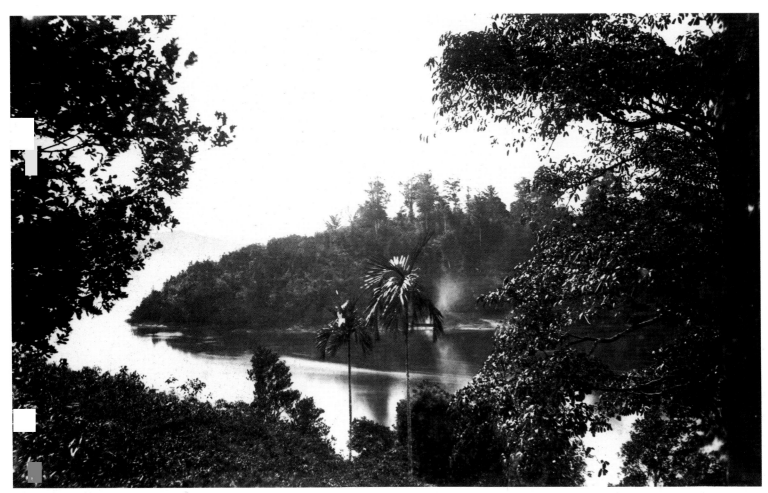

15  New Harbour, Singapore, *c.* 1864

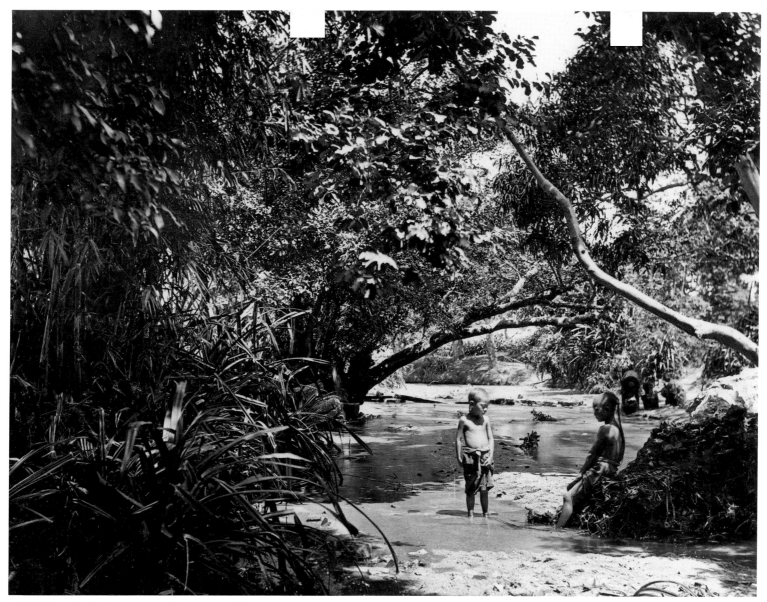

16 Children playing in a stream, Singapore, *c.* 1864

# II
# SIAM,
# CAMBODIA, VIETNAM

1865–1868

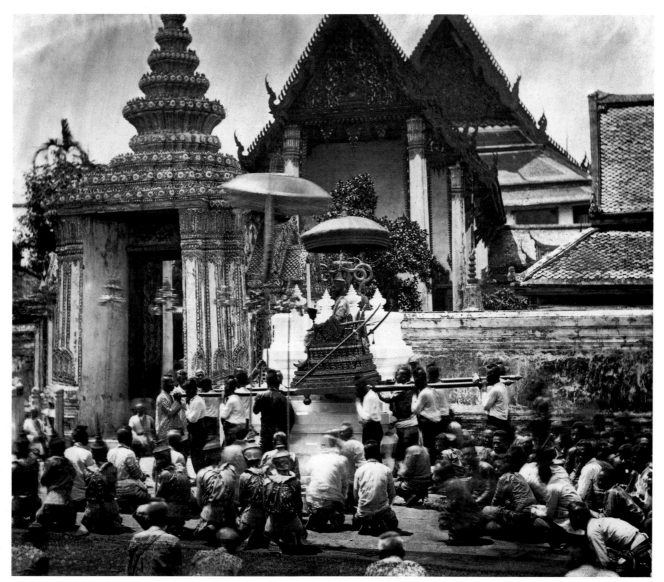

17  Arrival of the King of Siam at the Temple of the Sleeping Idol, 1865–66

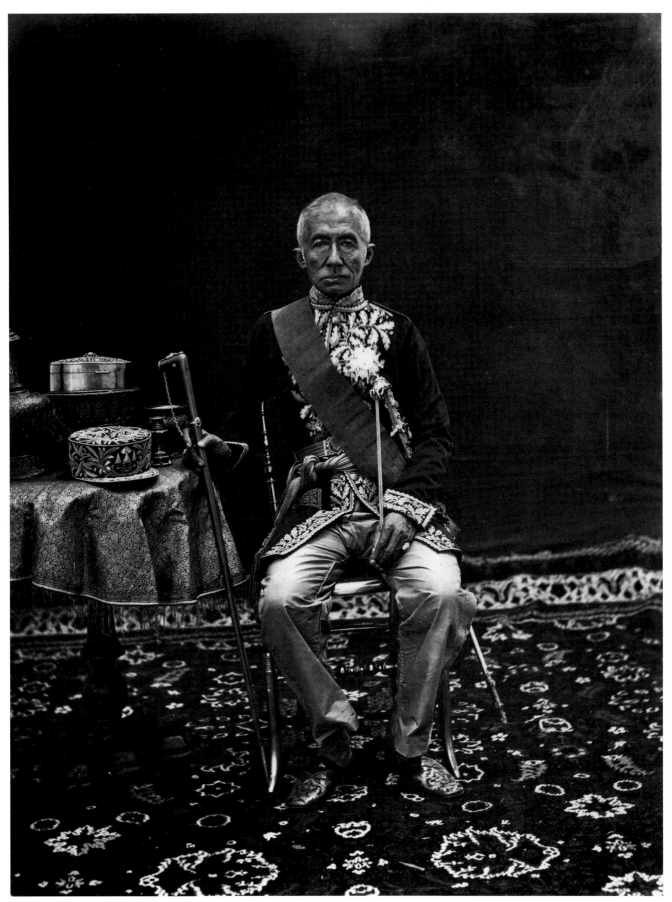

18  King Mongkut of Siam, Bangkok, *c.* 1865–66

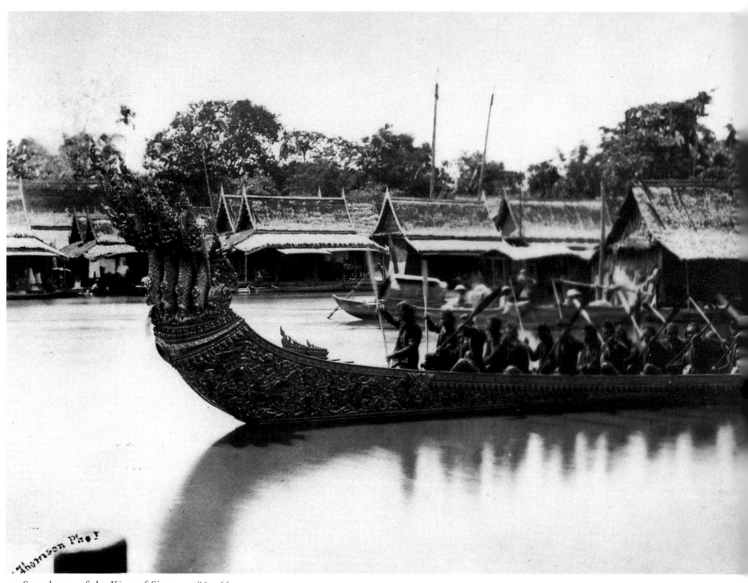

19  State barge of the King of Siam, *c.* 1865–66

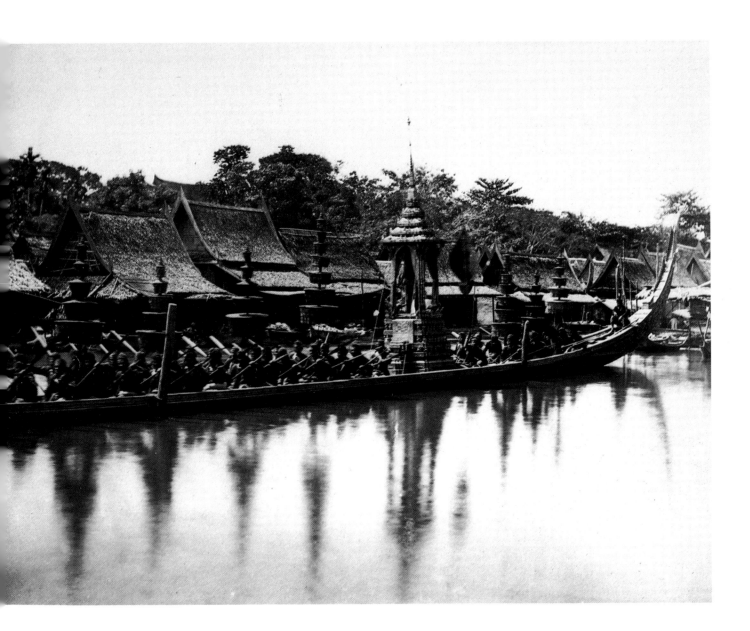

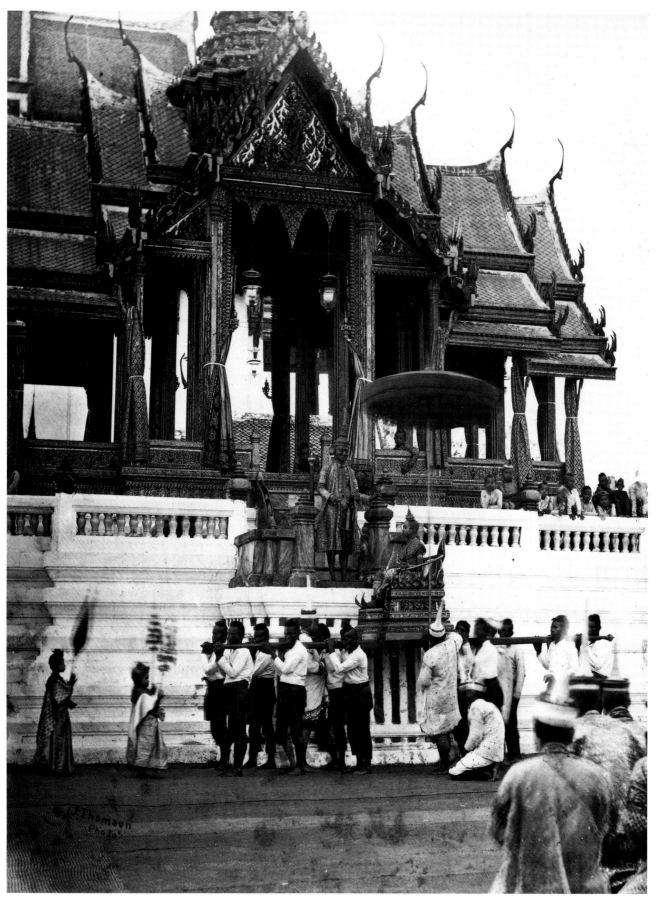

20 Presentation of a Prince to the King of Siam, 1865–66

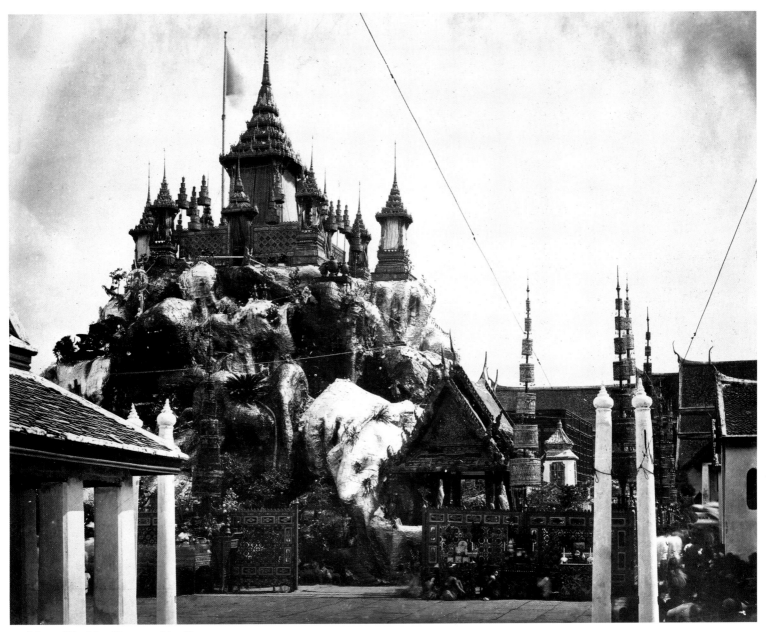

21 Mount Khrai-lat, Siam, *c.* 1865–66

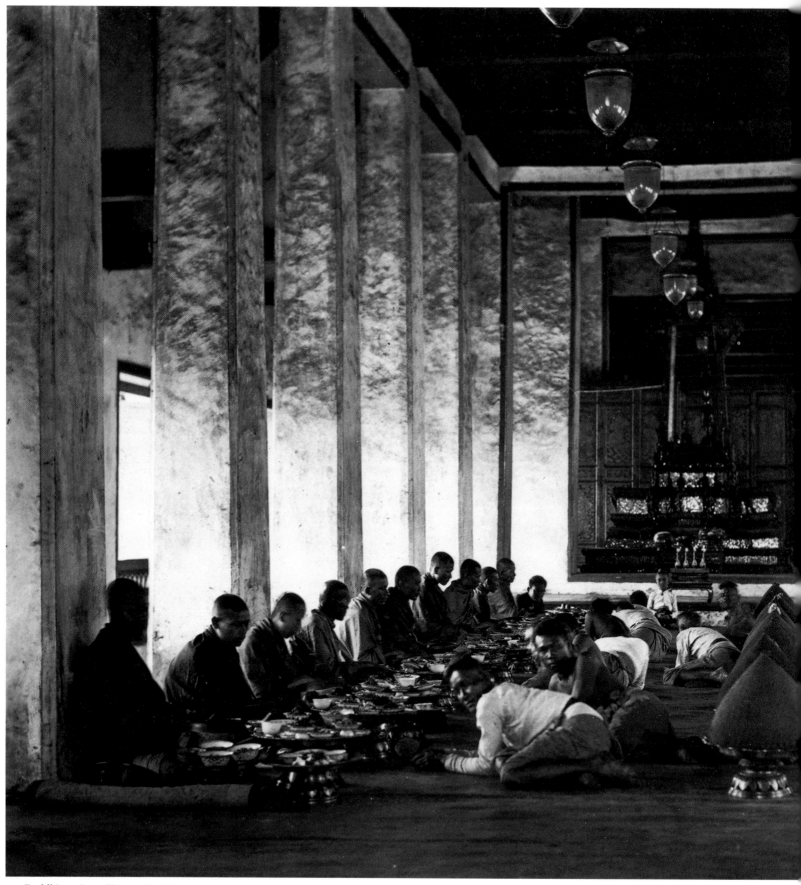

22 Buddhist priests, Siam, 1865–66

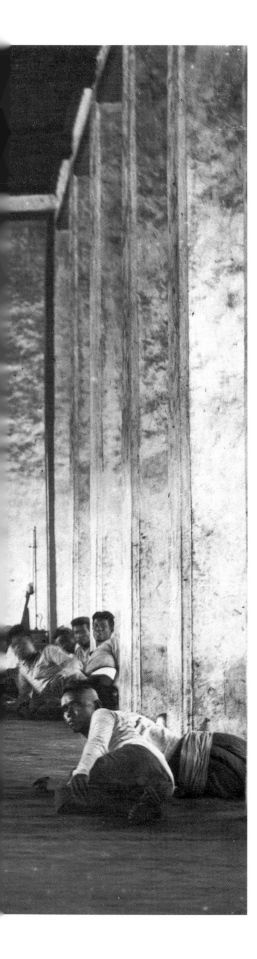

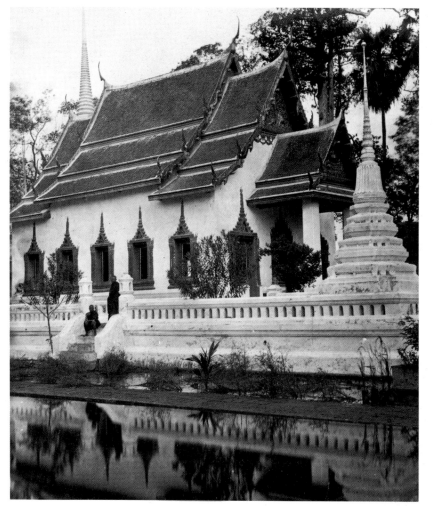

23 Buddhist temple, Siam, c. 1865–66

24 The King's Amazons, Siam, 1865–66

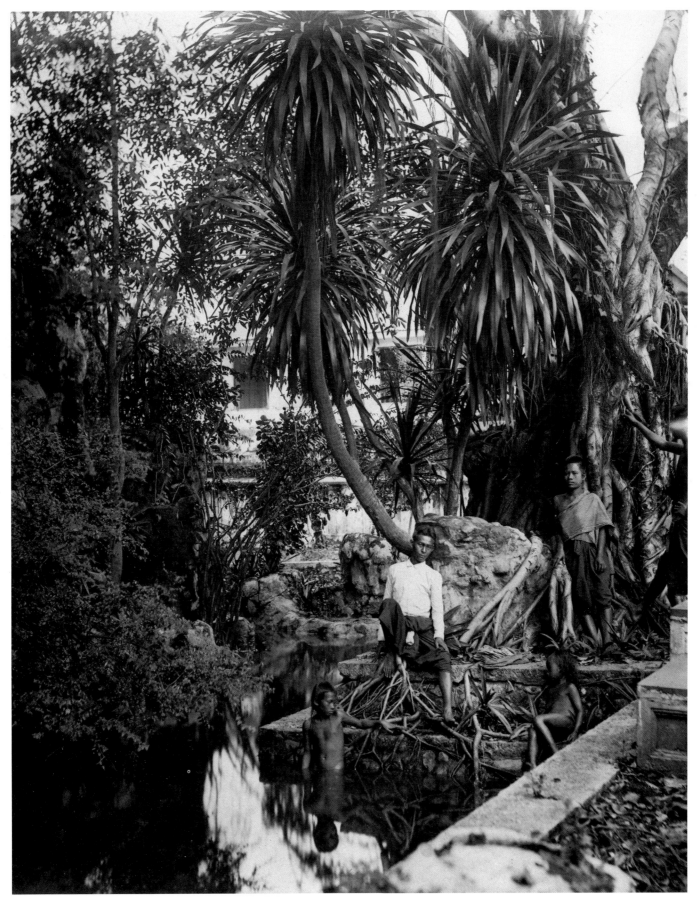

25  Figures in a garden, Siam, 1865–66

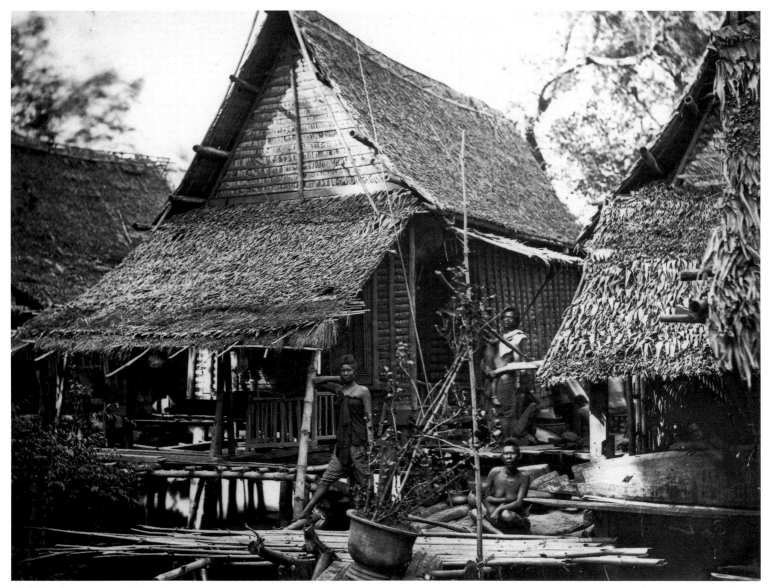

26 River huts, Siam, *c.* 1865–66

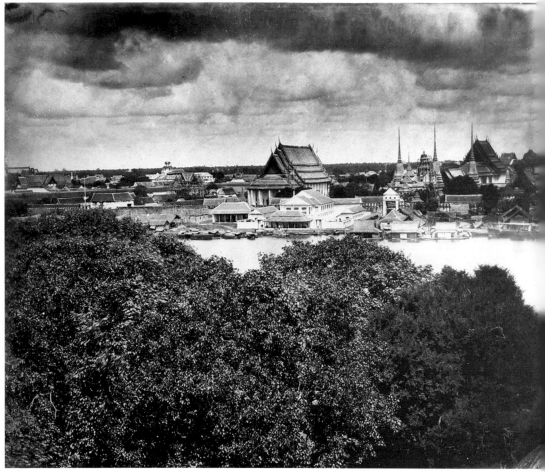

27  View of Bangkok from the River Menam, 1865–66

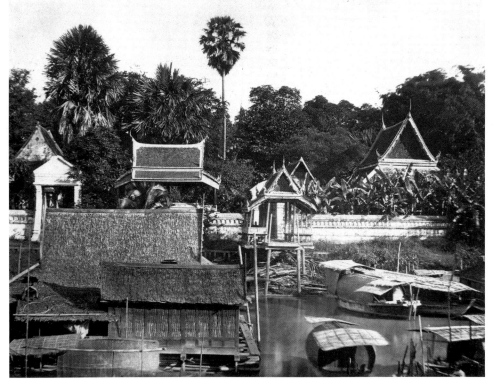

28  River architecture, Siam (attributed), 1865–66

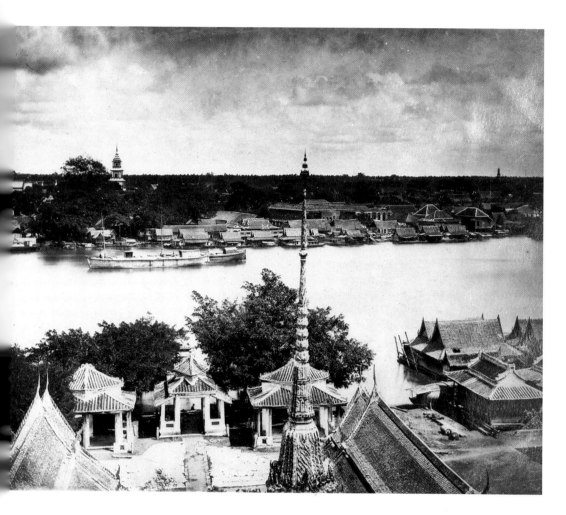

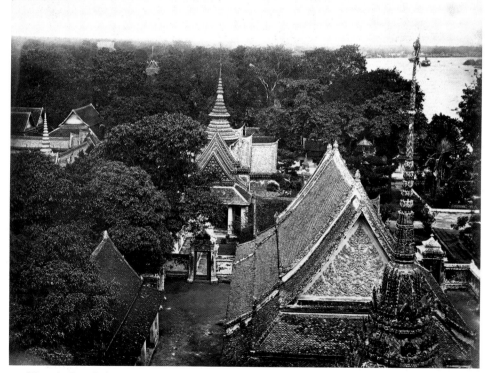

29  View in Bangkok, *c.* 1865–66

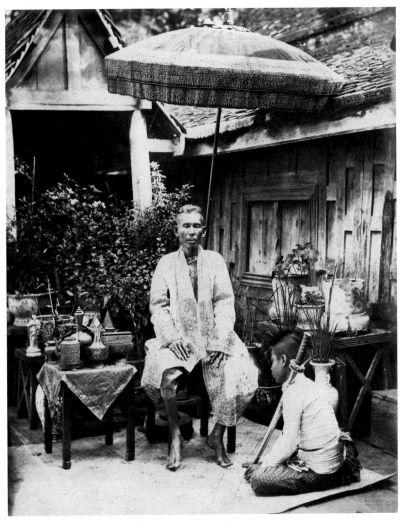

30 The Governor of Pandam, Siam, *c.* 1865–66

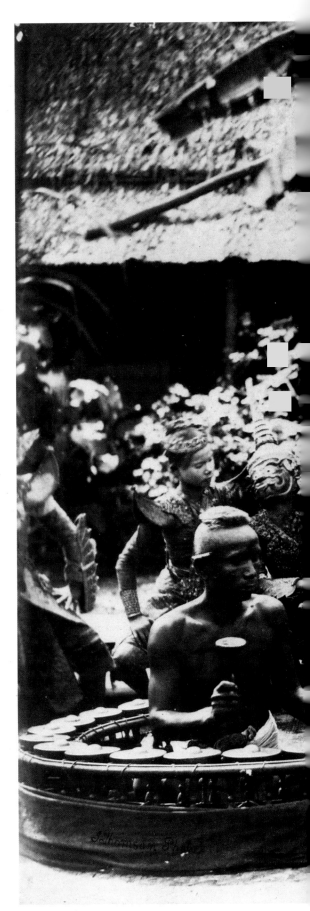

31 Siamese puppets, *c.* 1865–66

32 Lakon dancers, Siam, *c.* 1865–66

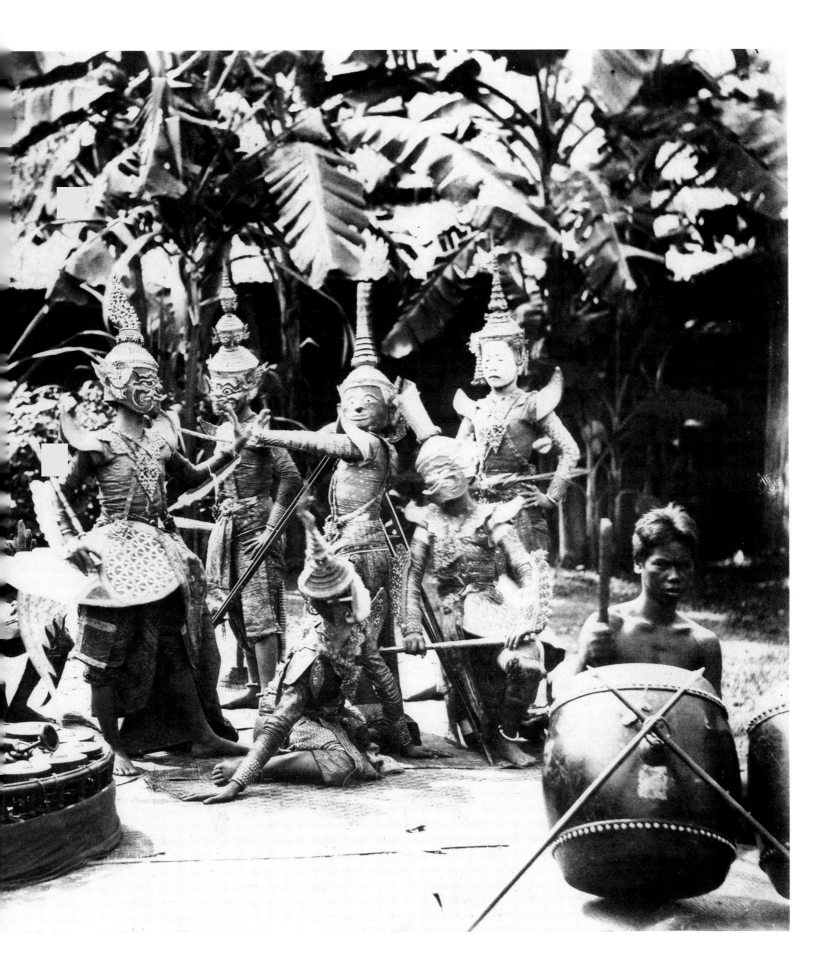

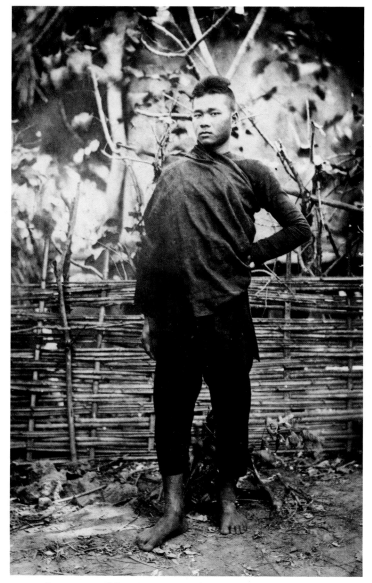
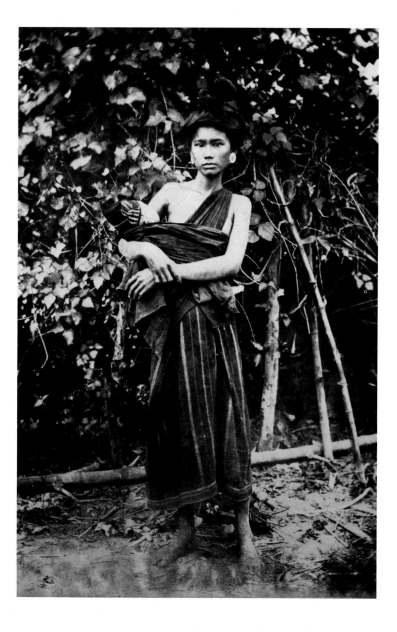

33, 34 Laos man and Laos woman, *c.* 1865

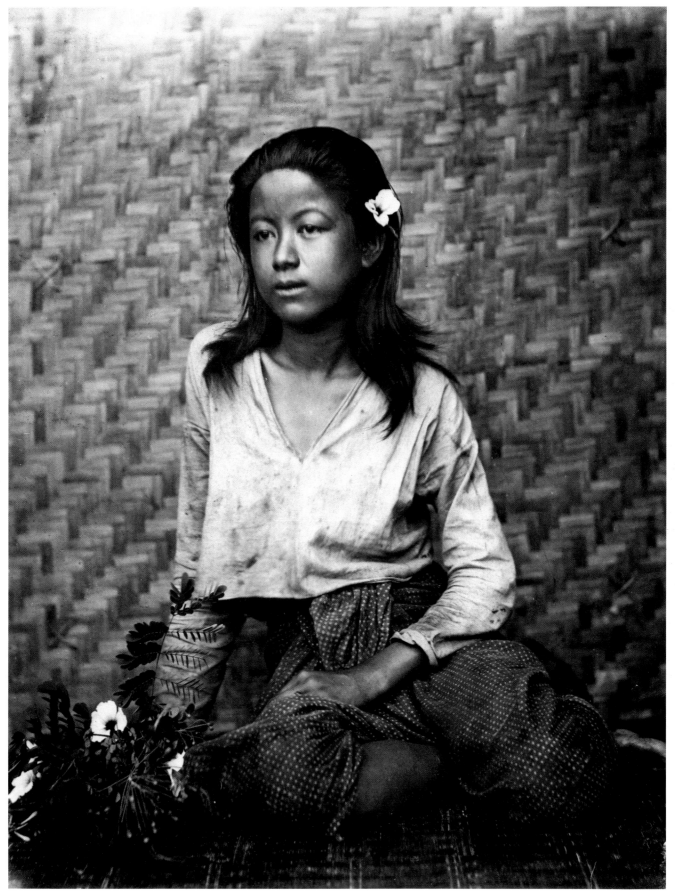

35 A Siamese girl, *c.* 1865–66

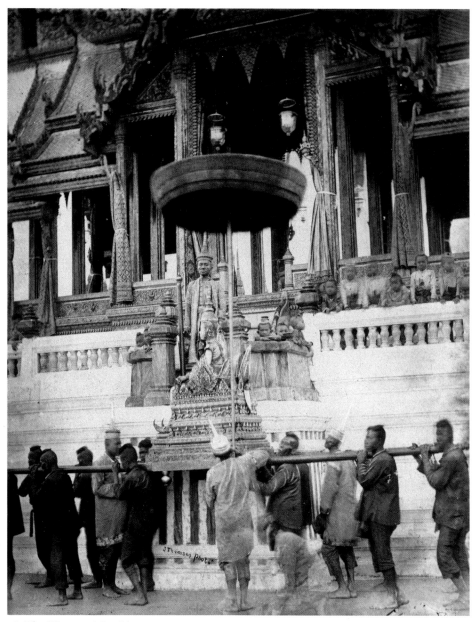

36 The King receiving his son, *c.* 1865–66

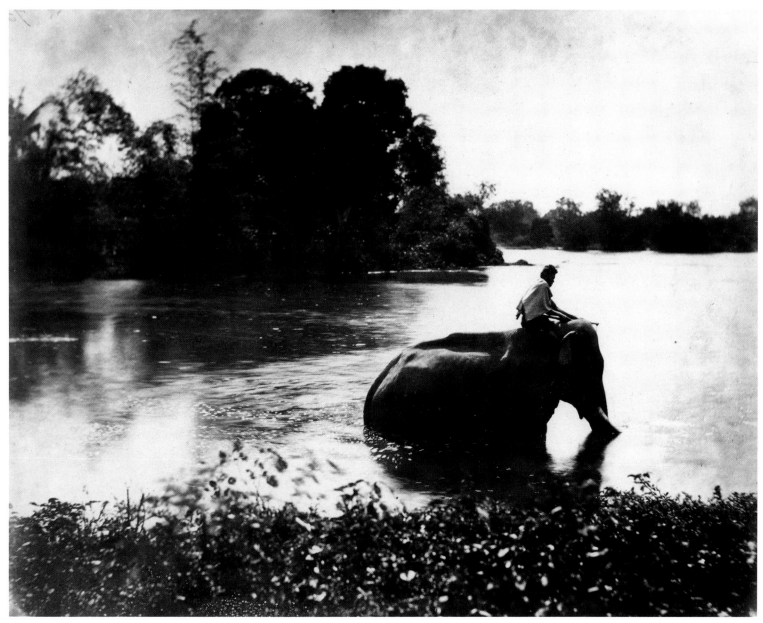

37 Elephant crossing a stream, Siam, *c.* 1865–66

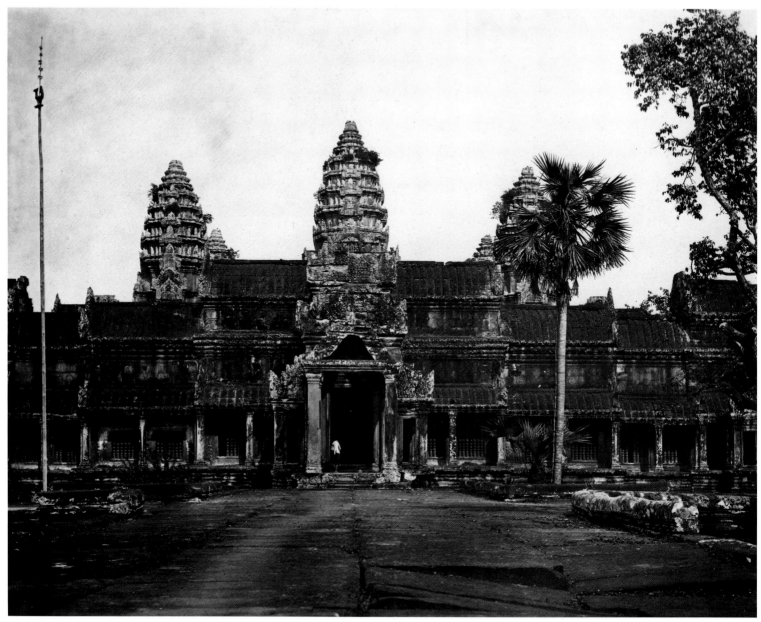

38 Nakhon Wat, western façade, central section, 1866

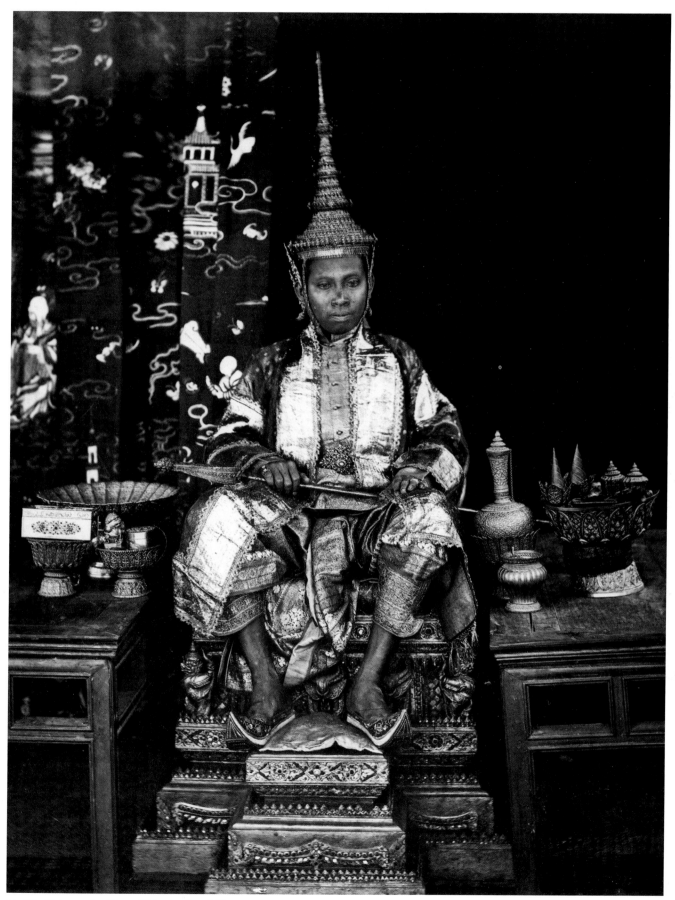

39 His Majesty, the King of Cambodia, 1866

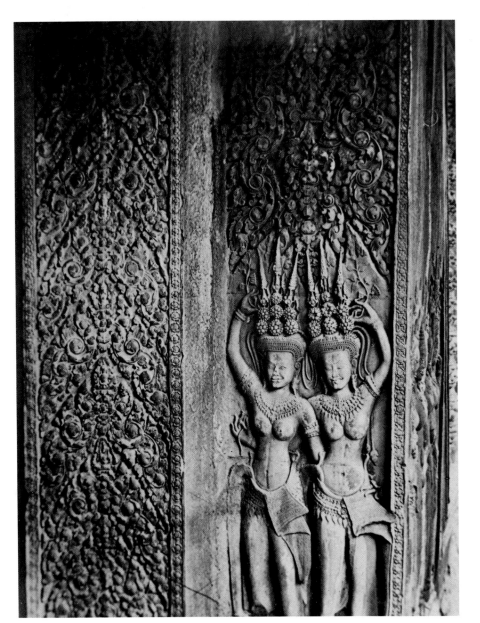

40 Wall carvings, Cambodian temple, 1866

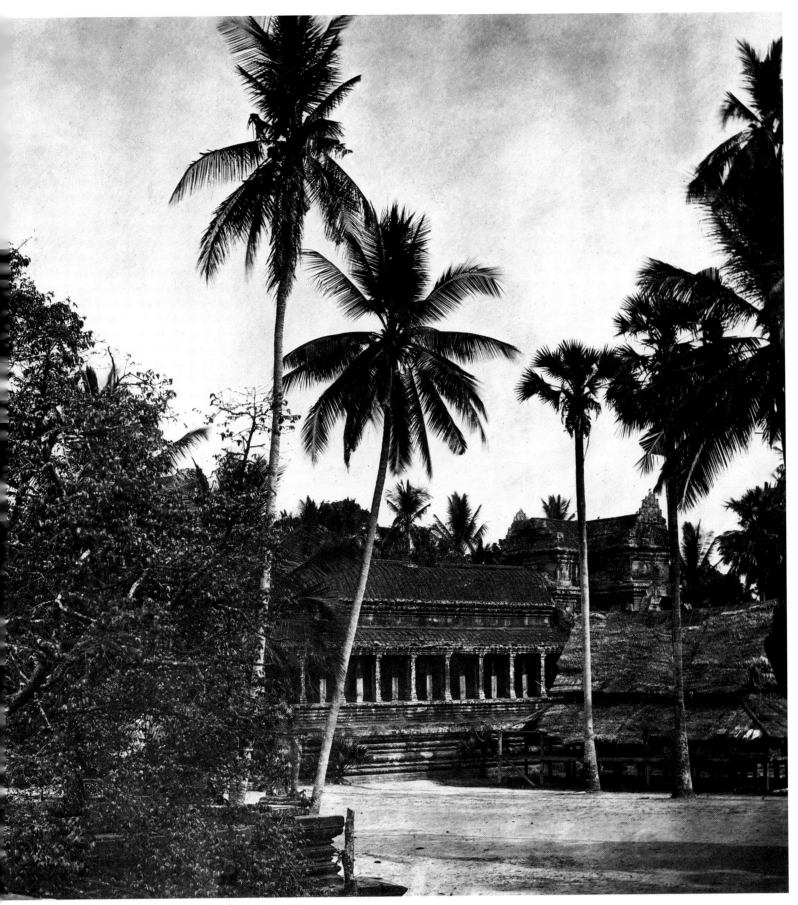

41 Nakhon Wat, western façade, right section, 1866

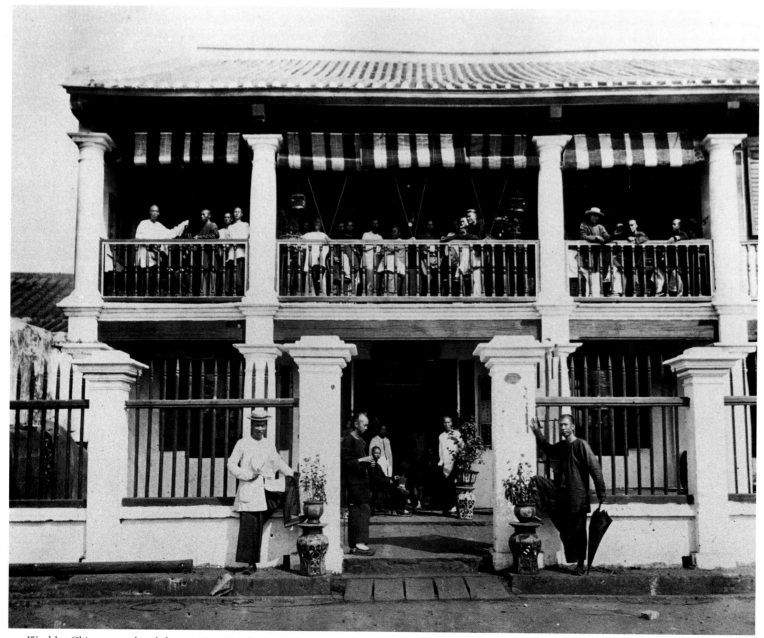

42 Wealthy Chinese merchant's house, New Year's Day, Saigon, *c.* 1868

43 Saigon, Bureau de Tabac, *c.* 1867

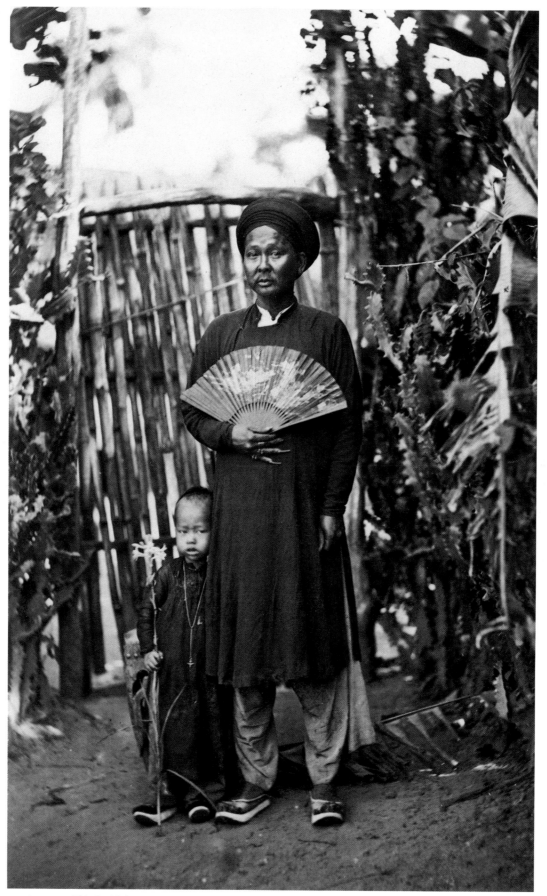

44  Anamese Chief with his young son, *c.* 1867

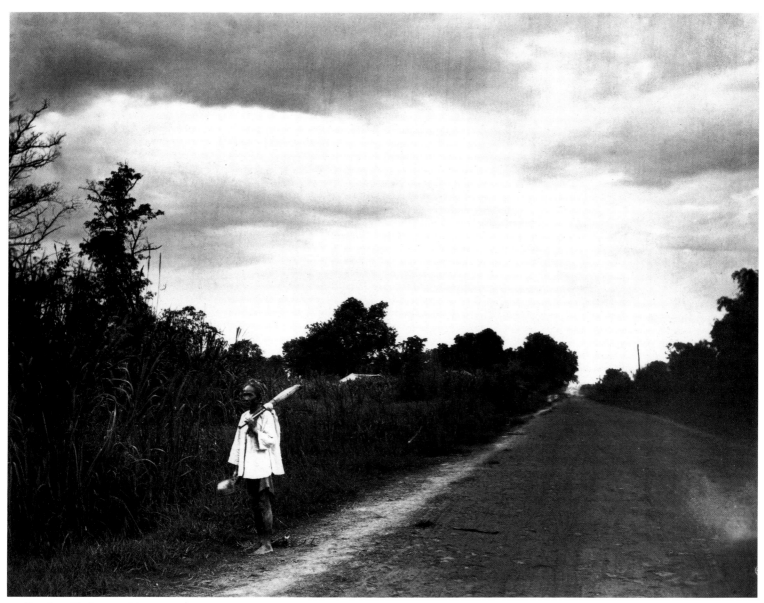

45 Road to Cholon, *c.* 1867

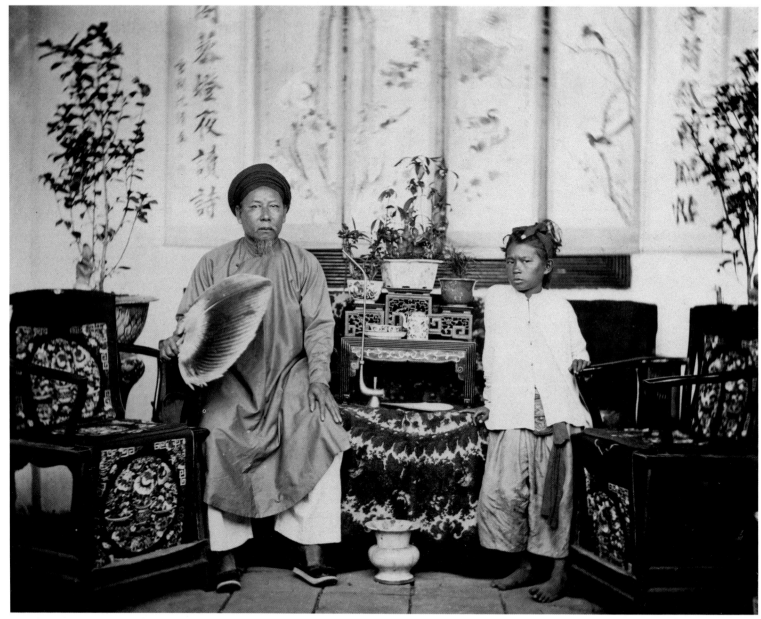

46  Chinese merchant and child, Vietnam, *c.* 1867

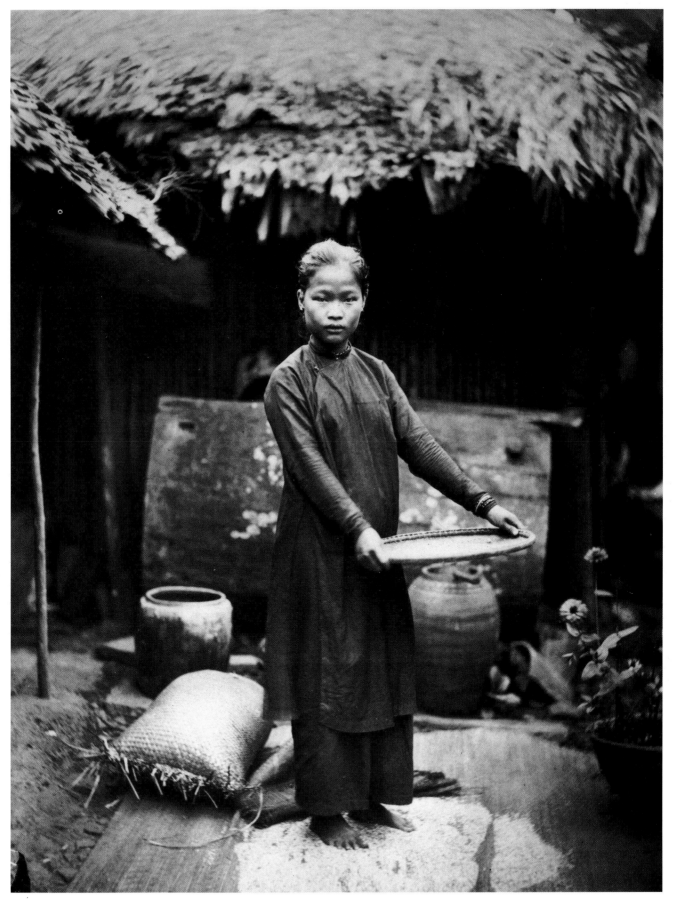

47 Girl winnowing rice, *c.* 1867

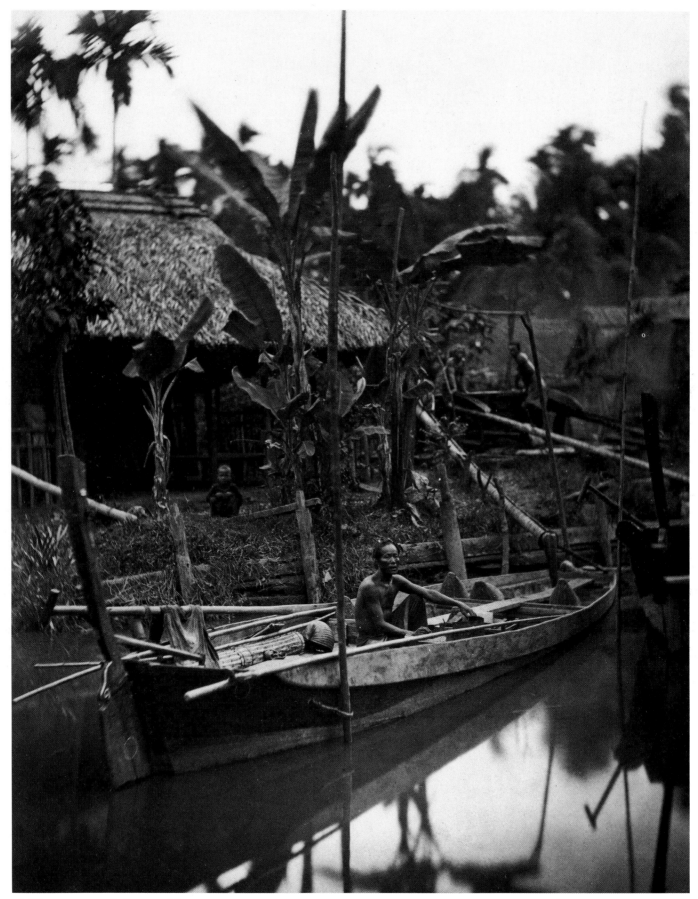

48 Vietnamese man in boat, *c.* 1867

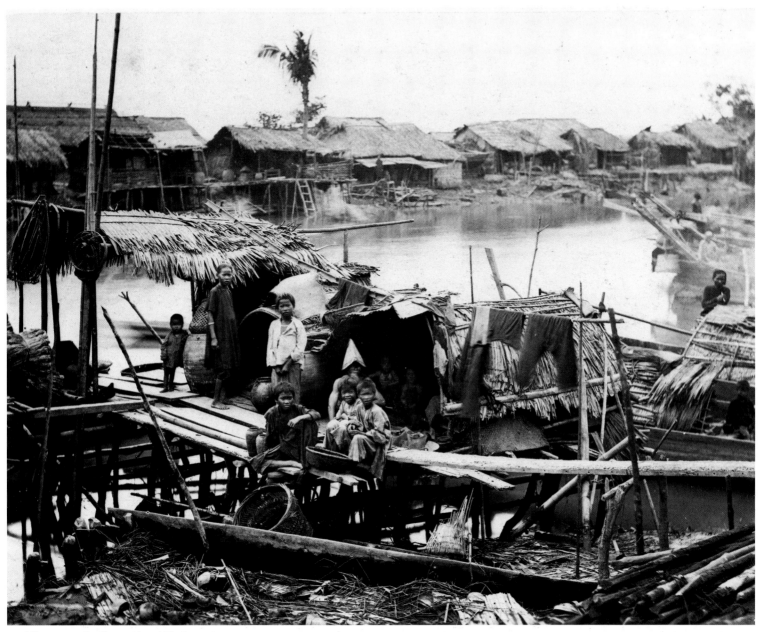

49  Vietnamese family on river, Cholon, *c.* 1867

50  Figures at the well, *c.* 1867

51  Winnowing rice, *c.* 1867

52 River bridge, Saigon, *c.* 1867

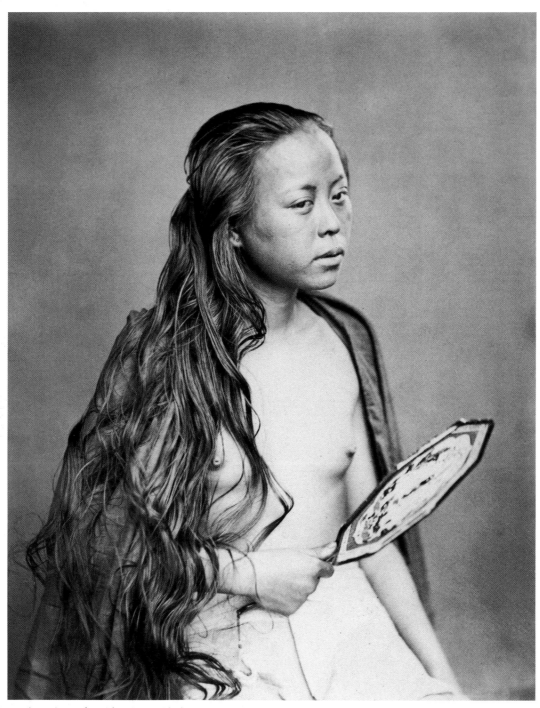

53 Anamite nude with mirror, Cholon, *c.* 1867

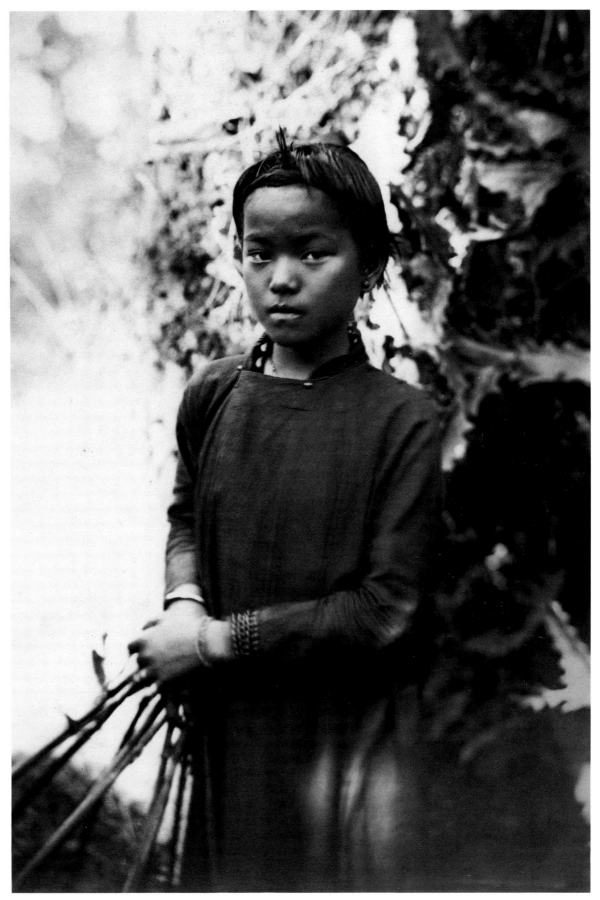

54 Young Vietnamese female, *c.* 1867

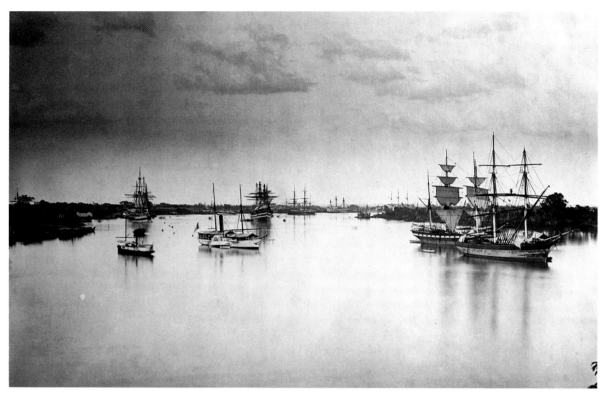

55 Shipping on the Mekong River, *c.* 1867

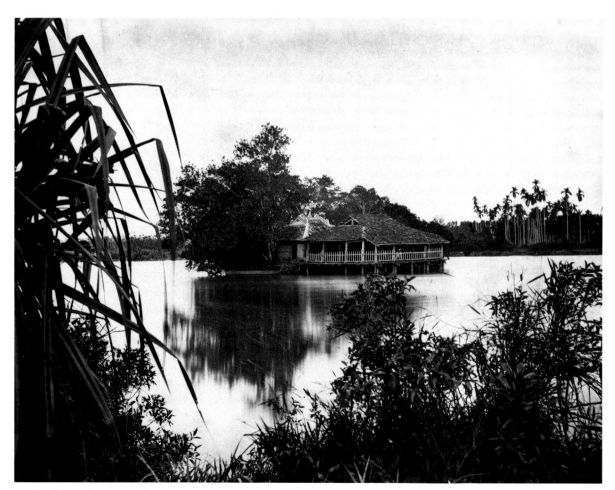

56 Island hut, Annam, *c.* 1867

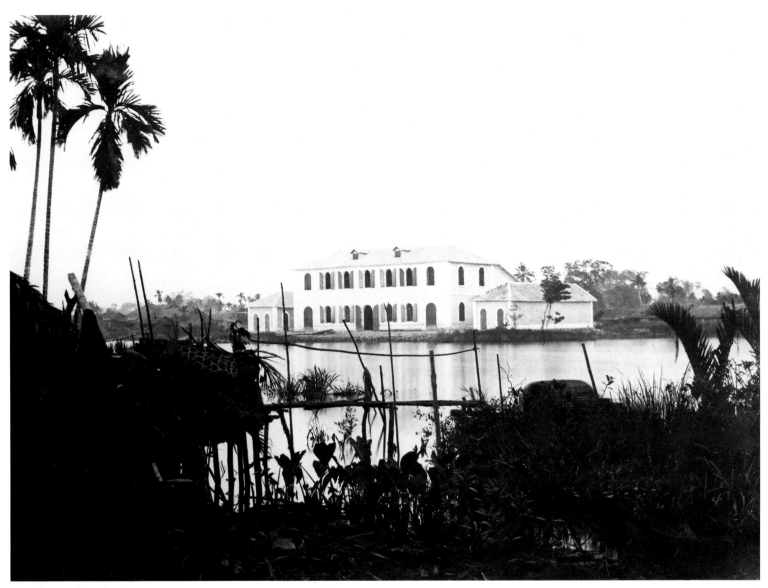

57 A house along the river, *c.* 1867

58 Study of water plants, *c.* 1867

# III
# SOUTH CHINA

1868–1870

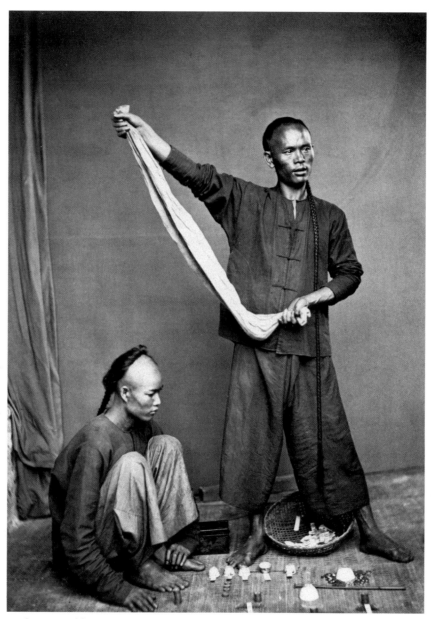

59 Street gambling, Canton, *c.* 1868

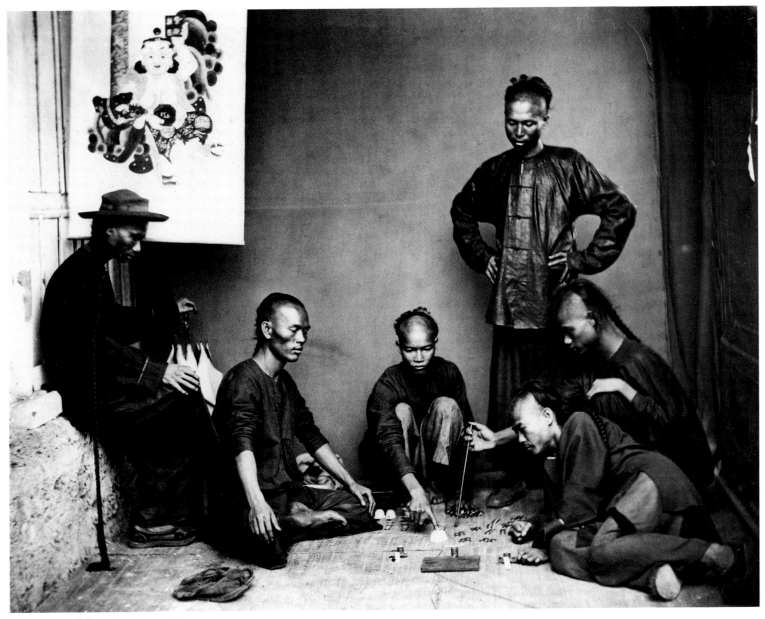

60  Street gambling, Canton, *c.* 1868

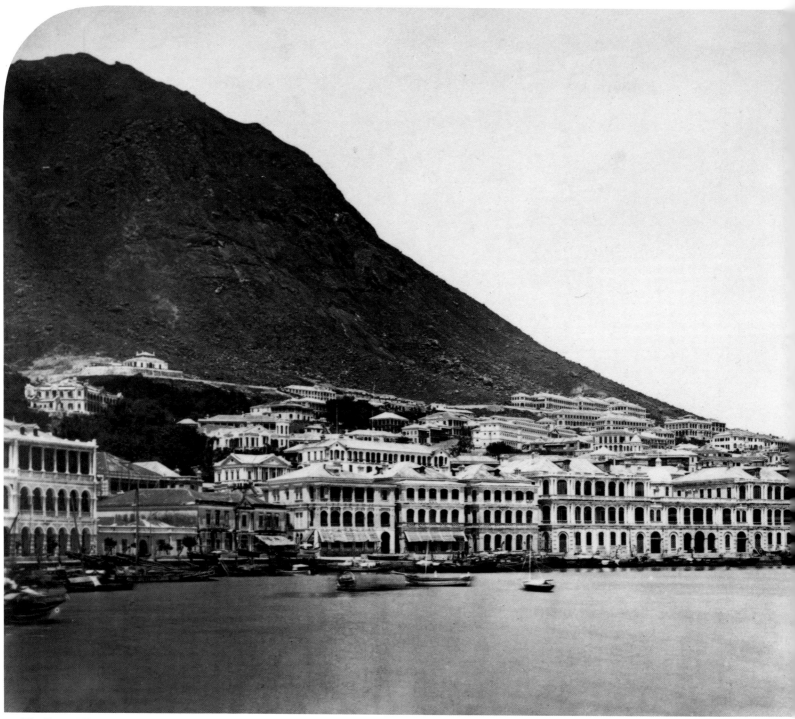

61 The Praya, Hong Kong, *c.* 1868

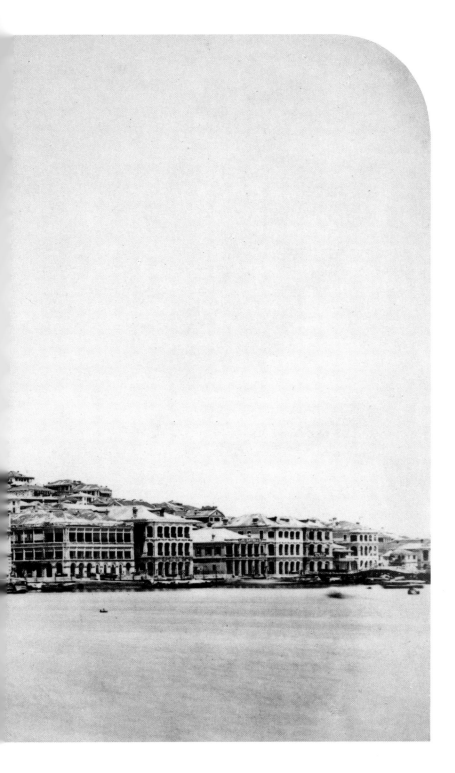

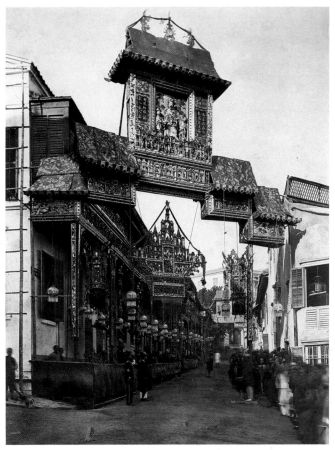

62  Chinese Street, Hong Kong, prepared for illumination, 1869

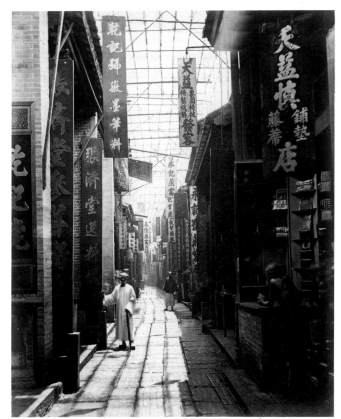

63  Physic Street, Canton, c. 1869

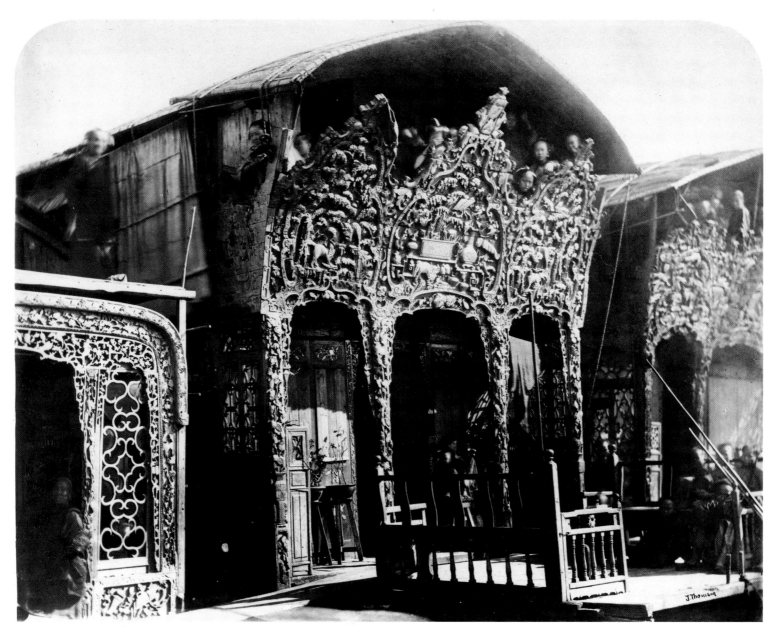

64  Flower boat, Canton, *c.* 1869

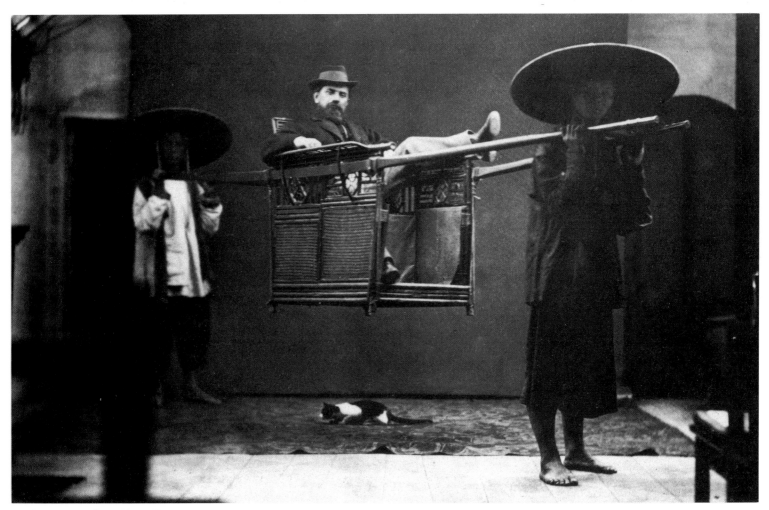

65  As we went about Hong Kong, *c.* 1868–69

66  English Consulate, Canton, *c.* 1869

67  View from the English Consulate, Canton, *c.* 1869

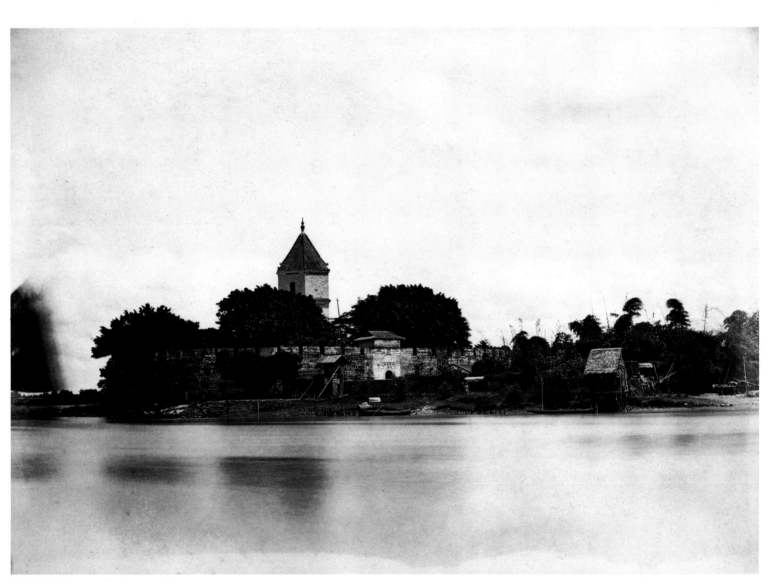

68 Macao Passage, Canton, *c.* 1869

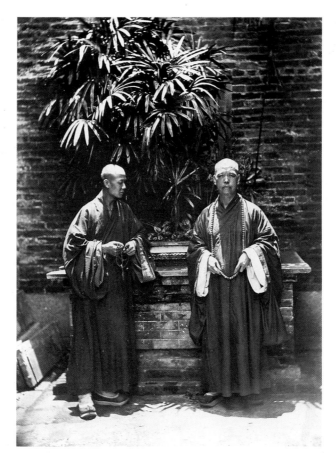

69 Two Buddhist priests, Canton, *c.* 1869

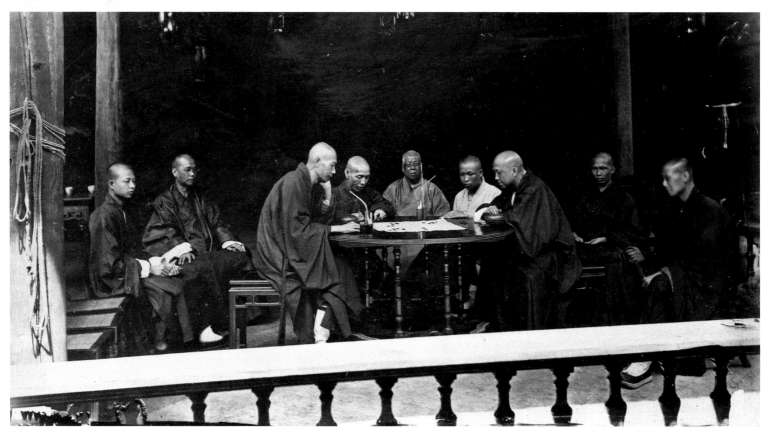

70 Buddhist monks at chess, Canton, *c.* 1869

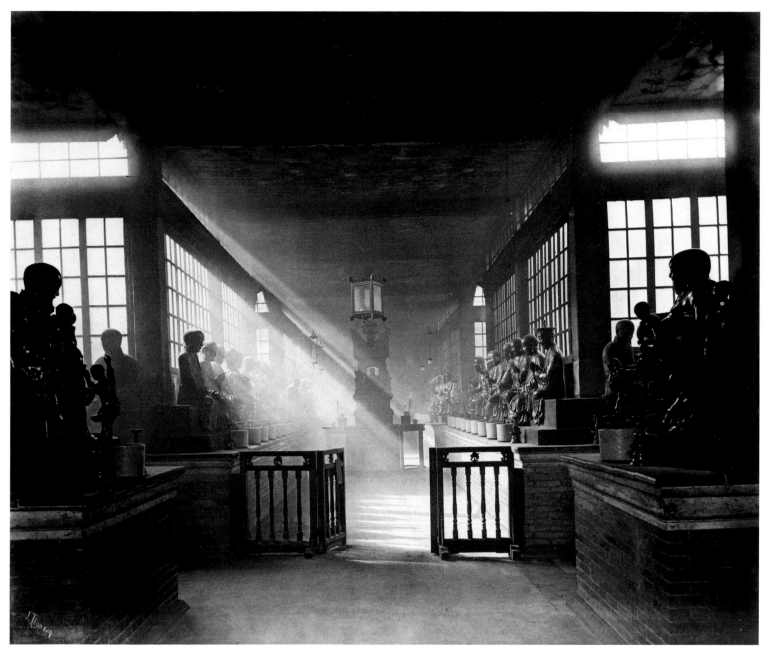

71 Temple of the Five Hundred Gods, Canton, *c.* 1869

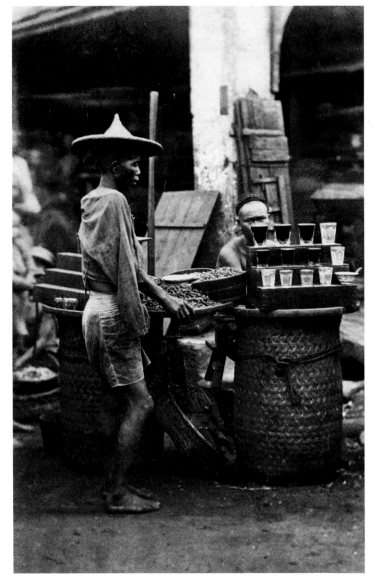

72 Beer and peanut hawker, Hong Kong, *c.* 1868

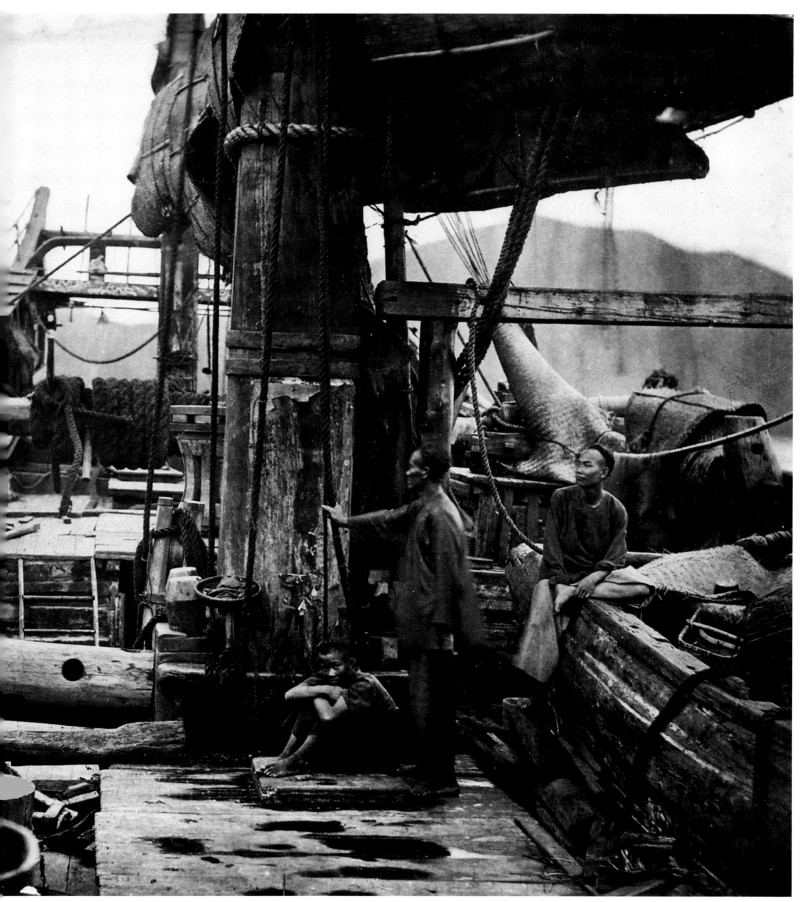

73  Deck of a Chinese junk, Hong Kong, *c.* 1868

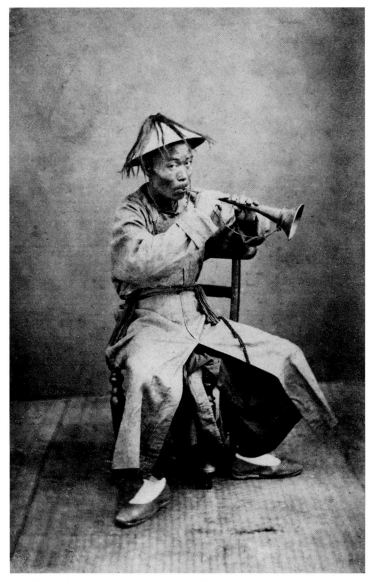

74 Chinese musician, Hong Kong, *c.* 1868

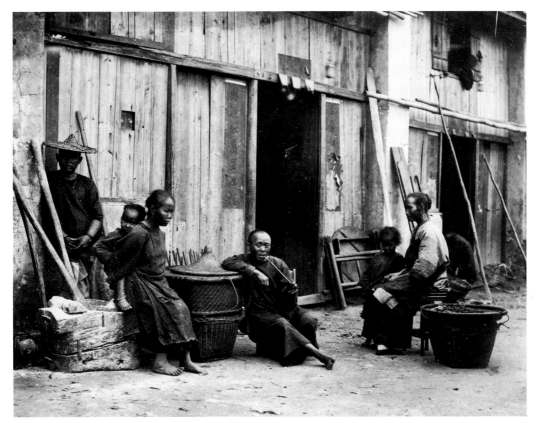

75  Family group, Canton, *c.* 1869

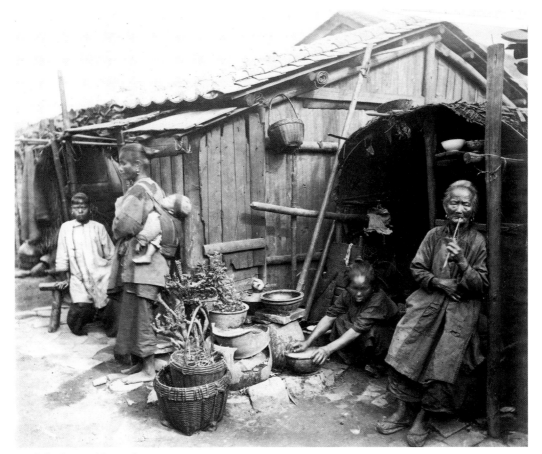

76  Suburban residents, Canton, *c.* 1869

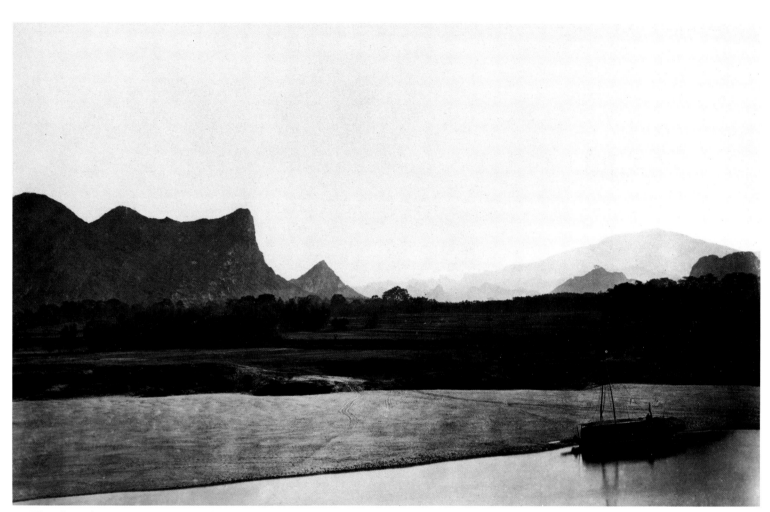

77 View from the Kwan Yin Cave, North River, *c.* 1870

# IV
# FOOCHOW
# AND THE RIVER MIN,
# FORMOSA

1870–1871

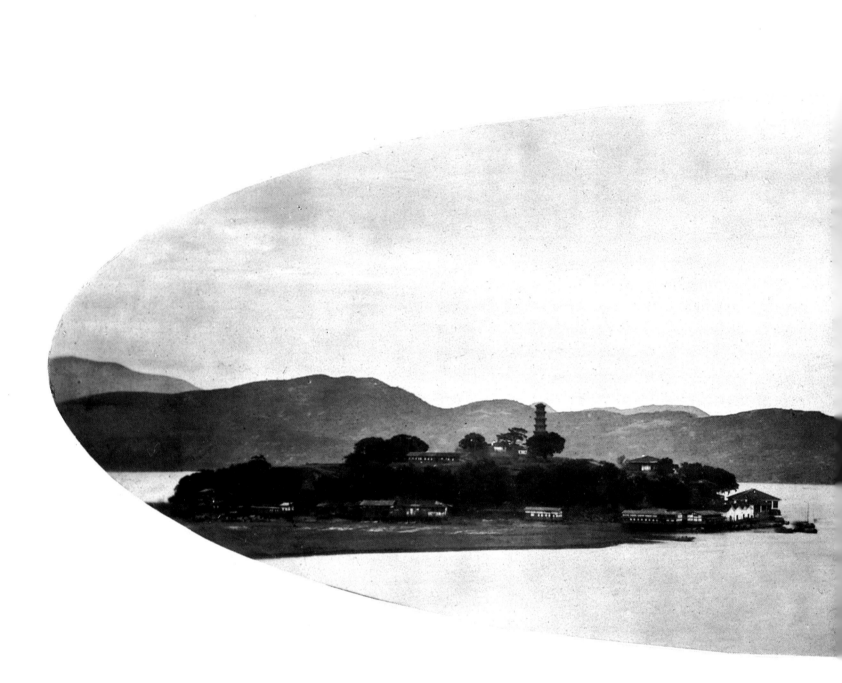

78 Pagoda Island, *c.* 1870–71

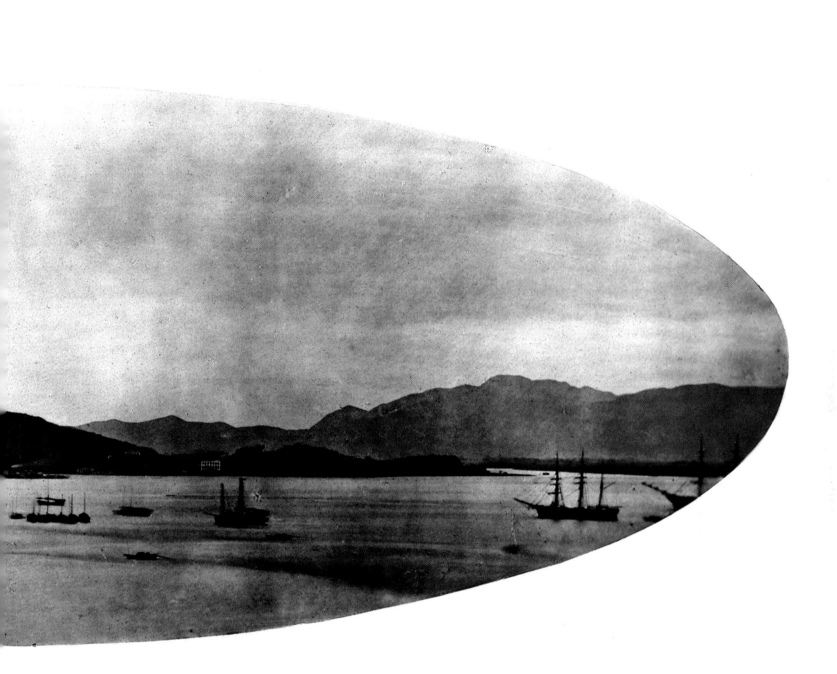

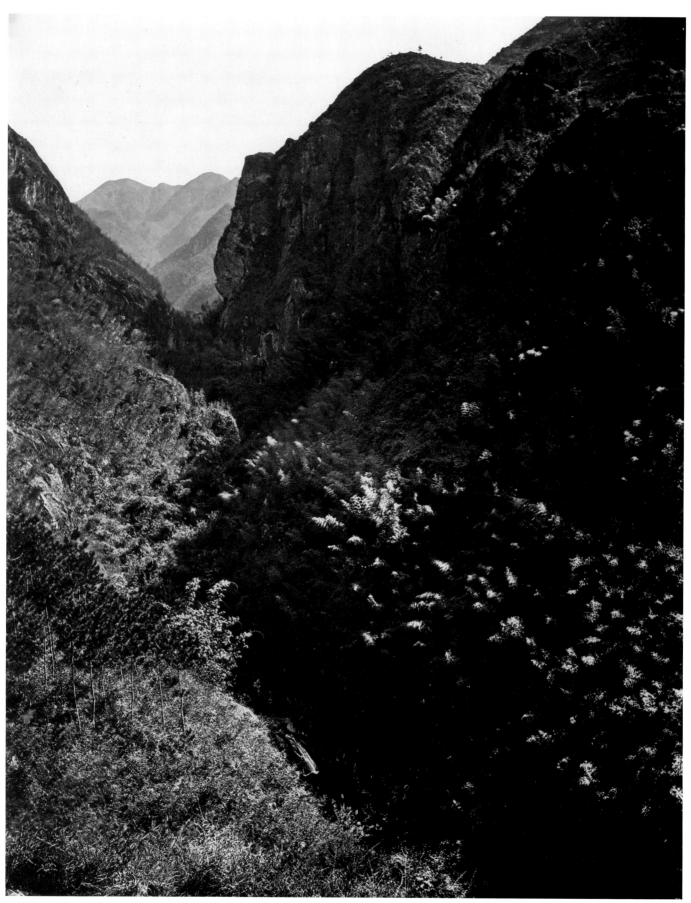

79 The Banker's Glen, *c.* 1870–71

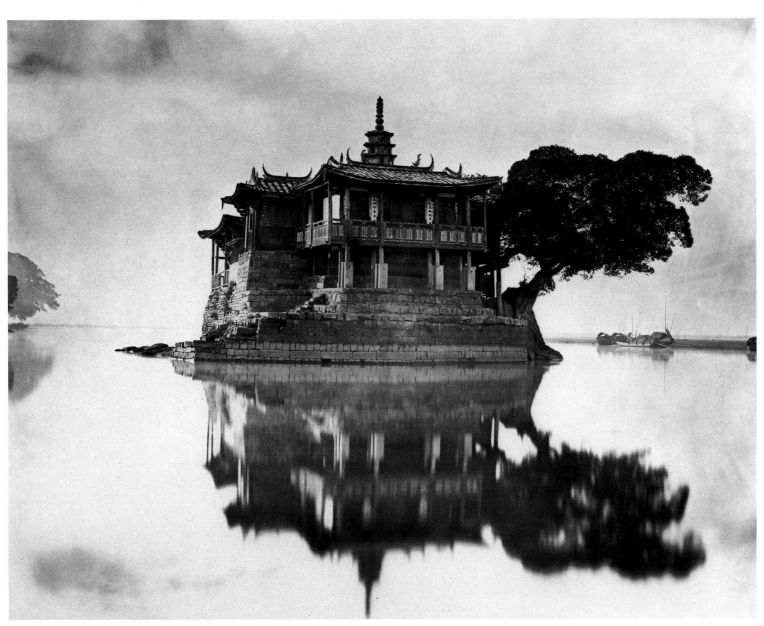

80 The Island Pagoda, *c.* 1870–71

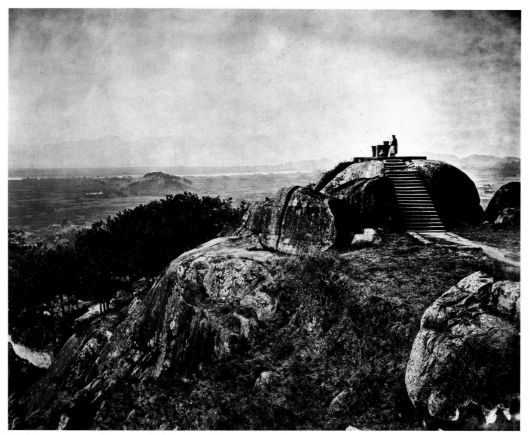

81 The Altar of Heaven, *c.* 1870–71

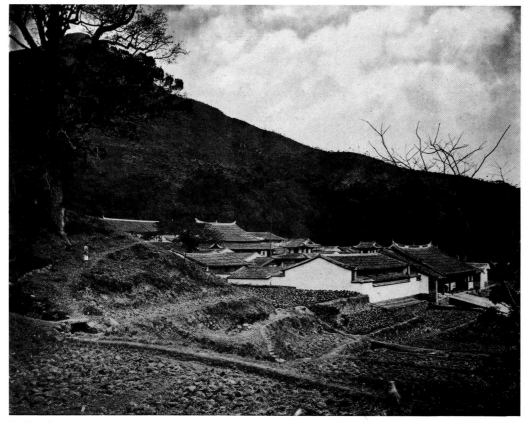

82 Ku-shan monastery, *c.* 1870–71

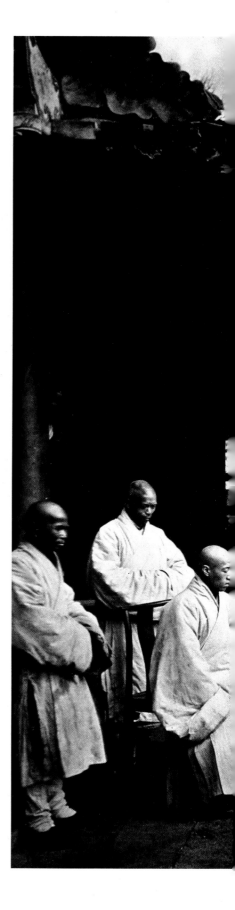

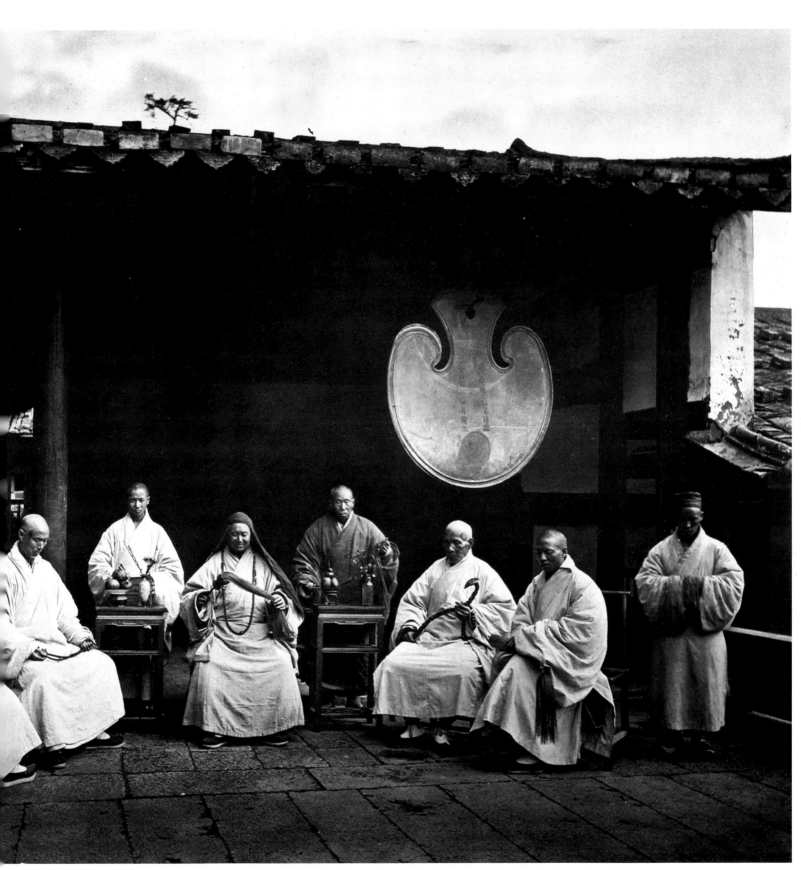

83  Buddhist monks, *c.* 1870–71

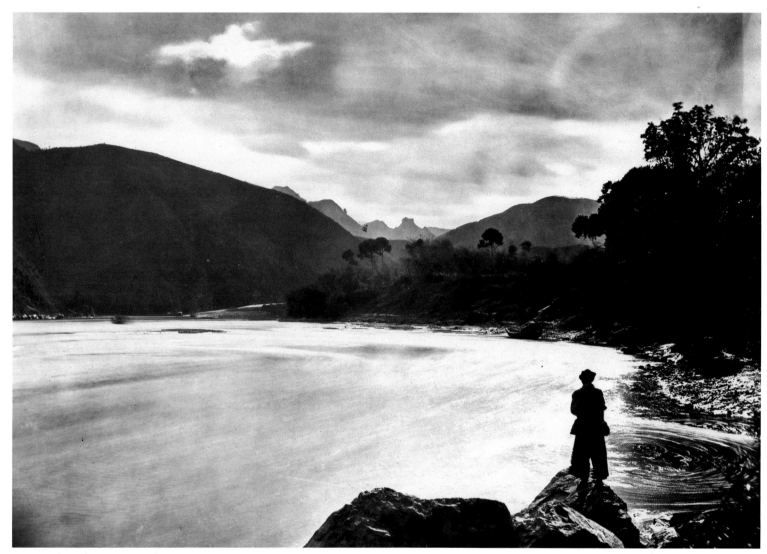

84  Yuan-fu rapid, *c.* 1870–71

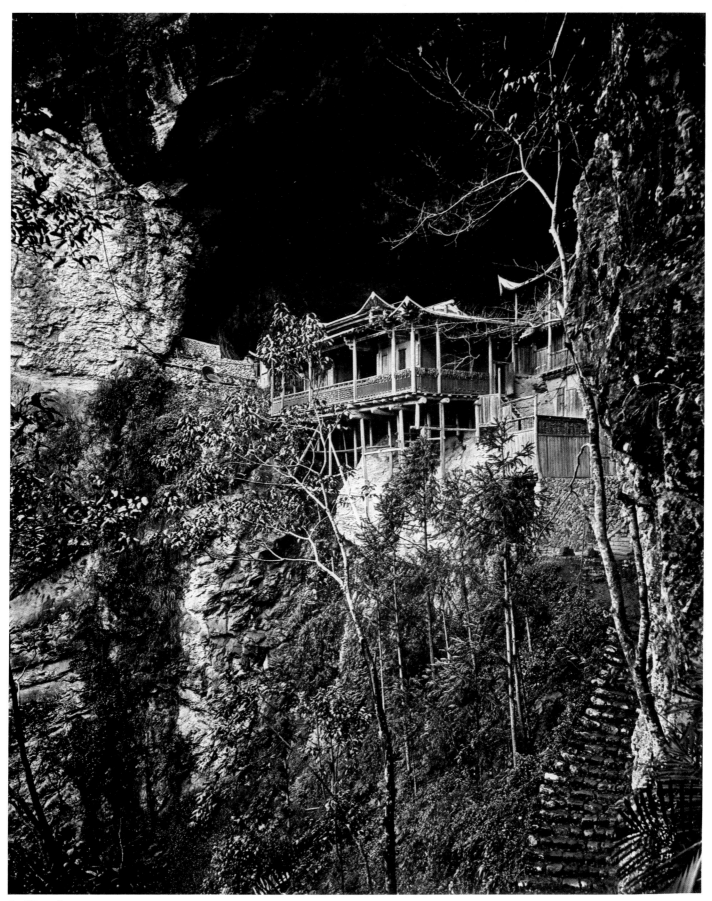

85 Yuan-fu monastery, *c.* 1870–71

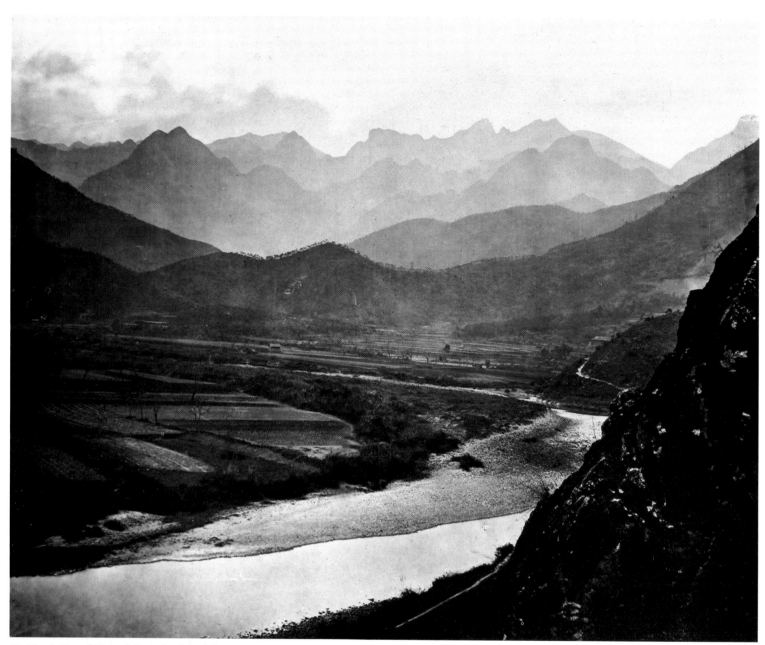

86  Mountains of Yuan-fu branch of the Min, *c.* 1870–71

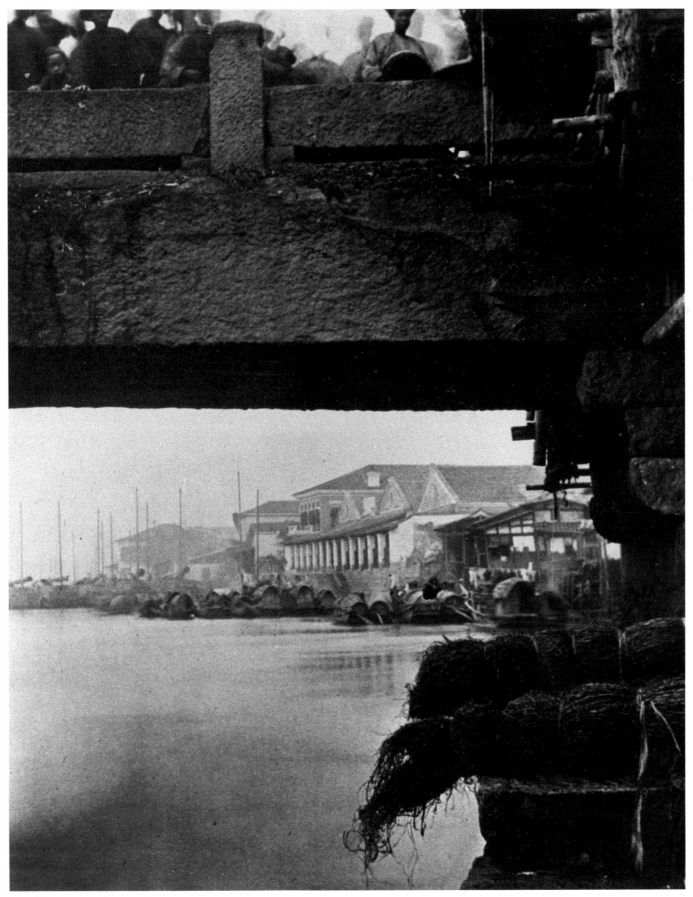

87 The Upper Bridge, Foochow, *c.* 1870–71

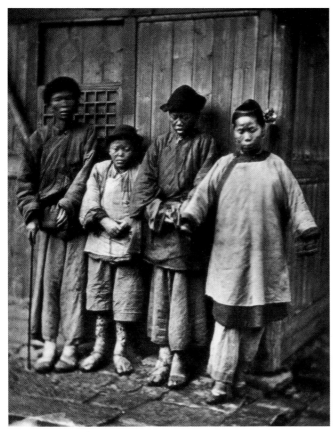

88 Lepers, Foochow, 1871

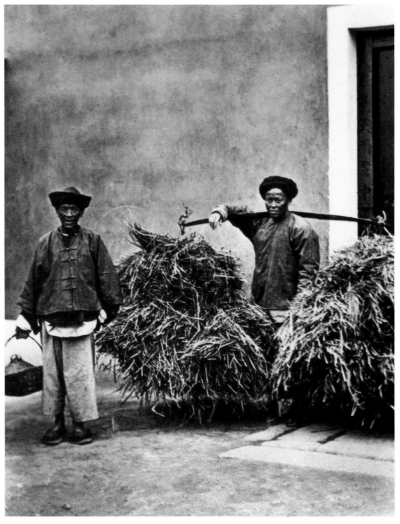

90 Coolies, Foochow, *c.* 1870–71

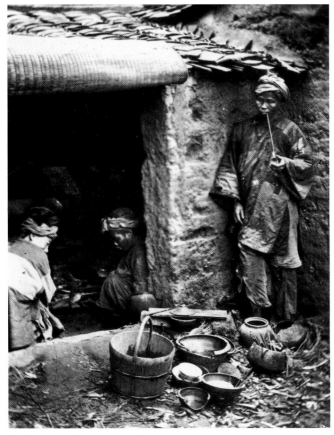

89 Beggars, Foochow, *c.* 1870–71

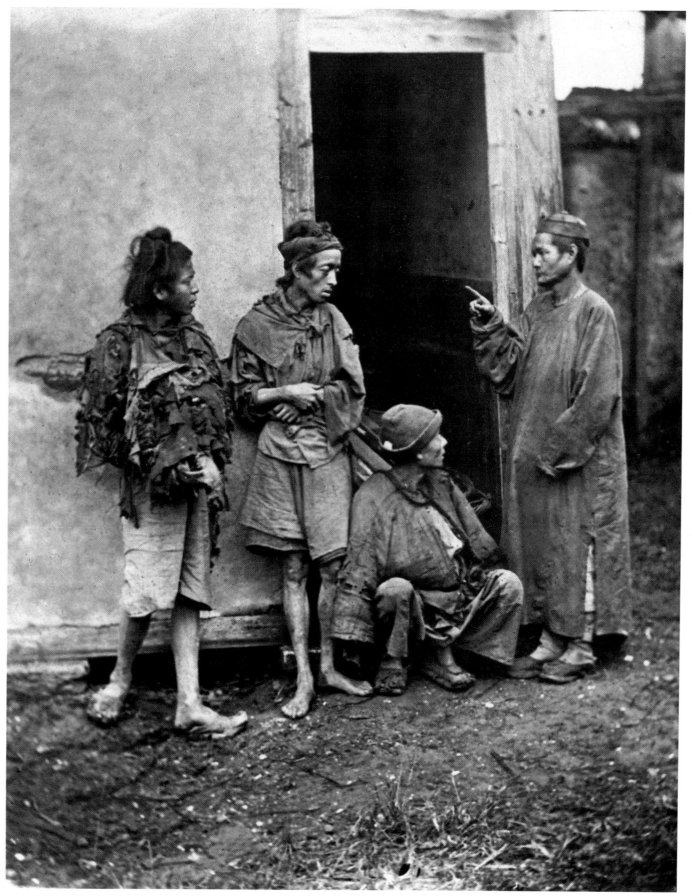

91  Beggars, Foochow, *c.* 1870–71

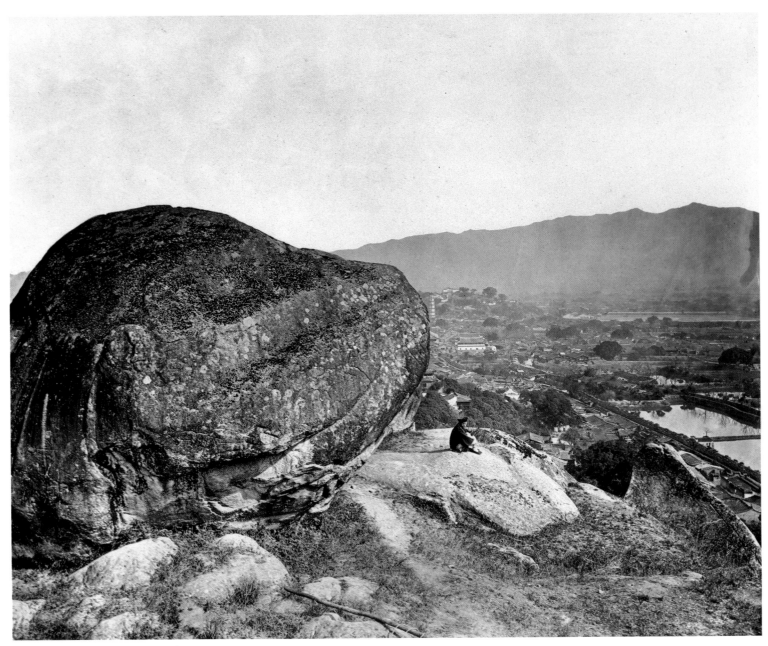

92 Foochow city, *c.* 1870–71

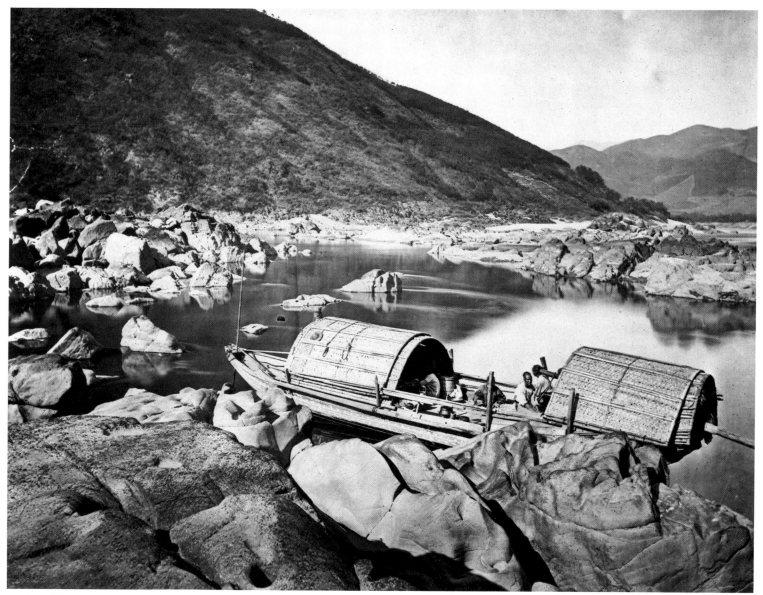

93 A rapid boat, *c.* 1870–71

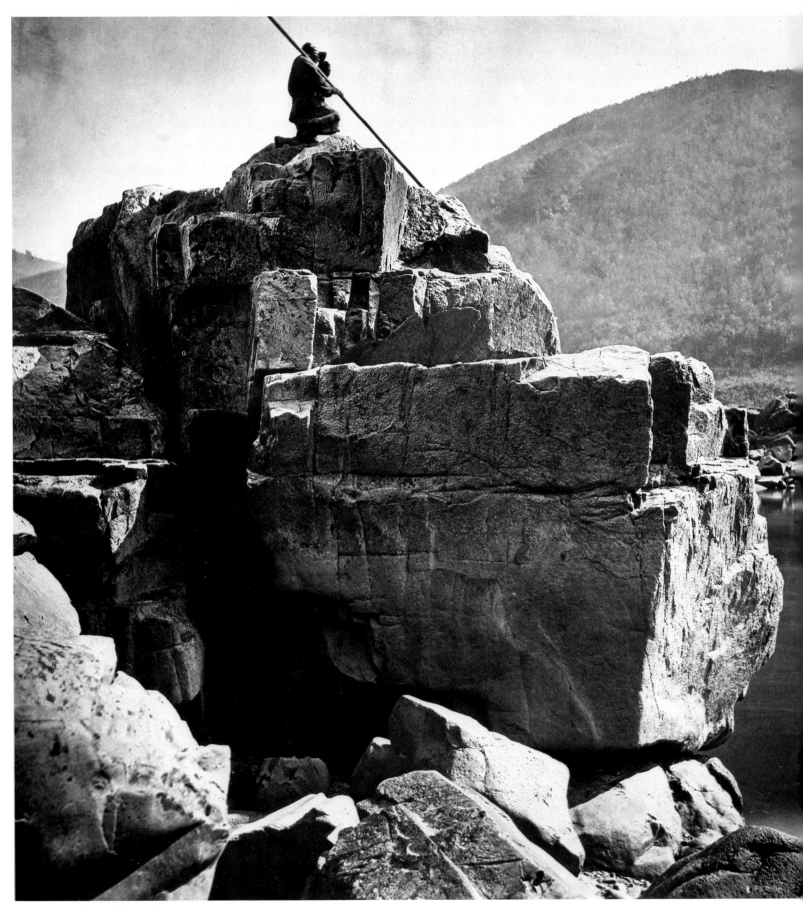

94 Rocks in the rapids, *c.* 1870–71

95  Rocks and foliage, River Min, *c*. 1870–71

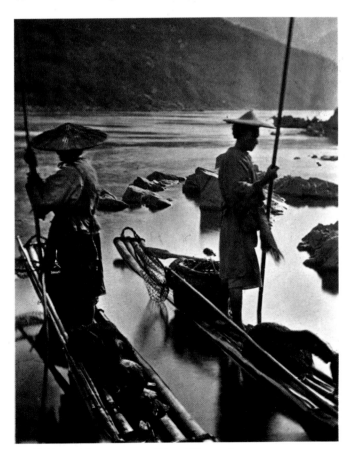

96  Fishing with cormorants, River Min, *c*. 1870–71

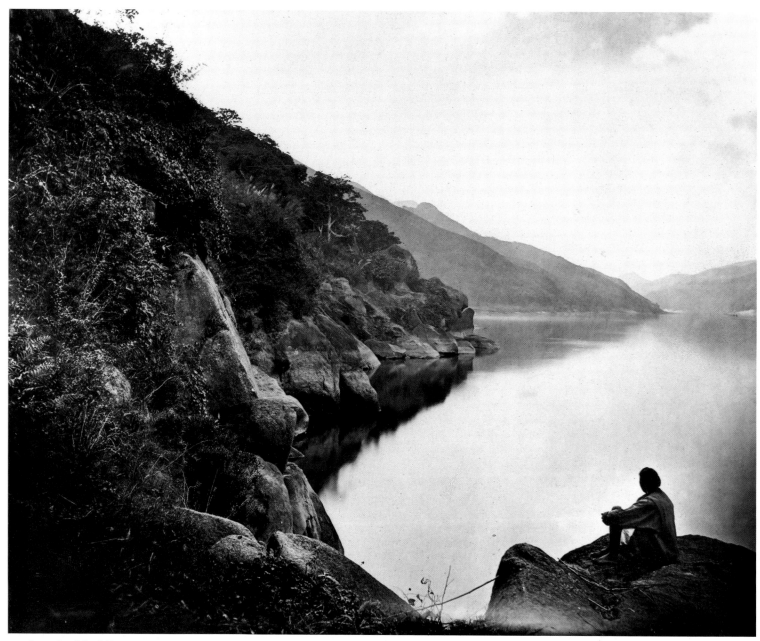

97 A reach of the Min, *c.* 1870–71

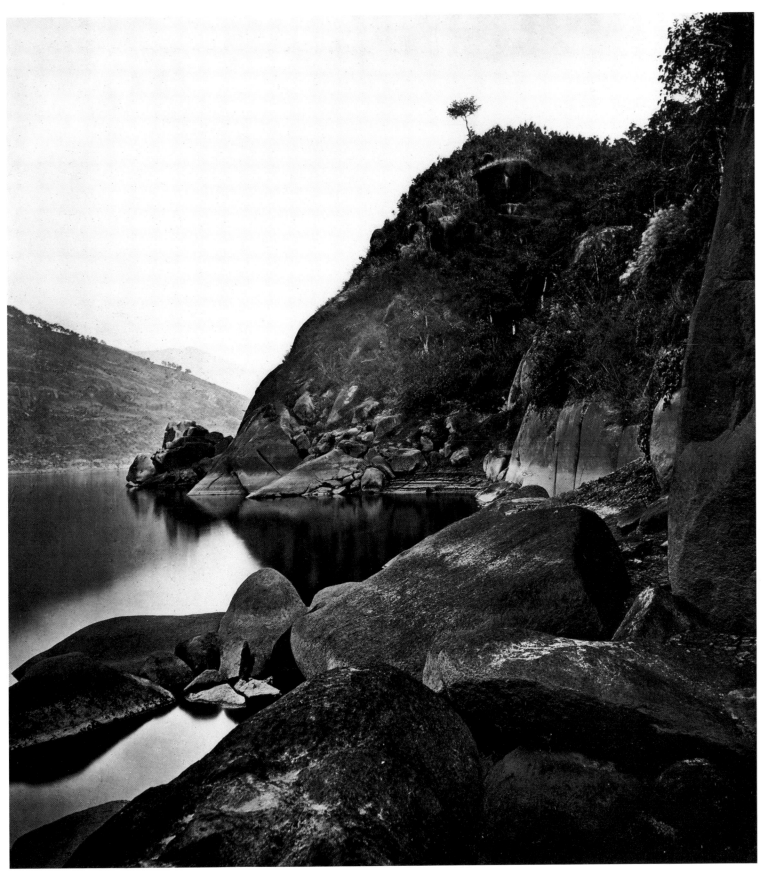

98  A reach of the Min, *c.* 1870–71

99 A rustic bridge, *c.* 1870–71

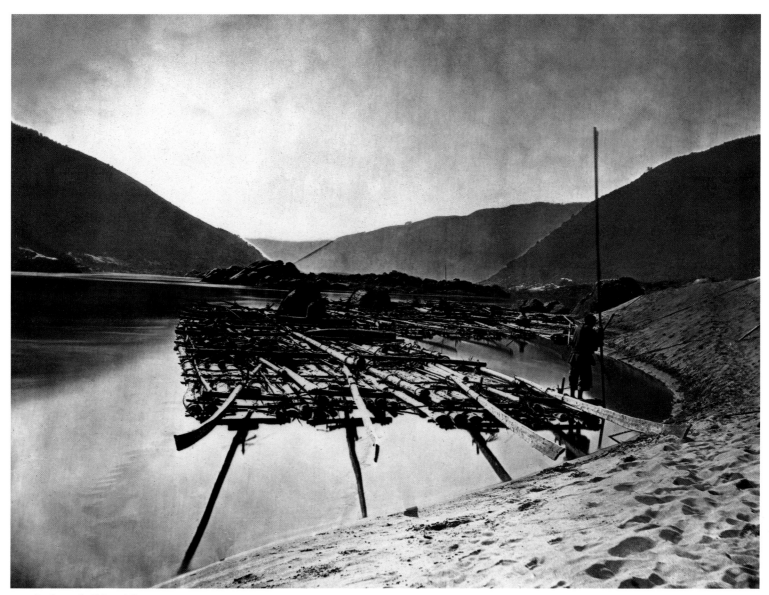

100   A pine raft, River Min, *c.* 1870–71

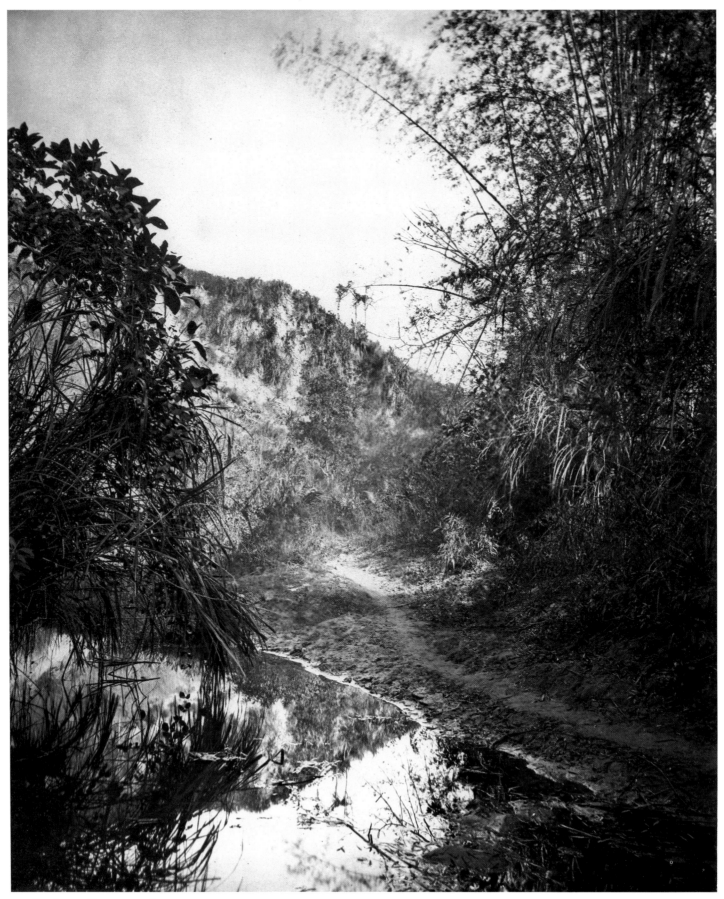

101 Landscape, Formosa, *c.* 1871

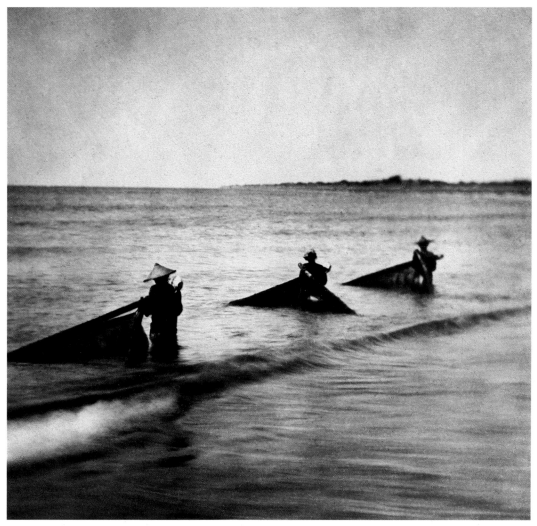

102 Fishing with nets, Formosa, 1871

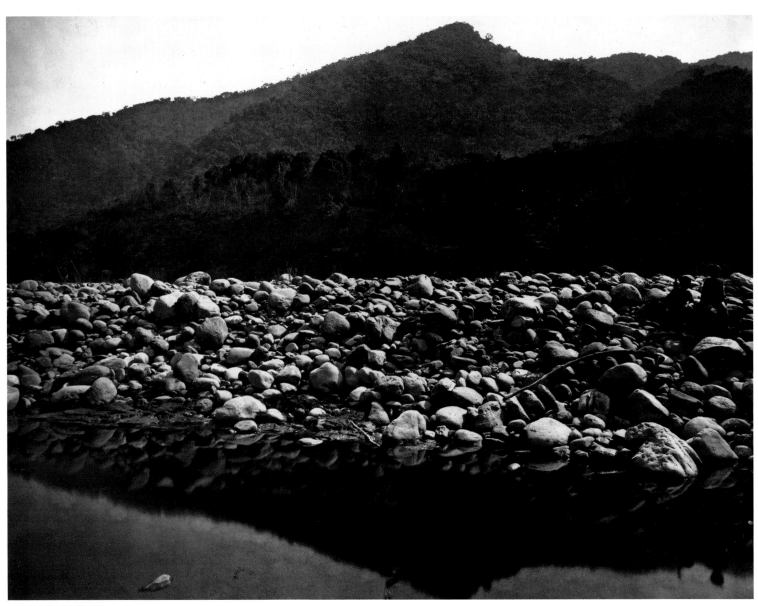

103 Right bank of Lakoli River, Formosa, *c.* 1871

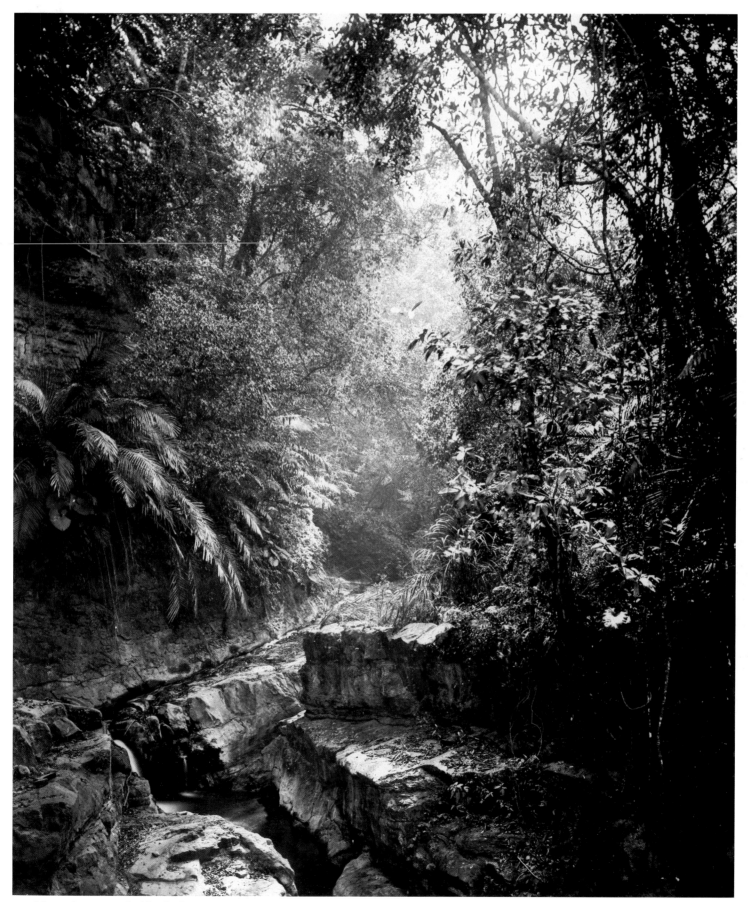

104  Mountain pass on the island of Formosa, *c.* 1871

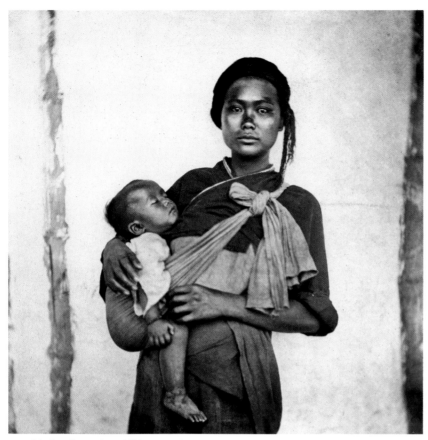

105 Mode of carrying children, c. 1871

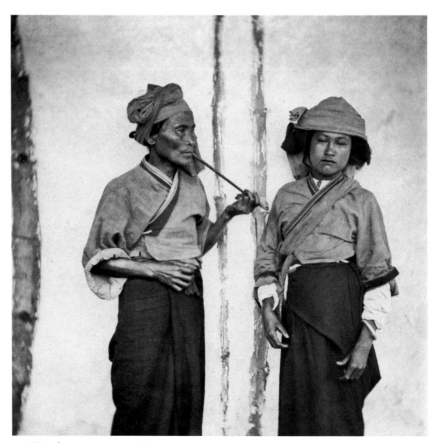

106 Pepohoan women, c. 1871

# V
# PEKING
# AND THE NORTH

1871–1872

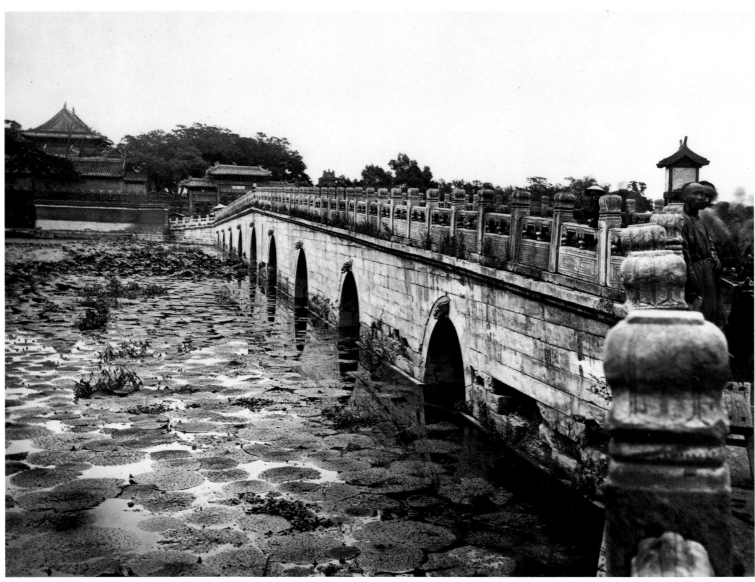

107  The Marble Bridge, Peking, *c.* 1871–72

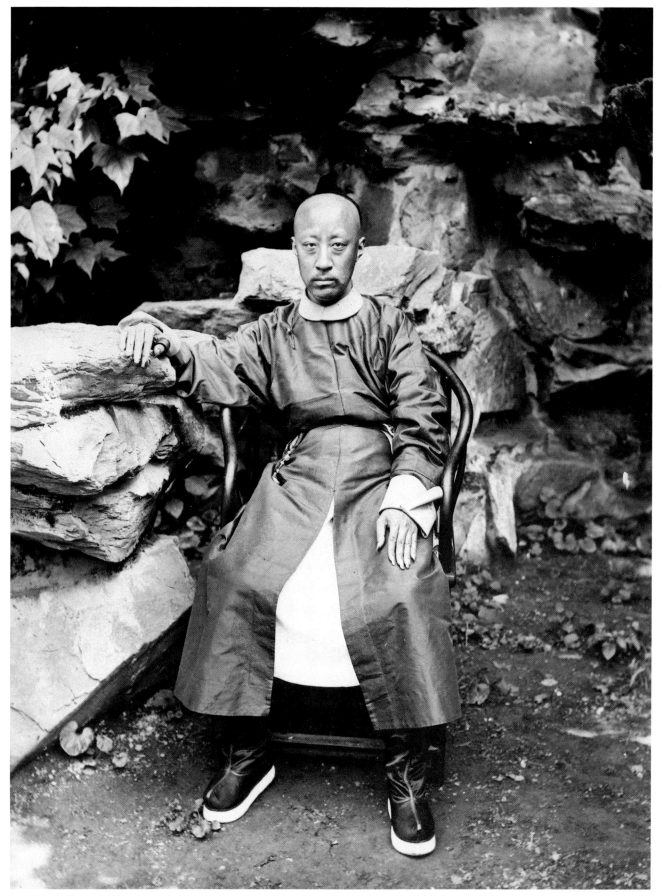

108  Prince Kung, Peking, *c.* 1871–72

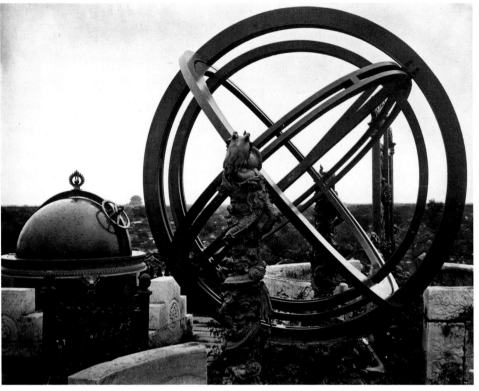

109  The Peking Observatory, *c.* 1871–72

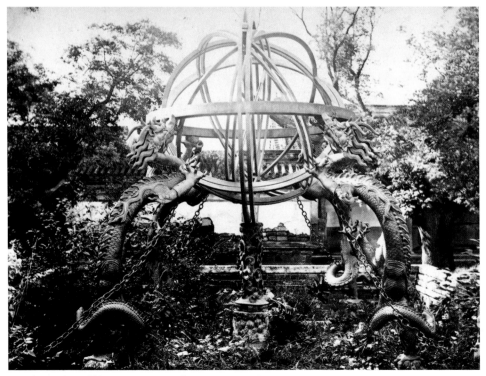

110  An ancient Chinese astronomical instrument, Peking, *c.* 1871–72

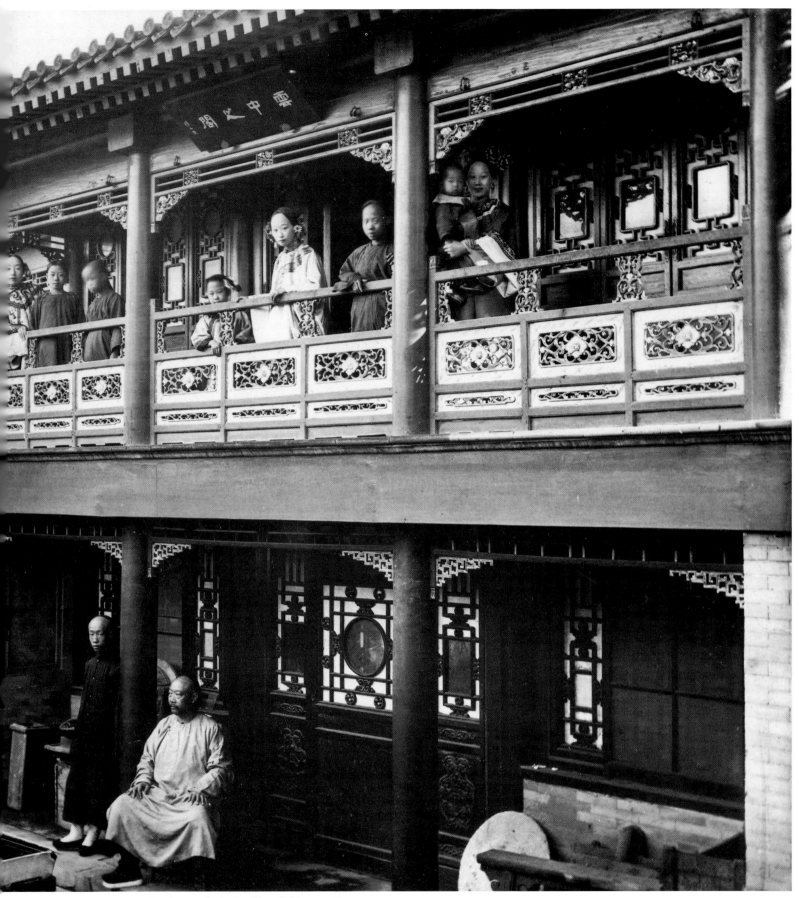

111  Interior (courtyard) of a mandarin dwelling, Peking, *c.* 1871–72

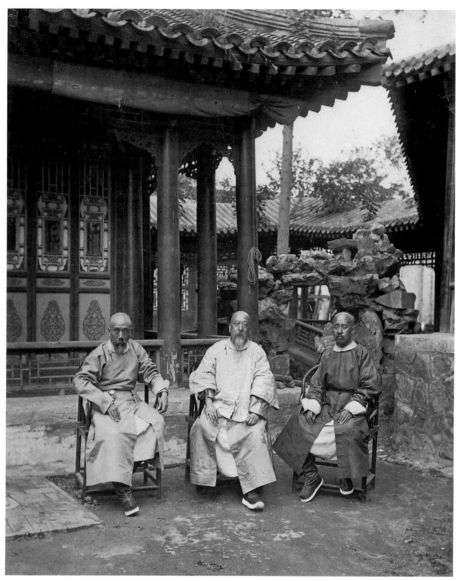

112 Ministers of the Foreign Office, Peking, *c.* 1871–72

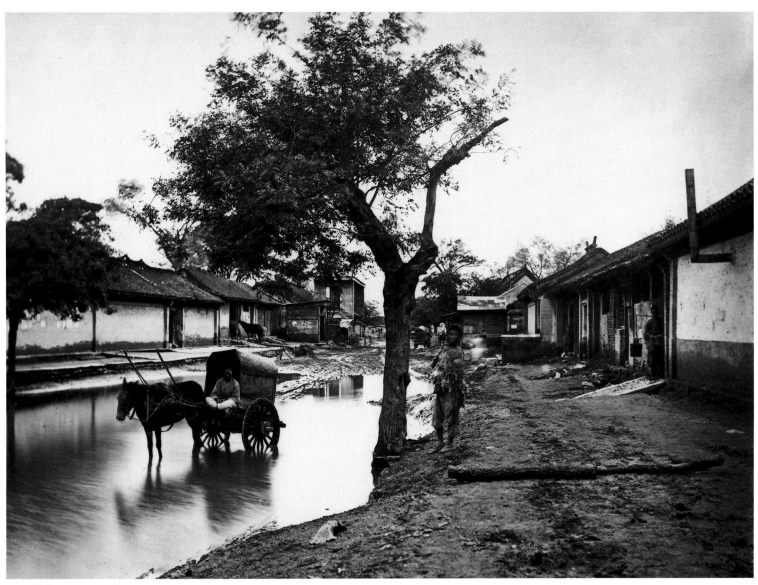

113  Peking on a wet day, *c.* 1871–72

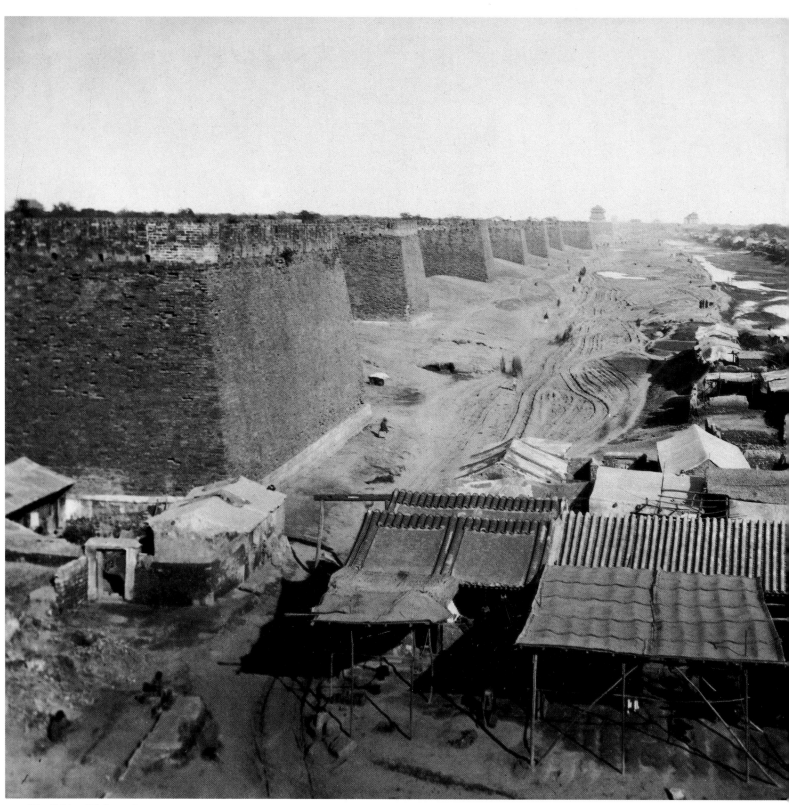

114 The Peking Wall, *c.* 1871–72

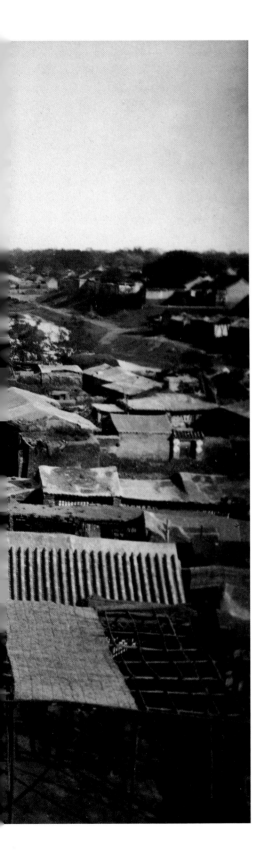

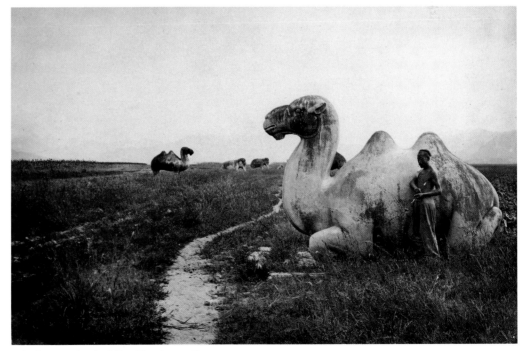

115 Stone animals, Ming Tombs, *c.* 1871–72

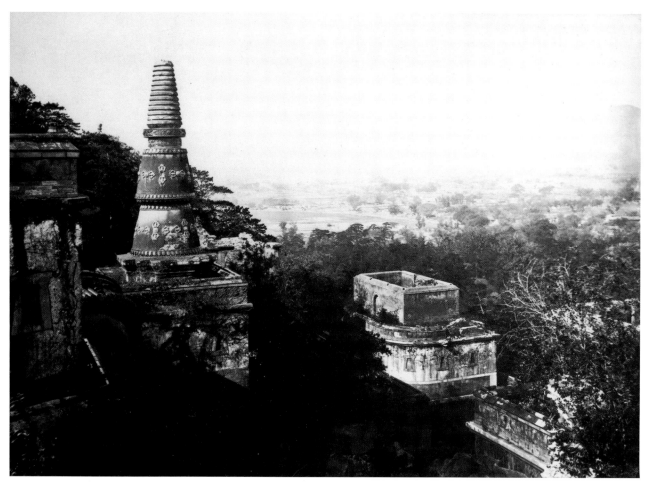

116 At the back of Wan-show-shan, *c.* 1871–72

117 The Sisters' Chapel, Tien-tsin, *c.* 1871–72

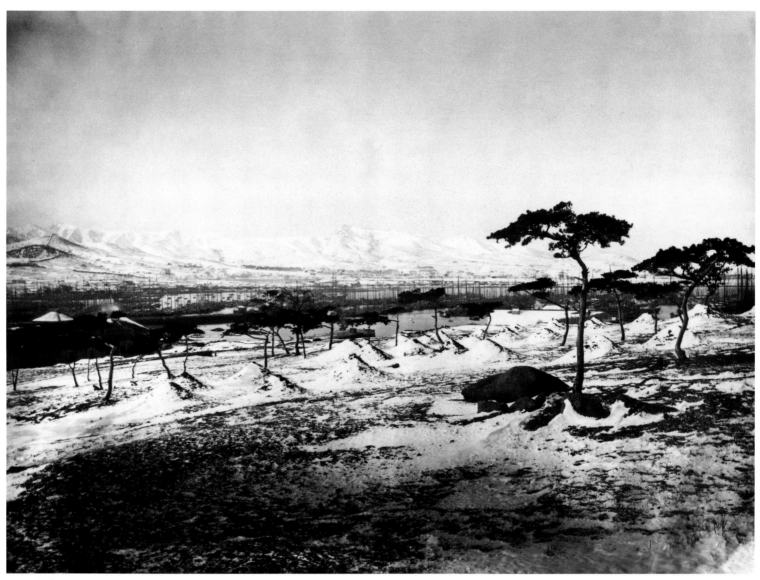

118  Chefoo, *c.* 1871–72

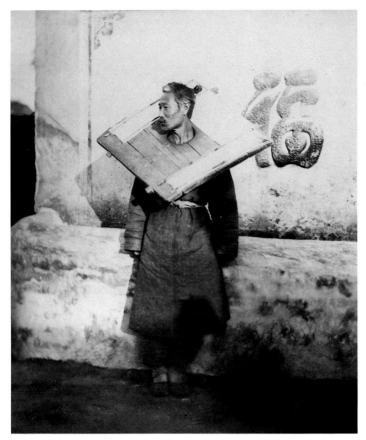

119 The cangue, *c*. 1871–72

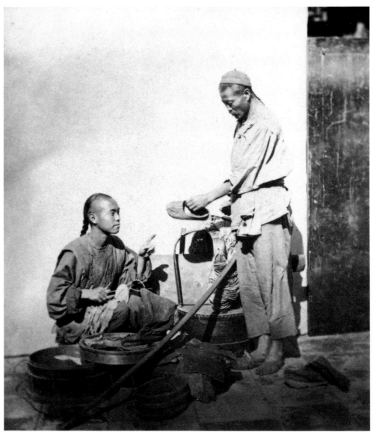

120 The street cobbler, *c*. 1871–72

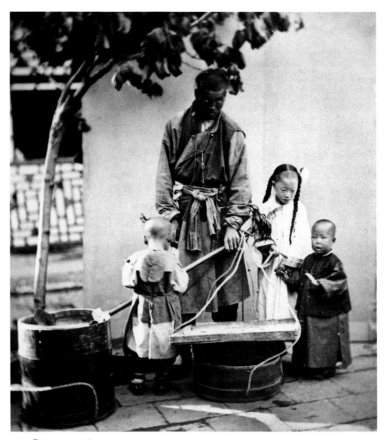

121 Sweets, *c*. 1871–72

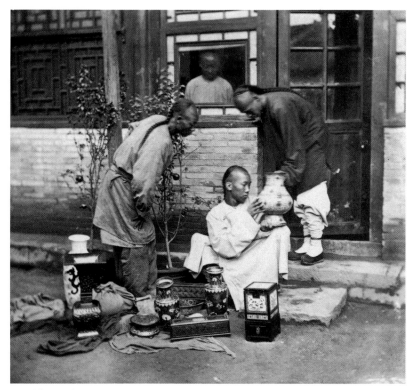

122  The curio man, *c.* 1871–72

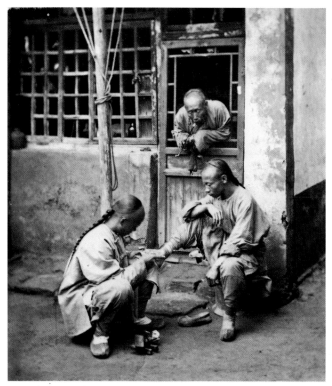

123  The street doctor, *c.* 1871–72

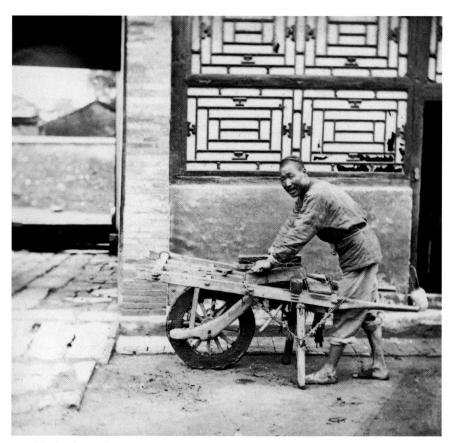

124  The knife-grinder, *c.* 1871–72

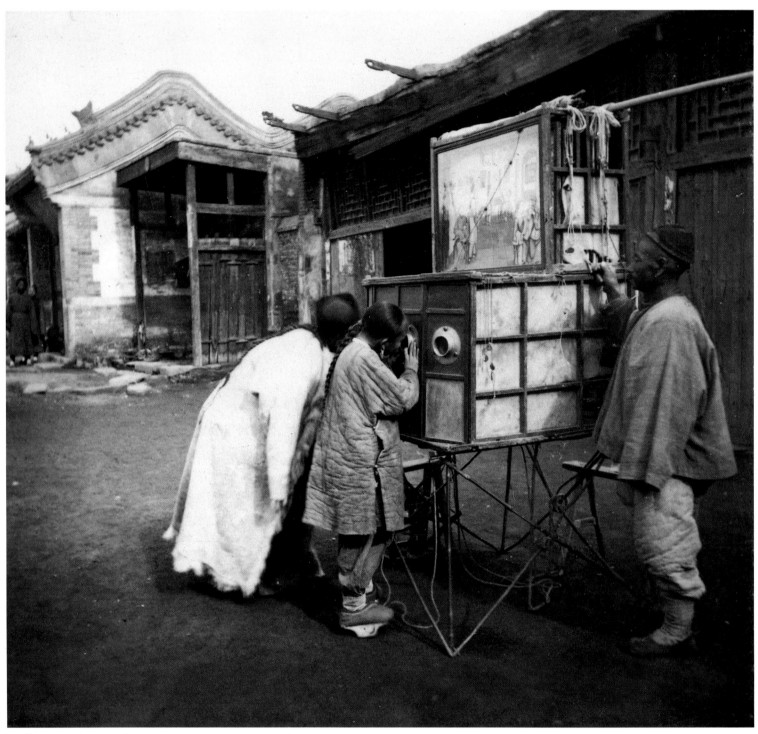

125 The peep-show, *c.* 1871–72

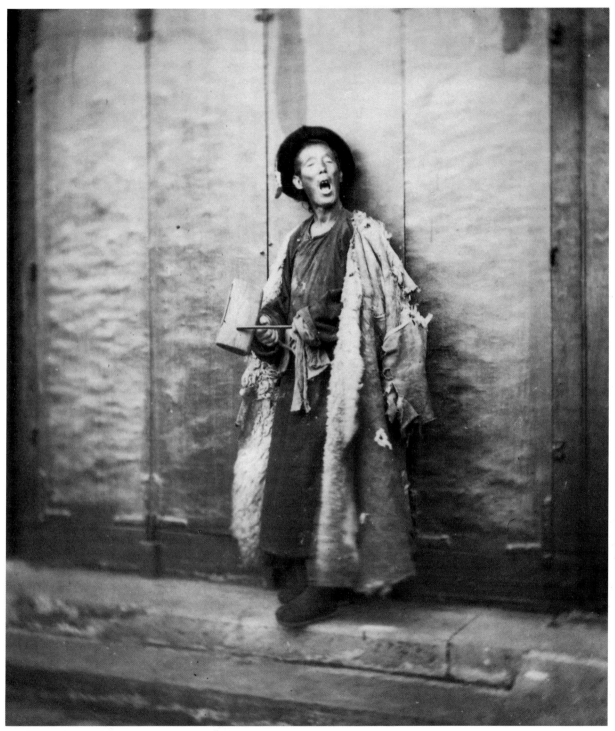

126 The night watchman, *c.* 1871–72

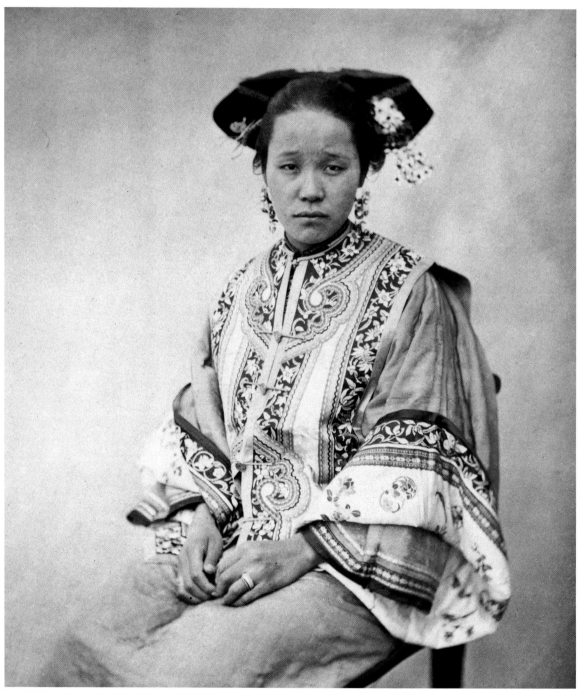

127 Peking woman, *c.* 1871–72

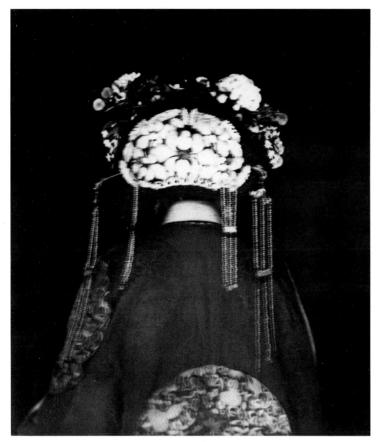

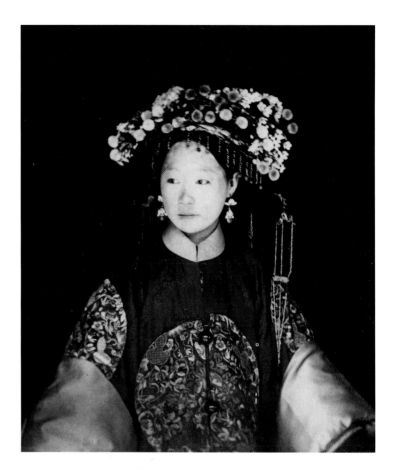

128, 129  A Tartar bride, rear and front view, *c.* 1871–72

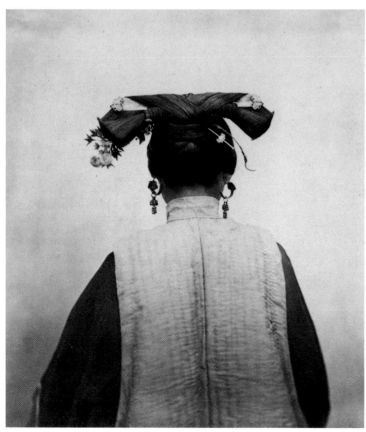

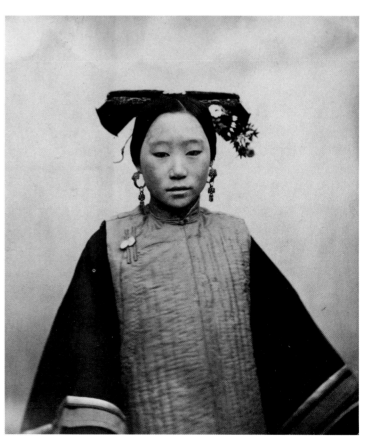

130, 131  Tartar female headdress (front and rear), *c.* 1871–72

132 Memorial tablets, Confucian temple, *c.* 1871–72

133 Interior of a mandarin's house, *c.* 1871–72

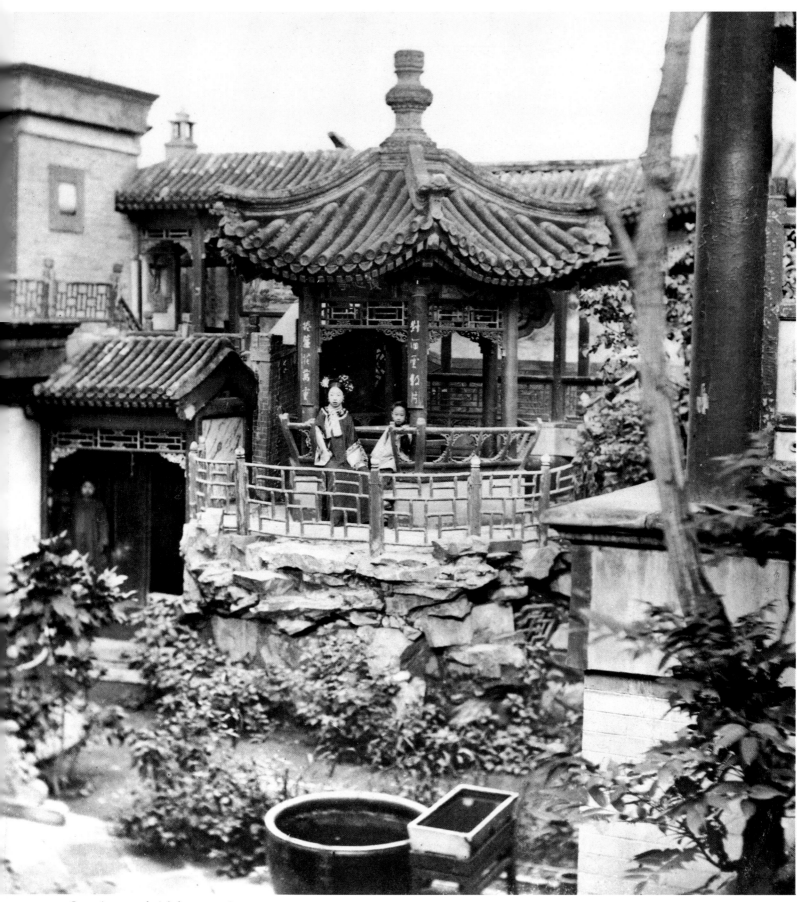

134  Court in a mandarin's house, *c.* 1871–72

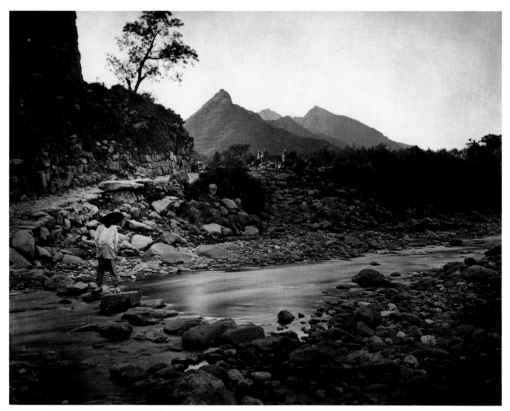

135  Nankow Pass, *c.* 1871–72

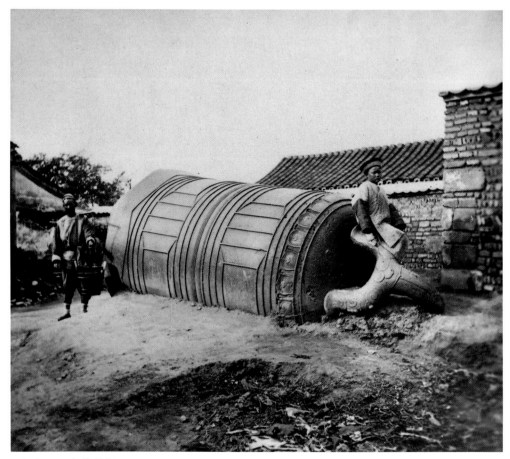

136  A great bell, Peking, *c.* 1871–72

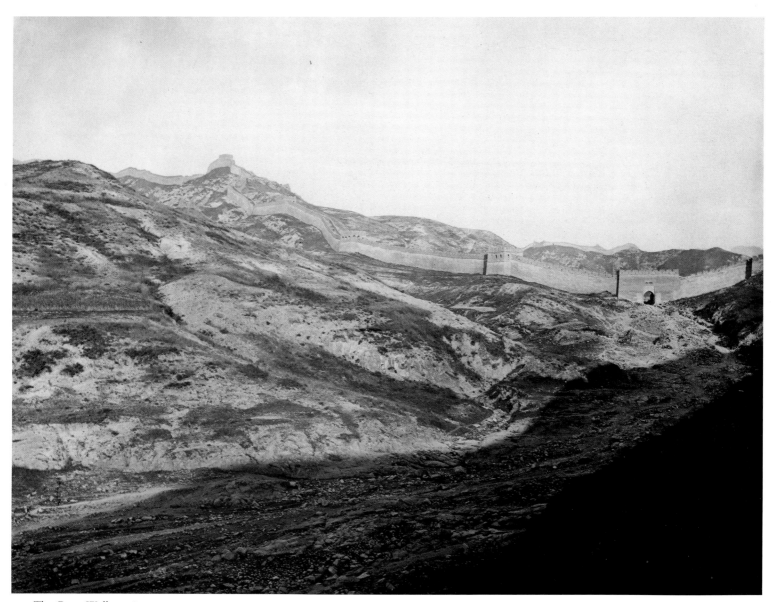

137  The Great Wall, *c.* 1871–72

138  Hatamen Street, Peking, *c.* 1871–72

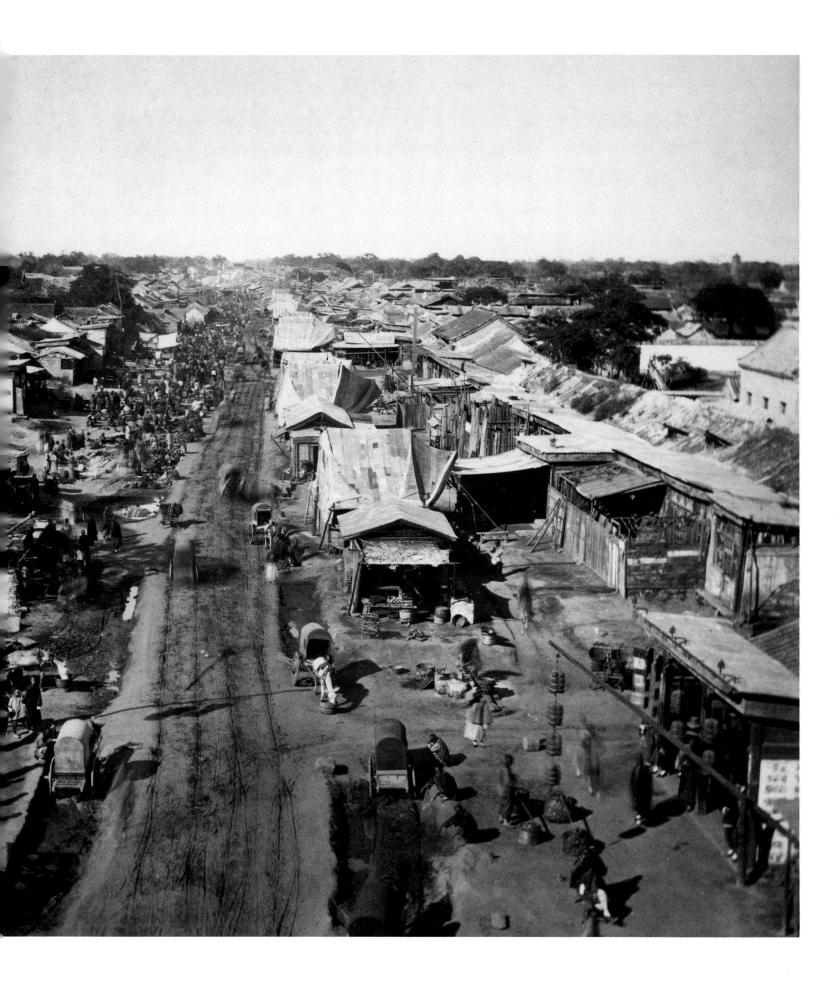

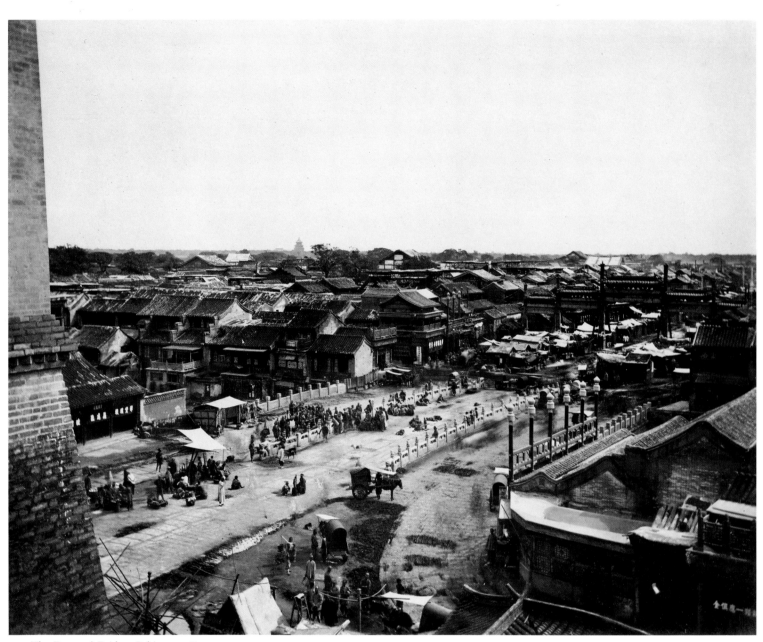

139  The Beggars' Bridge, Peking, *c.* 1870–72

# VI
# STREET LIFE IN
# LONDON

## 1876–1877

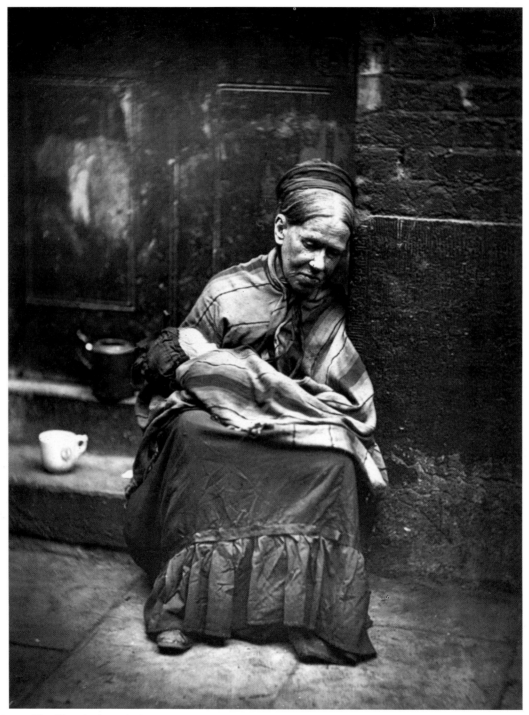

140 The 'Crawlers', c. 1876–77

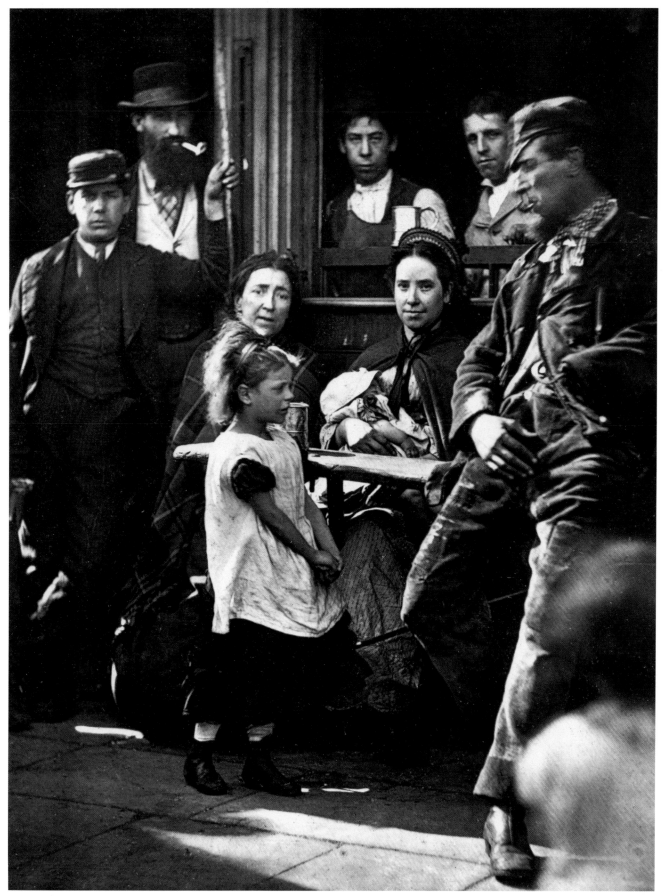

141 'Hookey Alf', of Whitechapel, c. 1876–77

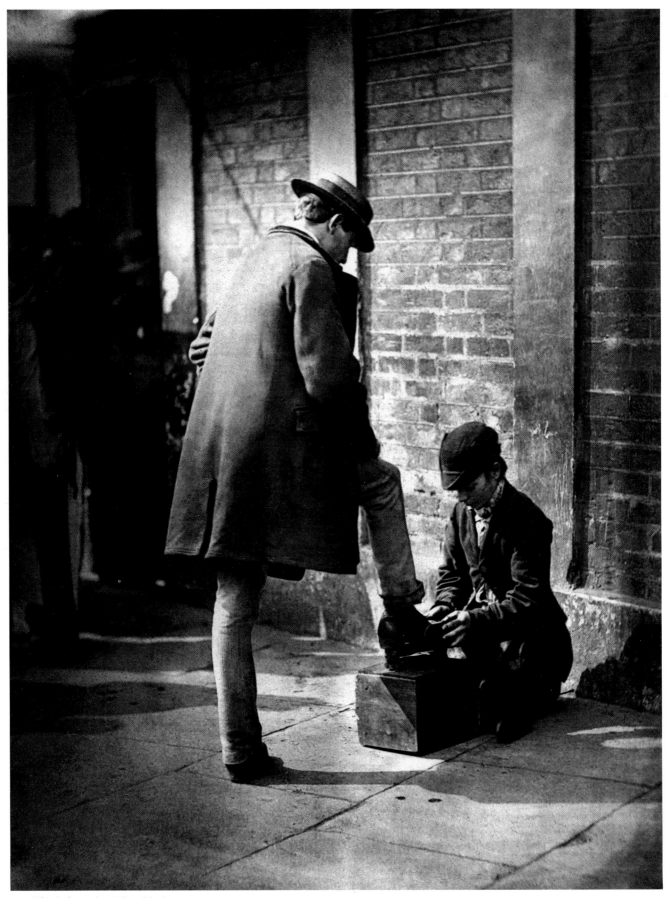

142   The Independent Shoe-black, *c.* 1876–77

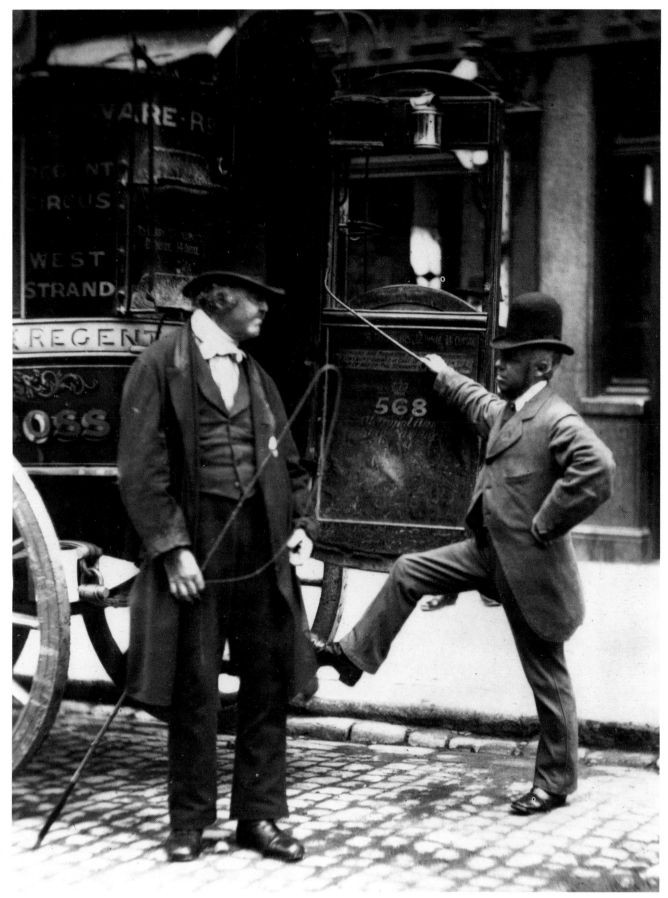

143  Cast-iron Billy, *c.* 1876–77

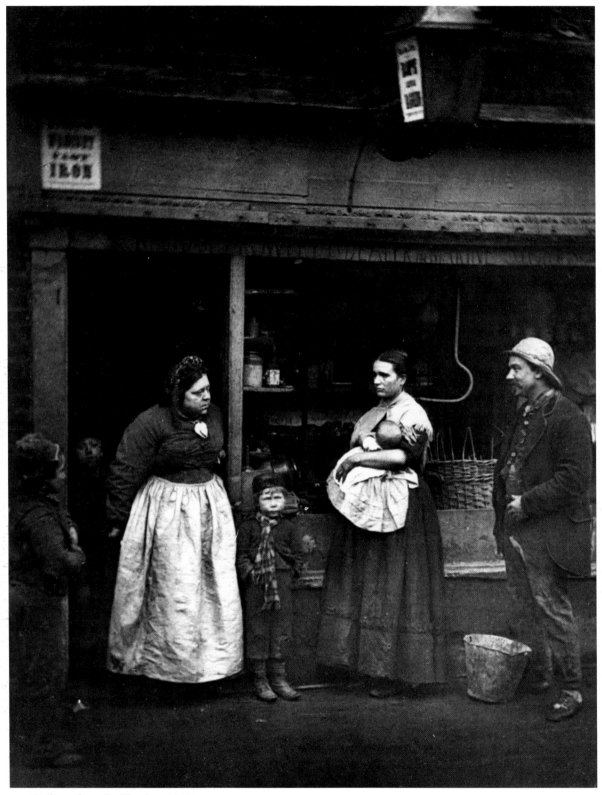

144  Sufferers from the Floods, *c.* 1876–77

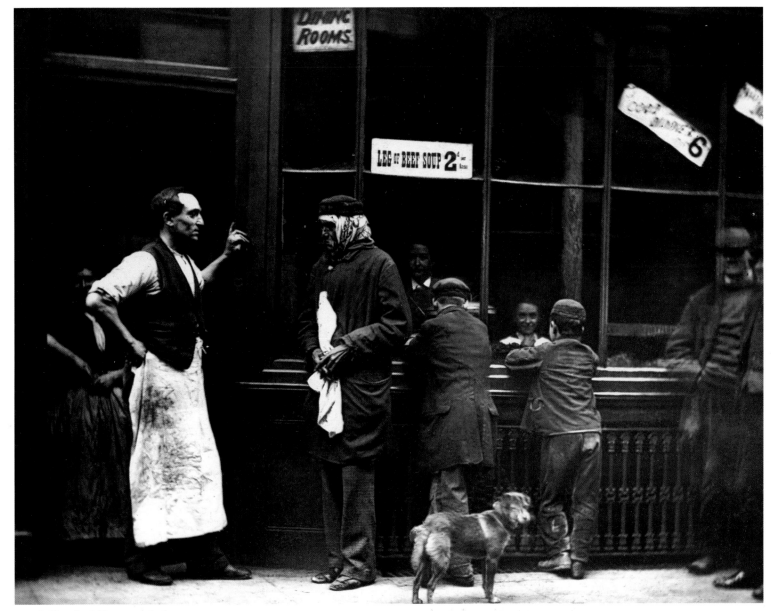

145  A Convicts' Home, *c.* 1876–77

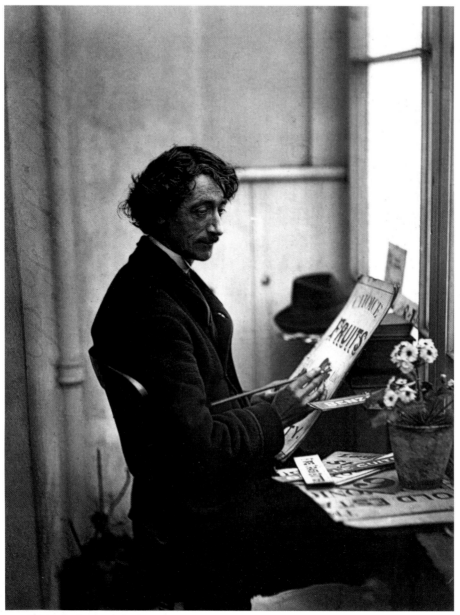

146 'Tickets', the Card-Dealer, 1876–77

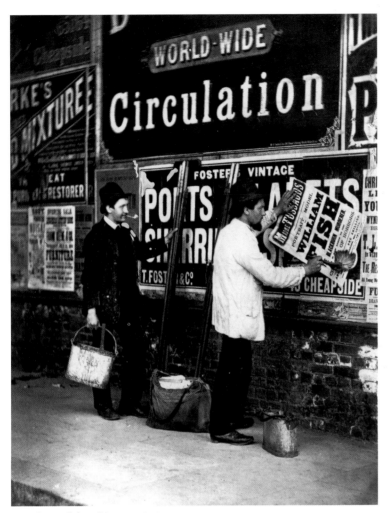

147 Street Advertising, *c.* 1876–77

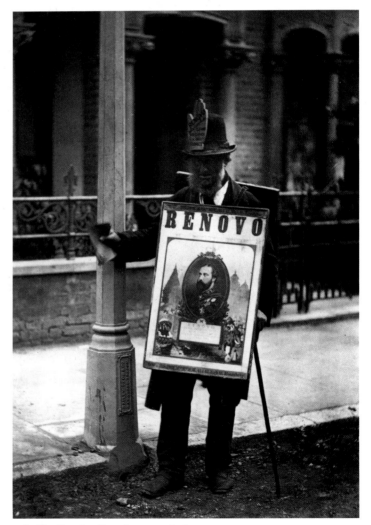

148 The London Boardmen, *c.* 1876–77

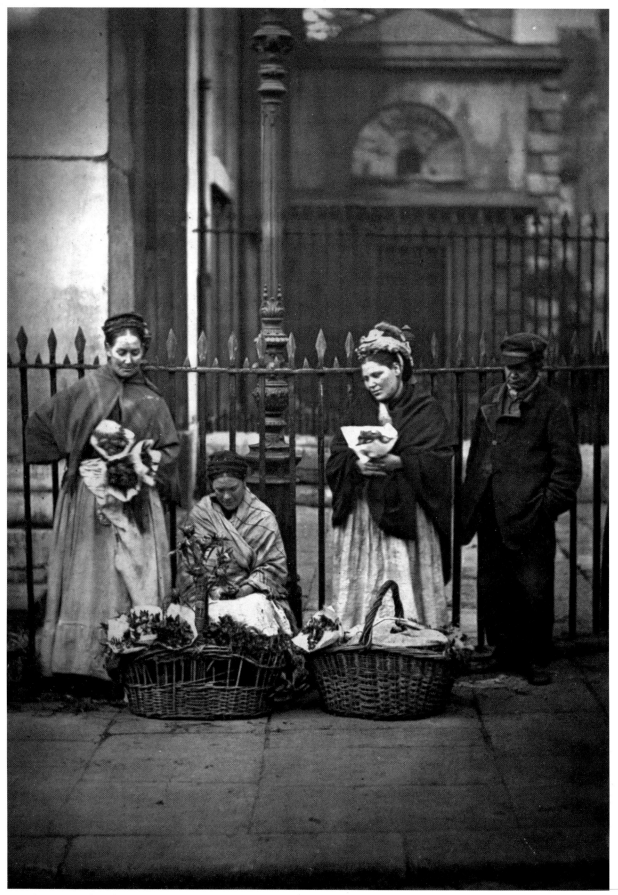

149 Covent Garden Flower Women, *c.* 1876–77

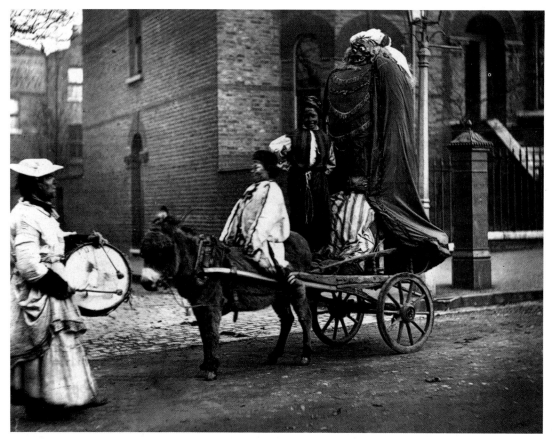

150  November Effigies, *c.* 1876–77

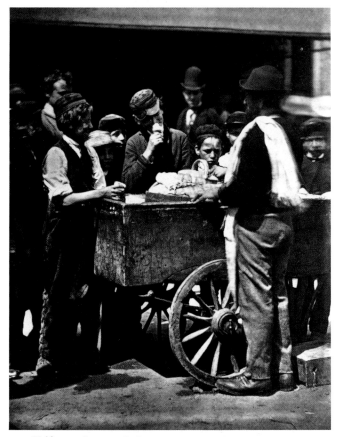

151  Halfpenny Ices, *c.* 1876–77

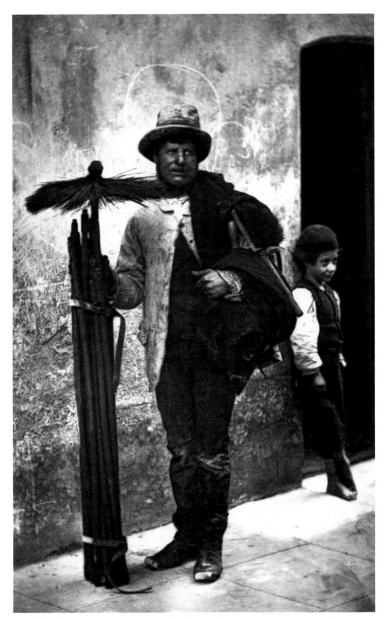

152  The Temperance Sweep, *c.* 1876–77

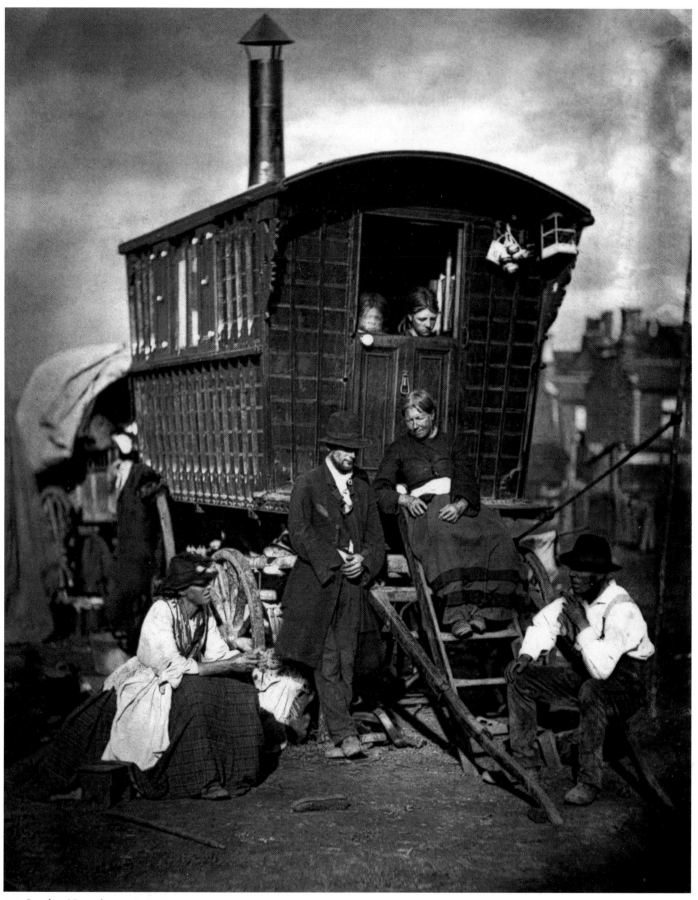

153  London Nomades, *c.* 1876–77

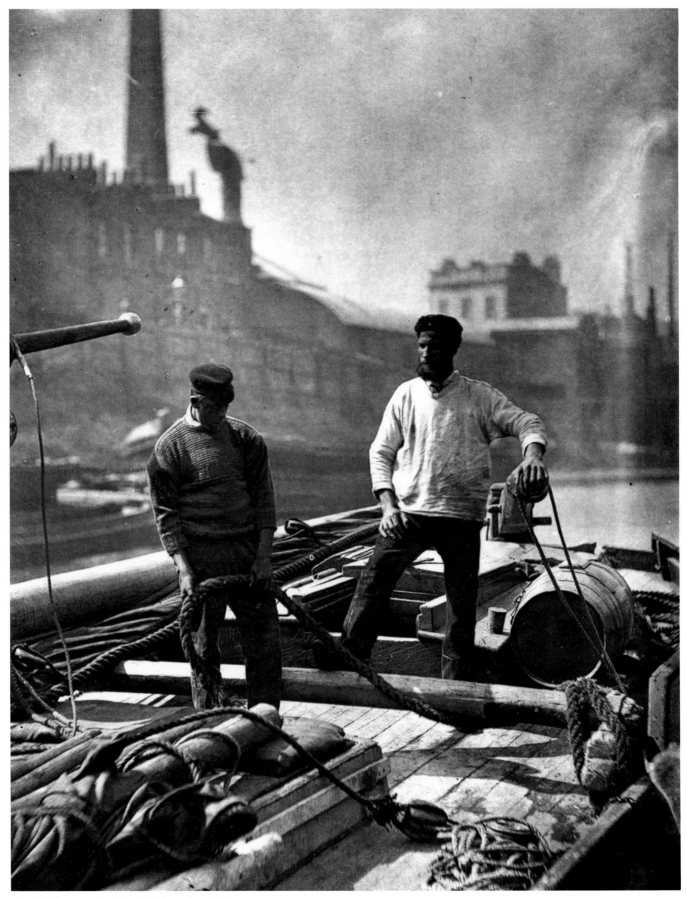

154 Workers on the 'Silent Highway', *c.* 1876–77

# VII
# CYPRUS

## 1878

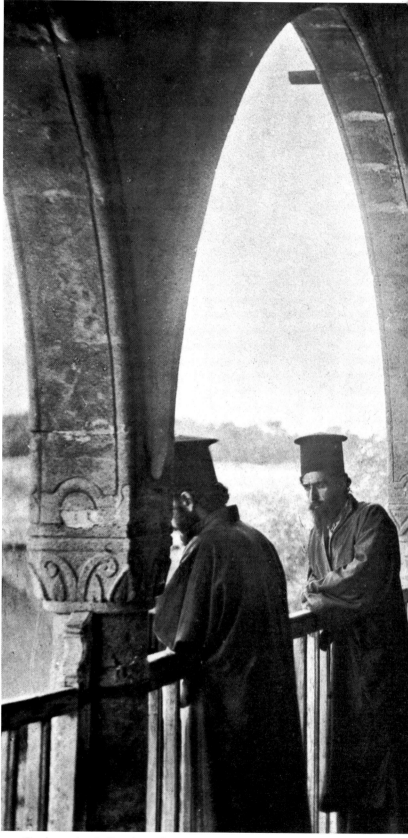

155 Greek monks, St Pantalemoni, 1878

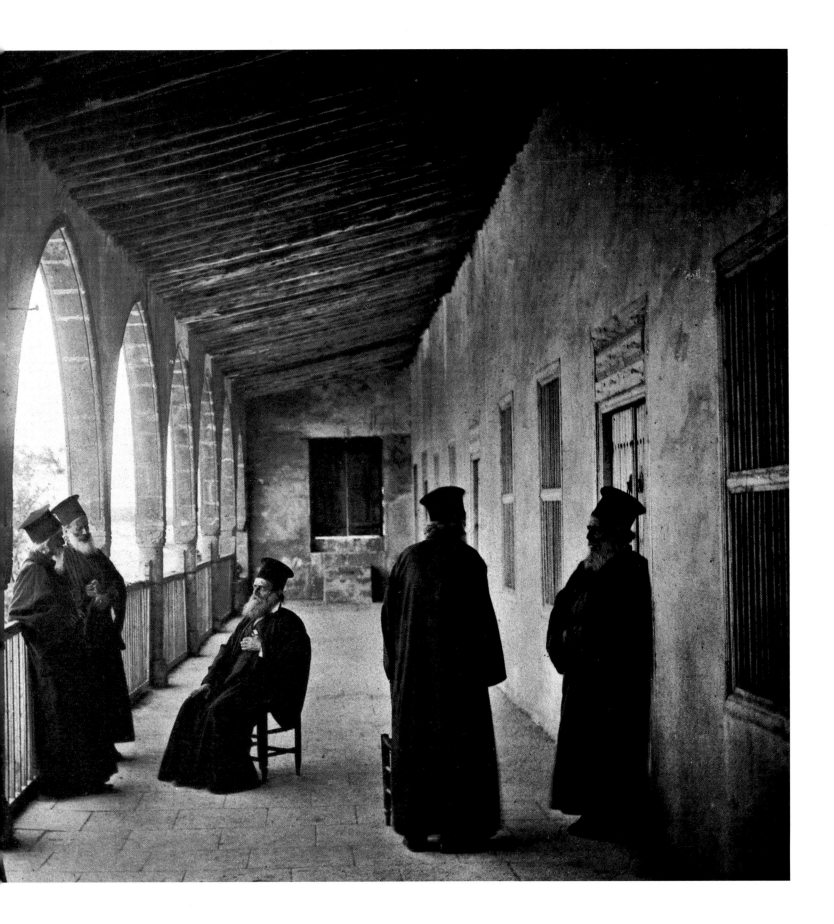

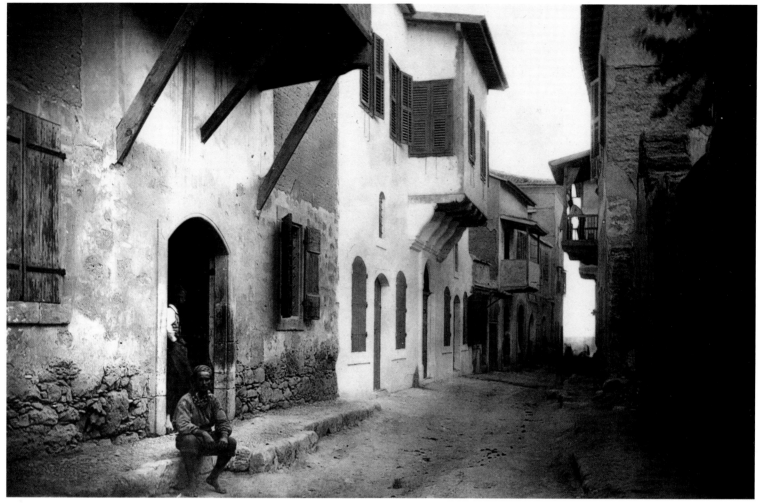

156 A street in Larnaca, 1878

157  A rock-cut tomb, Famagosta, 1878

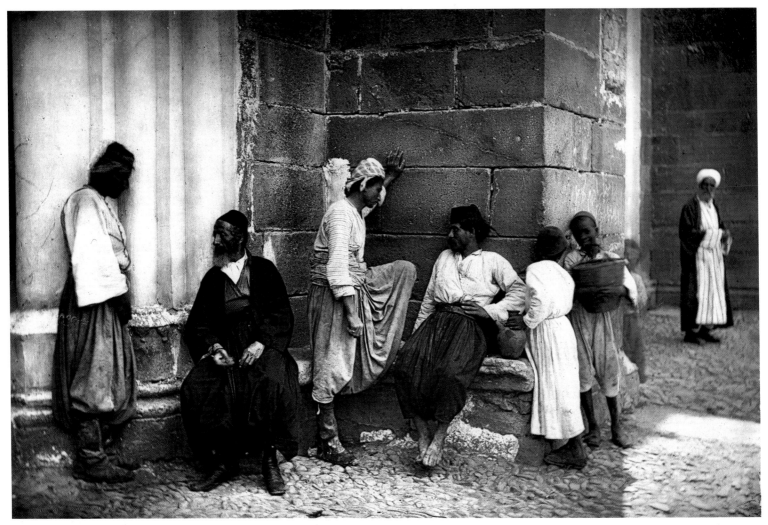

158 Native group, Nicosia, 1878

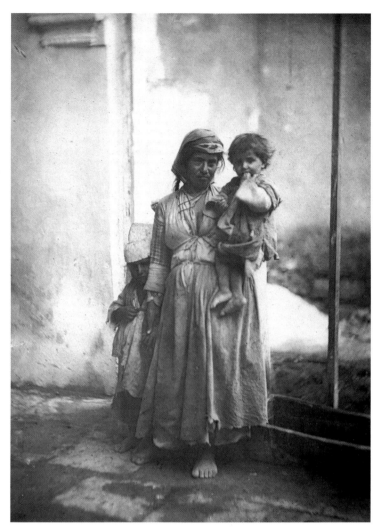

159 Beggars, Cyprus, 1878

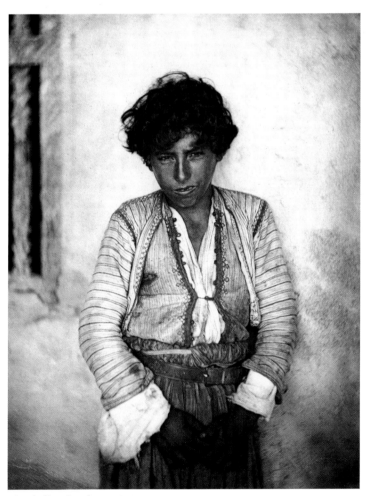

160 A Cypriote boy, 1878

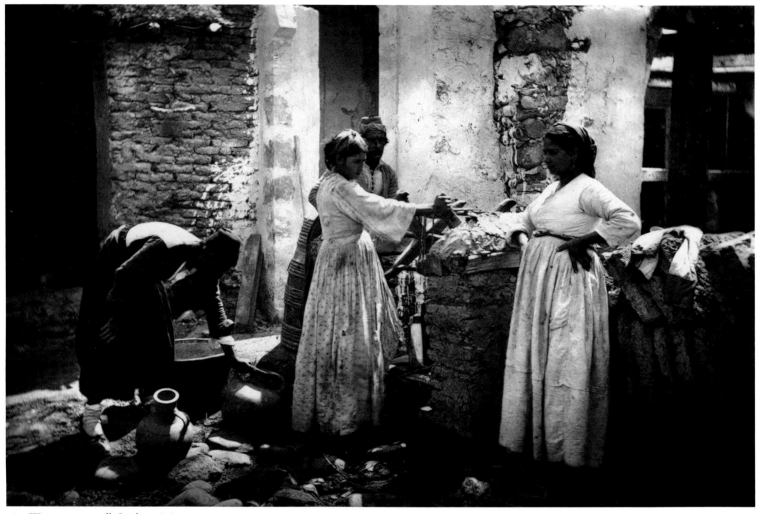

161 Women at a well, Levka, 1878

# NOTES ON THE PLATES

## I PRELUDE 1862–1864

**1** Commercial Square, Singapore, c. 1864. 'In Commercial Square – the business centre of Singapore, where buyers and sellers most do congregate – the visitor will find men of widely different types, and a great variety of nationalities.'

**2** Chinese merchants in Singapore, c. 1864. Thomson wrote with great respect about the Chinese businessman, who flourished outside his own country when he was no longer limited by various customs and government interference.

**3** Annual inundation of 'our garden', Singapore, c. 1864. Thomson had a studio in Singapore. A pictorial photograph such as this would have been made for a friend or as part of an assignment to photograph a European estate for a local resident.

**4** Straits fruits, Singapore, c. 1864. Many of the fruits of the Far East were exotic and unfamiliar to the European. In this photograph Thomson assembled a selection from the Straits of Malacca.

**5** 'Travellers'' palm, Singapore, c. 1864. One of Thomson's earliest attempts to create a circular effect by utilizing the growth around the palm to balance the fan design from underneath. His assistant standing at the foot provided some idea of scale.

**6** Main Street, Penang, c. 1862. This photograph shows one of Thomson's earliest town views taken in Penang, his first home in the Orient. 'During the ten months I spent in Penang and Province Wellesley,' he writes, 'I was chiefly engaged in photography – a congenial, profitable, and instructive occupation, enabling me to gratify my taste for travel and to fill my portfolio . . .'

**7** Cyclone, Calcutta, October, 1864. Thomson made a series of photographs documenting the destruction along the Hoogly River. In the same month he was admitted to the Bengal Photographic Society. He was resident in Singapore at the time of his visit to India.

**8** Province Wellesley, c. 1863. In one of his books Thomson wrote: 'Province Wellesley lies opposite to Penang, on the mainland of the Malayan peninsula. It is about thirty miles long, and from five to eleven miles in breadth. This district is, at present [c. 1863], the most productive in the Straits, exporting annually a very large quantity of sugar, tapioca, and rice.' This is Thomson's only known photograph of the area.

**9** 'Tree ferns', Penang Hill, Penang, c. 1862. One of the few existing photographs showing Thomson's earliest landscape work. Thomson came to Penang in 1862. He wrote, 'the foliage of the island of Penang, like that of the majority of the islands of the Malayan Archipelago, is dense and luxuriant, and remarkable more for its variety of form than for its different shades of green.'

**10** Malay huts, Penang or Singapore, c. 1862–64. Thomson wrote, 'there is a large Malay population on the island [Penang], greater than the Chinese. It is, however, a much more difficult task to point out how they are all occupied, as they do not practise any trades or professions, and there are no merchants among them.'

**11** Dyaks, Borneo, c. 1864. Borneo was directly across the China Sea from Singapore. Thomson possibly visited there on his way to or from the island of Java where his friend Walter Woodbury worked.

**12** Coconut plantation – early morning, Singapore, c. 1864. Thomson wrote in an article on photographing in the Far East: 'In any part of the East where I have travelled, I have generally found the early morning to be the best time for photographic purposes.' This daring photograph using the bright sun among the coconut trees was extremely experimental and ambitious for its time.

**13** Group of Boyamese, Singapore, c. 1864. This example of Thomson's careful posing incorporated the position of the tree as a counterbalance to the position of the men. His later work, beginning with Siam, produced even more subtle positioning of his subjects.

**14** View of the New Harbour, Singapore, c. 1864. The dramatic light on the coconut tree almost obscures Thomson's assistant posed beside it. The diagonal direction of the tree leads our eye into the valley below.

**15** New Harbour, Singapore, c. 1864. This photograph provides an opportunity to see Thomson's developing style, as he rings the two palm trees with growth and centres them, with the sun's rays striking to highlight the focus on his composition.

**16** Children playing in a stream, Singapore, c. 1864. Even in this early photograph Thomson showed strong control over the natural lighting of elements, using the bright sunlight to focus our attention on the children at play while their mother does the laundry in the background.

## II SIAM, CAMBODIA, VIETNAM 1865–1868

**17** Arrival of the King of Siam at the Temple of the Sleeping Idol, 1865–66. Part of the ceremony involving the King's elder son, who became King in the year 1868 upon the death of his father.

**18** King Mongkut of Siam, Bangkok, c. 1865–66. The King allowed Thomson to photograph him both in his royal robes and in this outfit of a Field Marshal that had been given to him by the French. It was his children that the Englishwoman, Anna Leonowens, was hired to educate.

**19** State barge of the King of Siam, c. 1865–66. 'It is the annual custom', wrote Thomson, 'for the King, in the month of November, to visit certain royal temples, and to make offerings to their priests. On these occasions, the monarch may be seen arrayed in all the splendour of his jewelled robes, enthroned in his state barge, and paddled by about a hundred men.' Thomson's photograph captured the boat as it departed. A two-part panorama such as this required extensive preparation.

**20** Presentation of a Prince to the King of Siam, 1865–66. This formed part of the ceremony, during which the heir apparent, Prince Chowfa Chul-along-korn, had the top-knot he had worn throughout his boyhood cut from his head. The ceremony took six full days, and Thomson says it was conducted 'with all the pride, pomp, and circumstance of a sacred Brahminical rite'.

**21** Mount Khrai-lat, Siam, *c*. 1865–66. Thomson wrote: 'within the grounds of the first King's palace there is a large paved quadrangle surrounded by picturesque buildings of an architecture purely Siamese, and shaded, here and there, by the wide-spreading banyan and other umbrageous trees; flowering shrubs adorn this enclosure, and in the centre there had been erected, by the King's command, an artificial hill known as Mount Khrai-lat, and bearing a tiny shrine upon its summit.'

**22** Buddhist priests, Siam, 1865–66. Monks at dinner. 'Each Buddhist monastery,' Thomson wrote, 'is in charge of an abbot or chief priest who receives a small monthly stipend from the government, or noble to whom the establishment belongs.'

**23** Buddhist temple, Siam, *c*. 1865–66. Thomson often used water to balance the elements in his photographs. The lower part of the picture uses the reflection to balance the horizontals, while the standing priest leads the eye upward into a vertical structure dominating the top half of the photograph. The two spires at each end balance the vertical windows, trees, and direction of the roof.

**24** The King's Amazons, Siam, 1865–66. This group of women guarded the King. They also served as guards around the palace and did the bidding of the King or the courts.

**25** Figures in a garden, Siam, 1865–66. This lyrical study of a Siamese family clearly shows Thomson's development from earlier work. The figures are posed so naturally in their environment that they blend with it imperceptibly, whereas Thomson's earlier work created a more stilted impression.

**26** River huts, Siam, 1865–66. Thomson was amazed by the number of residents who lived on the water. 'In Bangkok at least two-thirds of the native population pass their lives in their boats, or else in houses which float on the surface of the river. These floating houses are built upon platforms of bamboo, for the hard durable stems of this useful plant grow to great dimensions in that country, and offer special advantages in the construction of a raft.'

**27** View of Bangkok from the River Menam, 1865–66. Thomson made this two-part panorama of the city from across the river. 'The Menam river of Siam is the great trade route, which, with its endless ramifications of minor streams, canals, and creeks, establishes a network of communication over the vast interior of the country, and with the city of Bangkok, its capital.' About the city he added, 'its highways and its streets are the canals, which are lined with a throng of picturesque shops and houses, all of them afloat on rafts of bamboo moored to the banks.'

**28** River architecture, Siam (attributed), 1865–66. An excellent example of the way in which Thomson used verticals and horizontals in relation to one another to build a visual puzzle. His later architectural work in China is based on strong linear composition – emphasizing the horizontal, vertical or diagonal.

**29** View in Bangkok, *c*. 1865–66. This view of the city with the river in the background uses the bold spire in the foreground to lead the eye in a diagonal direction across the centre of the image.

**30** The Governor of Pandam, Siam, *c*. 1865–66. Thomson often photographed officials as he travelled through the Orient. A portrait was used as a method of gaining permission from a key person to photograph in some forbidden but desired area.

**31** Siamese puppets, *c*. 1865–66. Puppets have long been a popular form of entertainment throughout the Orient.

**32** Lakon dancers, Siam, *c*. 1865–66. Thomson wrote about these dancers who were part of the floating harem of a nobleman: 'The leader of these native musicians was performing a jubilant Siamese air on the "whong kong", a circle of musical bells, supported by the "cluae" (flageolet), and the Laos reed organ, on which the performers kept up a running accompaniment, intermingled with the woody tones of the bamboo harmonican "Ranat".'

**33, 34** Laos man and Laos woman, *c*. 1865. Thomson found the Laotians to be impressive looking people. 'The men were larger and more muscular than the Siamese, while the poorest among them were completely clothed in a dark blue cotton, closely resembling the dress worn by the labourers in some parts of China, and made up of a loose jacket, and trousers falling to two or three inches below the knees. The women, some of them, were of fair complexion and exceedingly pretty, having their long dark tresses coiled up so as to form an ample and picturesque covering for the head.'

**35** A Siamese girl, *c*. 1865–66. Thomson wrote: 'every portrait, so far as the work of the photographer is concerned, should be a work of art'. Thomson brought out both beauty and dignity in this study of a poor Siamese flower-girl.

**36** The King receiving his son, *c*. 1865–66. One of the strongest of Thomson's images of the ceremony surrounding the cutting of the top-knot of hair from the King's eldest son.

**37** Elephant crossing a stream, Siam, *c*. 1865–66. Elephants were a practical form of transportation in the dense jungles. Thomson rode on elephant back for part of the journey to the ruins of ancient Cambodia.

**38** Nakhon Wat, western façade, central section, 1866. Thomson wrote about his first reaction to seeing the temple: 'The view from the stone platform far surpassed my expectations. The vast proportions of the temple filled me with a feeling of profound awe, such as I experienced some years afterwards when sailing beneath the shade of the gigantic precipices of the Upper Yang-tsze.' Thomson was the first photographer to visit the ancient Cambodian ruins. He was as impressed by what he saw as he was disturbed by the environment surrounding it. 'The disappearance of this once splendid civilization', he wrote, 'and the relapse of the people into a primitiveness bordering, in some quarters, on the condition of the lowest animals, seems to prove that man is a retrogressive as well as progressive being . . .'

**39** His Majesty, the King of Cambodia, 1866. Thomson and his travelling companion, Kennedy, went to the capital Penompinh after visiting the Cambodian ruins. 'The King treated us with great

courtesy,' Thomson wrote, 'assigning us a house within the palace grounds, and entertaining us repeatedly at his table, where excellent dinners were specially prepared for us in completely European style. The fact is, his majesty had a French cook in his pay; and this was the secret of a culinary skill which at first took us somewhat by surprise.'

**40** Wall carvings, Cambodian temple, 1866. In an article on photography in the Far East Thomson explained that alcohol mixed into his collodion gave him the flexibility he needed. 'By using a collodion of this kind I have been enabled to develop some of my best photographs of bas-reliefs after exposing the plate for half-an-hour in a dark interior, where the thermometer stood at 98 Fah.; and with the same collodion I have obtained instantaneous effects.'

**41** Nakhon Wat, western façade, right section, 1866. In his description Thomson gave the proportions of the temple: 'It is carried upward from its base in three quadrangular tiers, with a great central tower above all, having an elevation of 180 feet. The outer boundary wall encloses a square space measuring nearly three-fourths of a mile each way, and is surrounded by a ditch 230 feet across.'

**42** Wealthy Chinese merchant's house, New Year's Day, Saigon, *c.* 1868. 'During the Chinese new-year holidays, I had an invitation to the house of one of these traders,' Thomson wrote. 'The place was built in semi-Chinese, semi-European style.'

**43** Saigon, Bureau de Tabac, *c.* 1867. Thomson described the town as follows: 'The town itself has a gay look about it, or had, at least, during the time of my visit; but it has a somewhat straggling appearance.'

**44** Anamese Chief with his young son, *c.* 1867. Thomson wrote an article about this man for *The China Magazine* (see p. 17). 'The subject of the photograph is out for a short evening stroll with his son, a promising youth, who has just tossed away his cigarette and substituted a water-lily with which to have his portrait taken.'

**45** Road to Cholon, *c.* 1867. In one of his most sophisticated studies Thomson combined the mood of an overcast sky with the linear shapes of the road from Saigon to Cholon. The photographer positioned his assistant with his umbrella pointed in a direction that would lead the viewer's eye as Thomson desired.

**46** Chinese merchant and child, Vietnam, *c.* 1867. The hostile expression of the subjects was common among the Chinese, many of whom had a primitive fear of the camera and its powers.

**47** Girl winnowing rice, *c.* 1867. In Vietnam, as in other parts of the Orient, rice was a major crop among the farmers and staple among the local population. Thomson's presentation of a farm girl is dramatized by the position of the sun on her face and the contrast made by her body sharply in focus, and the soft naturalistic background, a style made popular some twenty years later by P.H. Emerson.

**48** Vietnamese man in boat, *c.* 1867. Thomson photographed life along the rivers. Almost every man had a boat. They were 'scooped out of solid logs, and used for friendly visits, marketing, or fishing'.

**49** Vietnamese family on river, Cholon, *c.* 1867. Thomson reported on the river dwellings: 'Here a family of seven may be found domiciled in a hut which measures five feet by seven. The sanitary

arrangements are simple. The structure is elevated on a platform a few feet above the stream, into which all the refuse and garbage is allowed to fall.'

**50** Figures at the well, *c.* 1867. The two vertical figures create a contrast to the diagonal poles used to raise the water. Thomson sought out the elements in each scene that would make it appear natural.

**51** Winnowing rice, *c.* 1867. As in the photograph of the young girl winnowing rice (pl. 47), Thomson has softened the background to allow our eye to focus more clearly on the action in the foreground. The horizontal pole used by the man at work balances the spatial relationships of the people. Thomson composed these scenes much as a painter would, making sure each detail was in place before taking the photograph.

**52** River bridge, Saigon, *c.* 1867. Another of Thomson's achievements, made possible by a shorter exposure-time, was to include clouds in his photographs without making two separate negatives, one to register the earth and one the sky, and printing them together. The single exposure including clouds was still largely unknown in the 1860s. However, 'there are cloudy days occasionally, when a fine sky may be obtained and good photographs taken at any hour.'

**53** Anamite nude with mirror, Cholon, *c.* 1867. This unusual image is the only known semi-nude study by Thomson. Many Vietnam photographs appear to have been taken for personal reasons. They were never published in books, nor did many offer the simple narrative qualities usually preferred by tourists. Many of these images exist in a single print, with no negative known.

**54** Young Vietnamese female, *c.* 1867. One of the most unusual of Thomson's portraits. Thomson used lights and darks to create an almost mystical relationship between the girl and her environment.

**55** Shipping on the Mekong River, *c.* 1867. 'Facing the settlement there is a spacious haven, containing a floating-dock, and a fleet made up of ironclads, steamers of the "Messageries Maritime" line, and other private trading companies, besides many square-rigged ships awaiting cargoes of rice, the chief product of the vast alluvial plains of southern Cochin China.'

**56** Island hut, Annam, *c.* 1867. Thomson often chose a viewpoint that used foilage to circle the central subject of his image. As well as making the composition more interesting visually, it provided a scale of reference in much the same way as did the assistants he placed at the foot of buildings or trees.

**57** A house along the river, *c.* 1867. In this delicate still-life Thomson's mastery of the collodion process is evident. He has created in the foreground a subtle composition of vegetation, palm trees, a boat, and a net, while highlighted by the sun in the background stands the house bathed in soft light. His ability to shorten the exposure time of his photographs gave him great command, and allowed him to produce images with subtle tones that few of his contemporaries could match.

**58** Study of water plants, *c.* 1867. This tranquil scene shows Thomson's mastery of landscape photography. His interest went beyond the aesthetic, however. He collected botanical specimens, and

even had a variant of an *Ornithoptera* he found in Siam named for him. It is known as *O. Thomsonii*.

## III SOUTH CHINA 1868–1870

**59, 60** Street gambling, Canton, *c.* 1868. Photographs such as these would have had to be carefully posed, yet they have a feeling of authenticity. A quality that made Thomson's work so different from that of his contemporaries was his ability to recreate events in a way that made them appear spontaneous and natural, almost as if the subjects were unaware of the presence of the camera.

**61** The Praya, Hong Kong, *c.* 1868. This panoramic view of Hong Kong harbour was 'taken from the front of the Parade ground, and represents the principal business part of the Praya'.

**62** Chinese Street, Hong Kong, prepared for illumination, 1869. A photograph showing the festivities surrounding the visit of the Duke of Edinburgh to Hong Kong in 1869. It was one of the illustrations for a book by the Rev. Beach commemorating the visit.

**63** Physic Street, Canton, *c.* 1869. Thomson wrote: 'Physic Street, or more correctly, Tsiang-Lan-Kiai (our Market Street), as the Chinese term it – is one of the finest streets in Canton, and, with its varied array of brightly coloured sign-boards, presents an appearance no less interesting than picturesque.'

**64** Flower boat, Canton, *c.* 1869. These boats were available for hire for pleasure parties. They got their name from the flowers used for their decoration. They were hired mostly by Europeans.

**65** As we went about Hong Kong, *c.* 1868–69. For a time Thomson operated a studio in the Commercial Bank building in Hong Kong. Part of his income came from making photographs such as this one of a tourist posed in a sedan chair. Thomson had a general disdain for the imperialist mentality. He was also capable of total control over a photograph. Thomson may suggest his sentiments towards the client by including the cat in the photograph, and by placing the sedan bearers' faces in darkness, as if to inform the viewer that the tourist regarded them as non-people.

**66** English Consulate, Canton, *c.* 1869. Though this is the same garden as shown in plate 67, the addition of two strategically placed assistants gives the photograph an entirely different mood.

**67** View from the English Consulate, Canton, *c.* 1869. Thomson described his photograph as follows: 'This photograph is taken from the steps of the row of buildings . . . showing a portion of the garden; and, in the centre, the ruined gable of a palace, occupied about two centuries ago by the son-in-law of the Manchu conquerer. The pagoda is known to the Chinese as the "flowery ornate" Pagoda.'

**68** Macao Passage, Canton, *c.* 1869. The boat on the left of the photograph, moving too fast for Thomson's exposure, gives this image an almost etherial quality.

**69** Two Buddhist priests, Canton, *c.* 1869. It was only rarely that Thomson posed his subject squarely before the camera. He has positioned these priests to make effective use of the sunlight to illuminate their features.

**70** Buddhist monks at chess, Canton, *c.* 1869. This group of priests lived at the Temple of the Five Hundred Gods, which had been rebuilt in 1755. Thomson was received with great courtesy by the Abbot (the man in the centre of the picture). Thomson commented in his books upon the great hospitality he received in the temples of China.

**71** Temple of the Five Hundred Gods, Canton, *c.* 1869. Thomson's stunning photograph of the temple floods it with light, making the figures seem present before our eyes. When Thomson's classic four-volume work on China was published, this image was passed over for another of the same subject which showed the exact details of the temple interior.

**72** Beer and peanut hawker, Hong Kong, *c.* 1868. One in a series of photographs showing street occupations. Studies like these are forerunners of the better-known work Thomson did with the street people of London a decade later.

**73** Deck of a Chinese junk, Hong Kong, *c.* 1868. Thomson wrote: 'I may inform the reader that the accompanying picture of the deck of a junk was one which it cost me some trouble to obtain. I got it under the following circumstances. Two artistic friends and myself were one day pulling about Hongkong harbour in quest of a good subject for a picture, when after having scrambled by the aid of a convenient rope on to the deck of a junk at anchor there, we found the crew busy with a complex machinery of ropes, poles and windlasses, and indeed on the point of making sail. Suddenly they forsook their work, confronted us with angry gestures, and threatened to bar our advance.' Thomson went on to relate that the matter was then referred to higher authorities. After some debate Thomson was allowed to make his photograph.

**74** Chinese musician, Hong Kong, *c.* 1868. Thomson made a number of photographs in each place he stayed showing the various methods of earning a living, and the life of the local residents. These small *carte de visite*-size images were popular items for tourists to purchase.

**75** Family group, Canton, *c.* 1869. In every composition Thomson made he attempted to achieve a unity. Even with poor families such as this one, his photograph achieved the naturalness necessary to help us see them as individuals.

**76** Suburban residents, Canton, *c.* 1869. Thomson commented on the poverty he photographed: 'I remember one hut which had been pieced together out of the fragments of an old boat, bits of foreign packing-cases inscribed with trade-marks that betrayed their chequered history, patches of decayed matting, clay, mud and straw; a covering of odd tiles and broken pottery made all snug within. In the small space thus enclosed, accommodation was found for a lean pig that lived on garbage, two old women, one old man, the old man's daughter and the daughter's child. A small piece in front was arranged as the kitchen, while part of the roof and one or two pots were taken up with vegetables or flowers.'

**77** View from the Kwan Yin Cave, North River, *c.* 1870. Thomson's book on the North River appeared in Hong Kong in 1870. In the introduction Thomson apologized for the poor print-quality, saying that 'with a few exceptions, the efforts to obtain bright photographs of distant objects were baffled by a continuance of bad weather . . .'

## IV FOOCHOW AND THE RIVER MIN 1870–1871

**78** Pagoda Island, *c.* 1870–71. Thomson described the harbour at Foochow in one of his books: 'The harbour is about thirty miles from the mouth of the river [Min], and is wide enough to contain the entire merchant fleet of China. This spot is called "Pagoda Anchorage", and takes that name from a small island crowned with an old pagoda, which forms a conspicuous object in the landscape.'

**79** The Banker's Glen, *c.* 1870–71. Making positive use of the limitations of black and white, showing a mastery of natural lighting and contrast, Thomson has brought to life the flowers in the glen by using the sun to illuminate their glow.

**80** The Island Pagoda, *c.* 1870–71. 'Among the other temples in the neighbourhood of Foochow one of the most striking is "The Island Temple", which covers the entire surface of a small islet about eight miles from the city. This shrine is dedicated to the "Queen of Heaven", a deity worshipped by the boating population on the river Min.'

**81** The Altar of Heaven, *c.* 1870–71. 'In the City of Foochow,' Thomson wrote, 'on the southern side of the wall enclosure, are two hills, one known as Wu-shih-shan and the other as Kui-shen-shan, or the "Hill of the Nine Genii". On the top of the former there is an open altar – a simple erection of rude unhewn stone, approached first by a flight of eighteen steps, and finally by three steps, cut into the face of the rock.' Thomson noted that the outdoor altar was considered among the most sacred of all Chinese religious structures.

**82** Ku-shan monastery, *c.* 1870–71. '"Ku-shan", or "Drum Mountain", stands about seven miles below Foochow, and forms part of a range that rises abruptly out of the level, cultivated plain. The mountain enjoys a wide celebrity, as the great "Ku-shan" monastery is built in a valley near its summit, on a site said in ancient times to have been the haunt of poisonous snakes or dragons, able to diffuse pestilence, raise up storms, or blight the harvest crops.'

**83** Buddhist monks, *c.* 1870–71. 'The establishment (Ku-shan) though repeatedly destroyed, has been constantly rebuilt on its original foundations,' Thomson wrote, 'receiving considerable additions from time to time, until at the present day it accommodates 200 monks.'

**84** Yuan-fu rapid, *c.* 1870–71. When Thomson wanted to photograph nature, he used an assistant to give scale and depth, but never placed him in a way that would disrupt the scene.

**85** Yuan-fu monastery, *c.* 1870–71. This monastery was high in the mountains far up the River Min. Thomson wrote about his first impression of it: 'As we ascended a narrow path cut in the face of the rocks, we obtained a full view of the monastery, perched upon a huge boulder above our heads, and overshadowed by a grove of stalactites which hung down like pointed ornaments from the vaults of some cathedral roof. Never had I seen, nor even dreamt of seeing, any edifice so strange as this.'

**86** Mountains of Yuan-fu branch of the Min, *c.* 1870–71. The gentle slopes of the mountains, the curve of the river, all bring the photograph together in a way Thomson had in mind when he wrote: 'my share in the composition is very small indeed; I have only

permitted nature to do what she is always willing to do, if photographers do not stand in her way'.

**87** The Upper Bridge, Foochow, *c.* 1870–71. The power of this celebrated image is due to Thomson's bold composition, taking a section of the bridge with the spectators viewing his photographic work from above, and beneath the bridge a view of the harbour area. This unorthodox document could only have been attempted by an imaginative and highly skilled photographer. While Thomson published it in his album *Foochow and the River Min*, it appears nowhere else in his publications.

**88** Lepers, Foochow, 1871. Thomson visited the leper colony near the city on 25 February 1871. 'This little settlement numbered something over 300 souls, and had once contained a theatre for the amusement of its inhabitants, but that edifice had long fallen into decay. The streets, however, looked wonderfully clean, and the houses, many of them, partook of the same charm.' Despite this, Thomson found the experience painful, as he was 'surrounded by a crowd of men, women, and children, some too loathsome to bear description, and all clamouring for alms to buy food to sustain their miserable lives.'

**89** Beggars, Foochow, *c.* 1870–71. These beggars lived in a place where Chinese bodies were stored until fees were paid and conditions right for interment. 'I found them dwelling', Thomson wrote, 'with many others, in a Chinese city of the dead . . .' After talking with several of them he concluded, 'All of them, in truth, were dead to such of the finer feelings as usually have their home in a Chinaman's heart.'

**90** Coolies, Foochow, *c.* 1870–71. Thomson described the Chinese coolie as, 'a very humble character. Poor as he is, nevertheless he is cheerful and contented, industrious and easily managed; he has a smattering of education too; although he has not dipped into the classical lore of his country, he has a knowledge of the elementary characters of the language, which enables him to feast his mind on street literature, and revel in the simple books of folklore that are to be found in Chinese cities.'

**91** Beggars, Foochow, *c.* 1870–71. Beggars were of various classes in China. The man in the far right is a 'Beggar King'. Thomson explained his role: 'In Foochow the city is divided into wards, and within the limits of each ward a head man is appointed, who can count his descent from a line of illustrious beggars, and in him rests the right, which would seem to be, to keep the members of his order under his own management and control.'

**92** Foochow city, *c.* 1870–71. Thomson wrote that Foochow stood out among all of the open ports as 'perhaps the most picturesque, and its stone bridge of "ten thousand ages" proves that the ancient Chinese, had they so chosen, might have left monuments behind them more worthy of their civilization and prowess than their great unwieldy wall . . .'

**93** A rapid boat, *c.* 1870–71. Thomson had great respect for those who made their livings on rapid boats such as the one on which he travelled. 'When I watched the coolness, pluck, and daring, with which these poor river navigators will shoot the rapids of the river Min, risking their lives in every voyage – in a country where there are no insurances, except such as the guilds may chance to afford, and

where no higher reward is to be gained than a hand-to-mouth subsistence on the most wretched fare – I began to get a truer insight into the manly and hardy qualities latent in this mis-governed Chinese race.'

**94** Rocks in the rapids, *c*. 1870–71. The enormous rocks to the left descend at an angle to the mountain sloping from the right side of the picture. To help our eye find the natural balance, Thomson has placed his assistant at the top of the rocks with a pole positioned to smooth and assist the descent of our eye down the rocks.

**95** Rocks and foliage, River Min, *c*. 1870–71. The majestic scenery of the Min provided Thomson with some of his best opportunities for landscape work.

**96** Fishing with cormorants, River Min, *c*. 1870–71. 'As we passed down stream,' Thomson related, 'we saw great numbers of men fishing with cormorants. These fishermen poled themselves about on bamboo-rafts, and on each raft was a basket, and two or three cormorants trained to dive and bring up fish for their owners.'

**97, 98** A reach of the Min, *c*. 1870–71. Thomson wrote: 'Between the many rapids great masses of rock rose up in bold headlands, covered above with waving plumes of tall flowering grasses, and draped with a profusion of foliage that reached right down to the shore, and was there reflected in the placid pools.' In plate 97, though using similar subject-matter to plate 98, rocks along the shore of the Min, Thomson created an entirely different mood. No longer is the strength of the rocks the predominant element; they become dwarfed by the natural beauty of the landscape, as does the man sitting on a rock observing the view. It may have been this scene Thomson wanted to describe when he wrote: 'Beyond the banks we see hills, dales, and giant rocks mingled together in grand disorder, clothed with dark pines and other trees, and wearing rich autumnal tints.'

**99** A rustic bridge, *c*. 1870–71. Bridges were of particular interest to Thomson, and he photographed many of them in various parts of China.

**100** A pine raft, River Min, *c*. 1870–71. This was one of Thomson's supremely successful China photographs, a combination of natural elements photographed from a viewpoint and an angle that gave the image an almost futuristic appearance. Many of Thomson's most powerful photographs have never before been published. *A pine raft* was only used in *Foochow and the River Min*, a book with extremely limited circulation.

**101** Landscape, Formosa, *c*. 1871. Thomson wrote extensively about the variety of flora, and the beauty of the island. The island was named by the Portuguese, who called it Isla Formosa, or 'beautiful island'.

**102** Fishing with nets, Formosa, 1871. Thomson's brilliant choice of angle here displays the diagonal of the wave line, the three fishermen lined up in the same diagonal way, and a counterbalance.

**103** Right bank of Lakoli River, Formosa, *c*. 1871. As he often did, Thomson uses a reflection – in this case the reflection of the mountains in the river – to balance the elements of his photograph.

**104** Mountain pass in the island of Formosa, *c*. 1871. It may have been this scene that caused Thomson's frustration when he wrote the

following words: 'Here we halted awhile to admire the intense loveliness of the mountain gorge, and to obtain a photograph of the scene, regretting all the time that the picture on glass would, after all, give us but the bare light and shade, with none of the varied tints of the hoary bearded rocks, their mossy nooks and crannies, the colours of the pendant climbing plants, or the play of the bright sunshine through the canopy of leaves, and among the dark rocky masses beneath.'

**105** Mode of carrying children, *c*. 1871. The Pepohoans were a friendly tribe living in the villages outside Taiwan. Thomson photographed a mother using the typical method of transporting her infant.

**106** Pepohoan women, *c*. 1871. 'The women, however, show a more independent spirit, and adhere to their ancestral attire, one that closely resembles in its style the dress of the Laos women whom I have seen in different parts of Cambodia and Siam.'

## V PEKING AND THE NORTH 1871–1872

**107** The Marble Bridge, Peking, *c*. 1871–2. The white marble bridge spanning the city moat was one of many connecting the various sections of Peking.

**108** Prince Kung, Peking, *c*. 1871–72. The Prince was the sixth son of the late Emperor Tao Kwang. He was uncle to the present Emperor. Thomson described him as follows: 'Quick of apprehension, open to advice, and comparatively liberal in his views, he is the acknowledged leader of that small division among Chinese politicians who are known as the party of progress.'

**109** The Peking Observatory, *c*. 1871–72. 'The Observatory', Thomson wrote, 'has been set up on the wall on the eastern side of the Tartar city. Here, in addition to the colossal astronomical instruments erected by the Jesuit missionaries in the seventeenth century, we find two other instruments in a court below, which the Chinese made for themselves towards the close of the thirteenth century, when the Yuen dynasty was on the throne.'

**110** An ancient Chinese astronomical instrument, Peking, *c*. 1871–72. Thomson wrote of the ancient instruments: 'The old Chinese astronomical instruments, although constructed with an amazing degree of skill and exactness, would now be perfectly useless; for the mode of taking astronomical observations at that time was widely different from the system in use at present, besides which the circles are inaccurately divided.'

**111** Interior (courtyard) of a mandarin dwelling, Peking, *c*. 1871–72. Thomson had met a Mr Yang, a wealthy gentleman and amateur photographer: 'Here I was, then, admitted at last into the sacred precincts of the mysterious Chinese dwelling. Its proprietor was an amateur, not merely of photography, but of chemistry and electricity, too.'

**112** Ministers of the Foreign Office, Peking, *c*. 1871–72. These three men were supporters of Prince Kung, who presided over the foreign council. Shen-kwe-fen (left) was known for his efforts to suppress opium, Tung-sean, centre, was an author, scholar, and President of the Board of Finance, and Maou-cheng-he (right) was President of the Board of Works.

**113** Peking on a wet day, *c.* 1871–72. 'Next to the shops, the footpaths in front of them are perhaps most curious to a foreigner,' Thomson observed. 'In these paths, after a shower of rain, many pools occur – pools which it is impossible to cross except by wading, unless one cares to imitate an old Pekingese lady, who carried two bricks with her wherever she went, to pave her way over the puddles.'

**114** The Peking Wall, *c.* 1871–72. This photograph shows part of the city wall. Thomson states that, 'In the plan of the city of Peking there is every evidence of careful design, and this has been carried out minutely, from the central buildings of the palace to the outermost wall of fortification.'

**115** Stone animals, Ming Tombs, *c.* 1871–72. The Ming Tombs, some thirty miles north of Peking, are the burial ground of thirteen Emperors from the Ming dynasty, famed for the stone animals and warriors guarding the approach.

**116** At the back of Wan-show-shan, *c.* 1871–72. This great temple remained intact after the destruction of the Summer Palace of the Emperor by Allied forces during the Taiping Rebellion. The Summer Palace complex originally contained over two hundred buildings, many of porcelain and marble. Most of these were destroyed at the command of Lord Elgin in October, 1860, because of Chinese refusal to honour treaty obligations.

**117** The Sisters' Chapel, Tien-tsin, *c.* 1871–72. Scene of a massacre that took place in 1870, when several of the Sisters of Mercy who ran a hospital there were murdered in an attack by a mob. Thomson explained: 'This feeling [against foreigners] was without doubt greatly intensified by horrible stories, most ingeniously spread abroad by the literary members of society, describing how foreigners manufacture medicines from the eyes and hearts of Chinese children, or even of adults.'

**118** Chefoo, *c.* 1871–72. Thomson commented on the conditions surrounding the taking of his photographs at Chefoo: 'When I executed the illustration which I introduce to my readers I was standing in eighteen inches of snow drift. The thermometer being very low, I should say near zero Farenheit, I had engaged a group of coolies to hold my dark room down, for the wind threatened every moment to hurl it off its legs. When washing the plate free from cyanide of potassium the water froze on its surface, and hung in icicles around its edges, so that in order to save the picture I was forced to take it to a neighbouring native house, and there to thaw the ice above a fire.'

**119** The cangue, *c.* 1871–72. 'The cangue,' Thomson wrote, 'or collar of wood, is one of the lightest punishments of China, inflicted for minor offences, such as petty theft. The nature of the crime, as well as the name and residence of the delinquent, if he has any, are inscribed in prominent characters on cards, and fixed to the cangue. The wearer is usually located in front of the house or shop where the offence was committed, and is forced to depend for food on the charity of passers-by, as the imposing dimensions of the wooden encumbrance prevent him feeding himself.'

**120** The street cobbler, *c.* 1871–72. It was in Peking that Thomson made his most impressive group of photographs depicting various tradesmen and town characters.

**121** Sweets, *c.* 1871–72. As in most large cities, much trade was done on the streets of Peking.

**122** The curio man, *c.* 1871–72. 'The curiosity-mongers spread out before me sundry specimens of old China, and a variety of articles such as those shown, and for all these they demanded the most extortionate prices. However they seemed by no means anxious to sell their goods. I had been warned beforehand to be careful in my dealings with these gentlemen, but after all I was more than once taken in.'

**123** The street doctor, *c.* 1871–72. Thomson had much to say about the honoured tradition of Chinese medicine before berating the various quacks that abounded in China. 'The subject of the illustration', he wrote, 'is a travelling chiropodist, operating upon a corn, and dressing the toe-nails of a customer; while a second patient waits placidly until his own turn arrives, smoking the pipe of peace from a broken window.'

**124** The knife grinder, *c.* 1871–72. Another of the many street occupations carried on in the city.

**125** The peep-show, *c.* 1871–72. 'And as for the peep-shows – well, the less one says about them the better; they certainly would not be tolerated in any public thoroughfare in Europe.'

**126** The night watchman, *c.* 1871–72. 'The subject of this picture is an old Tartar bannerman,' Thomson wrote. 'Wrapped in his sheep-skin coat, and in an underclothing of rags, he lay through the cold nights on the stone step of the outer gateway, and only roused himself at times to answer the call of his fellow-watchman near at hand. This call is supposed to be passed from watchman to watchman all round the city.'

**127** Peking woman, *c.* 1871–72. The dress and hairstyle of a married Manchu or Tartar woman.

**128, 129** A Tartar bride, rear and front view, *c.* 1871–72. Thomson describes Manchu marriage customs as follows: 'In Manchu families, when a son has reached the age of fourteen or sixteen years, his mother selects him a partner, and the latter will be brought into the family, and entirely subjected to her new parent's rule; so that should the young bride have a hard-hearted mother-in-law, she may look forward to spending the first years of married life in a state of abject slavery, and is even liable to be beaten by her mother-in-law, and husband too, if she neglects to discharge her duties as general domestic drudge. It is therefore always deemed fortunate by the girl's friends if the mother of the bridegroom be already dead.'

**130, 131** Tartar female headdress (front and rear), *c.* 1871–72. The headdress is that of a married Manchu or Tartar woman. According to Thomson it consisted of 'a flat strip of wood, ivory, or precious metal about a foot in length. Half of the real hair of the wearer is gathered up and twisted in broad bands round this support, which is then laid across the back of the head.'

**132** Memorial tablets, Confucian temple, *c.* 1871–72. The marble tablets on each side of the temple were inscribed, according to Thomson, with names of the successful Han-lin scholars for many centuries back, and one, supported upon the back of a tortoise, was said to have been set up here when Marco Polo was in China.

**133** Interior of a mandarin's house, *c.* 1871–72. The reception hall of Mr Yang's house overlooked a small courtyard. 'Never during my wanderings in China had I fallen in with anything more quaint and pretty than the view from this apartment into the second smaller court . . .'

**134** Court in a mandarin's house, *c.* 1871–72. In describing the inner yards of the house, Thomson wrote, 'but each court was tastefully laid out with rockeries, flowers, fish-ponds, bridges and pavilions. Really the place was very picturesque, and admirably suited to the disposition of a people affecting seclusion and the pleasures of family life . . .'

**135** Nankow Pass, *c.* 1871–72. The Nankow Pass was some thirty miles from Peking. It was this pass that led to the Great Wall and formed part of the divide 'separating China proper from the lands of the barbarians beyond'.

**136** A great bell, Peking, *c.* 1871–72. 'One of the five great bells cast during the Ming Dynasty, reign of Yung-Lo, found in a lane in Peking.'

**137** The Great Wall, *c.* 1871–72. This is one of Thomson's most successful images, using a diagonal shadow as counterpoise to the diagonally rising wall. When published in *Illustrations of China and Its People*, the photograph was placed on a page with another and almost the entire shadow-section was cropped, the result being a far more conventional image.

**138** Hatamen Street, Peking, *c.* 1871–72. An impression of the scale of activity and general confusion that dominated many of the busy streets of Peking.

**139** The Beggars' Bridge, Peking, *c.* 1871–72. Thomson took this view 'from the city wall of Peking, close to the Ching-yang-men, or central gate, between the Chinese and Tartar quarters. It is in a direct line with the centre of the palace, and is the route which the Emperor traverses on his way to the Altar of Heaven . . . This street, like all the thoroughfares in the Tartar city, is a very wide one, and is a place of great concourse and traffic.' Thomson related that 'wheeled vehicles are forbidden to cross the centre of the bridge, this being reserved for the sole use of the emperor. It is, however, a favourite resort for beggars – one among many such – and is known, therefore, to the European residents in Peking as the Beggars' Bridge.'

## VI STREET LIFE IN LONDON 1876–77

**140** The 'Crawlers', *c.* 1876–77. Of all the pathetic street people highlighted in the book, the most pathetic were those so poor they 'have not the strength to struggle for bread, and prefer starvation to the activity which an ordinary mendicant must display'. 'Crawlers' were women too proud to beg. Weakened by hunger and lack of sound sleep they literally crawled on hands and knees to fetch hot water to make the weak tea that was their chief nourishment. The crawler photographed with a small child was keeping it for its mother who had found a job in a coffee-shop. 'The mother returns from her work at four in the afternoon, but resumes her occupation at the coffee-shop from eight to ten in the evening, when the infant is once more handed over to the crawler, and kept out in the streets through all weathers with no extra protection against the rain and sleet than

the dirty and worn shawl which covers the poor woman's shoulders; but as she explained, 'it pushes its little head under my chin when it is very cold, and cuddles up to me, so that it keeps me warm as well as itself'.

**141** 'Hookey Alf', of Whitechapel, *c.* 1876–77. Many of the photographs in *Street Life in London* depicted people down on their luck, but fully worthy of concern and assistance. Such a man was Ted Coally, or 'Hookey Alf', as he was called. 'His story', Smith tells us, 'is a simple illustration of the accidents that may bring a man into the streets, though born of respectable parents, well trained and of steady disposition. This man's father worked in a brewery, earned large wages, married, kept a comfortable home, and apprenticed his son to the trunk-making and packing trade.' The story of Hookey's misfortunes is related in a sympathetic manner.

**142** The Independent Shoe-black, *c.* 1876–77. Smith used this photograph to discuss the competition between independent boot-blacks and those that belonged to the legitimate Book-black Brigades. This latter group was backed by the police, while the independent suffered. 'If he deposits his box on the pavement, the policeman will kick it out in the street, among the carriages, where it will probably be broken and the blacking spilt. The independent boot-black must always be on the move, carrying his box on his shoulders, and only putting it down when he has secured a customer.'

**143** Cast-iron Billy, *c.* 1876–77. William Parragreen was a discharged London omnibus driver. 'Forty-three years on the road or more,' said Cast-iron Billy, 'and but for my 'rheumatics I feel almost as 'ale and 'earty as any gentleman could wish. But I'm lost, I've been put off my perch. I don't mind telling you I'm not so handy wi' the ribbons as in my younger days I was. I'll never hold the whip again,' he told Smith and Thomson. 'I can't sit at 'ome, my perch up there [the driver's seat] was more 'ome to me than 'anythink. Havin' lost that I'm no good to nobody; a fish out o' water I be.' Fearing old age in the workhouse, William still hoped to end his days as a watchman at some gentleman's gate, working for fourteen hours out of the twenty-four.

**144** Sufferers from the Floods, *c.* 1876–77. Thomson describes the effect of the Thames floods on the poor of Lambeth, where 'a few hours spent among the sufferers in the most exposed neighbourhoods will convince any one that the danger is not yet over; that disease may still play sad havoc among the people. The effects of disasters are still pressing heavily upon a hard-working, under-fed section of the community. I, myself, have listened to tales of bitter distress from the lips of men and women who shrink from receiving charity.'

**145** A Convicts' Home, *c.* 1876–77. Baylis was pointed to as an example of how someone could rise from the streets, attain success, then have the ability to help his fellow men. Baylis used his business as a half-way house for discharged prisoners, attempting to help them obtain employment. He also remembered his own childhood in the streets of London. 'For fourteen years he has taken delight in serving the wretched people around him; but, remembering his own past experience, his generosity is unbounded towards the pale-faced street Arabs who with hungry eyes frequently throng about his door.'

**146** 'Tickets', the Card-Dealer, 1876–77. Tickets was a Frenchman, who had travelled much of the world before arriving in London, where he made his living making cards, or 'tickets' as they were

known, for small businesses. 'Tickets' was a man with hope, according to the author. 'He hopes that the number of his customers will gradually increase, and that he will be able to save on his earnings. Then, like a true Frenchman, he will return to France, and purchase the goodwill of some small shop.'

**147** Street Advertising, *c. 1876–77*. Each kind of street occupation attracted different kinds of people. 'The men who paste bills on the hoardings, &c., are, however, considered a grade higher in the social scale, though their antecedents are generally more humble and less interesting. The boardmen are often men who have fallen in the world, some have even once enjoyed the title of 'gentlemen', boast of an excellent education, but have been reduced to their present pitch of degradation through what they fashionably term dipsomania!'

**148** The London Boardmen, *c. 1876–77*. These men were among the lowest of the street population. 'Few men who earn their living in the streets are better abused and more persistently jeered at than the unfortunate individuals who let themselves out for hire as walking advertisements. The work is so hopelessly simple, that anyone who can put one foot before the other can undertake it, and the carrying of boards has therefore become a means of subsistence open to the most stupid and forlorn of individuals.'

**149** Covent Garden Flower Women, *c. 1876–77*. Social conscience is evinced in the comments surrounding a number of the photographs. 'Unfortunately, with the spread of civilization, nature seems to lose its hold, and artifice gains on almost every sphere of human endeavour. The fruits, which the earth gives gratuitously, have been converted into the property of a privileged few; and the pauperized street vendor must bargain and haggle before she can obtain the refuse flowers disdained by fashionable dealers.' Smith comments on the consistency with which the flower-women appear in the same places. 'When death takes one of the group away, a child has generally been reared to follow in her parents' footsteps; and the "beat" in front of the church is not merely the property of its present owners, it has been inherited from previous generations of flower-women . . . as a rule the same women may be seen standing on the spot from year's end to year's end, and the personages of the photograph are well known to nearly all who are connected with the market.'

**150** November Effigies, *c. 1876–77*. While Guy Fawkes Day had once been celebrated as a day of national rejoicing, the poor had come to use it as a way of collecting money for survival. The small images of Guy Fawkes carried about by boys forty years before had now been replaced by all manner of unpopular figures. The making of a guy 'is a matter of considerable difficulty to the persons who undertake such ventures, for they are generally very restricted in their means. Spangles and paper play a prominent part in the apparel of a guy. But now it is also the fashion to dress the men and boys who attend, and sometimes clowns are engaged to follow and amuse all who deign to look at the show. The accompanying photograph is that of a nondescript guy, somewhat clumsily built up by a costermonger who lives in the south-east of London.' Smith felt that the sombre atmosphere surrounding Guy Fawkes Day among the very poor placed it in a poor light beside the more lively celebrations of various holidays on the Continent.

**151** Halfpenny Ices, *c. 1876–77*. A long chapter was written about the ice-cream sellers, all Italians, who prospered by selling their wares in the London streets. The Italian colony lived apart, in 'a curious quarter' around Saffron Hill. Each morning the icemen spread out from there across the entire city of London, walking up to ten or twenty miles per day. Smith noted that they were frugal, and did not drink. Many became quite well off, able to buy a house and land in Italy after ten or twenty years. 'Yet some of these men are known to be the worst characters that Italy produces. As a rule, they almost invariably style themselves Neapolitans, and in answer to questions will say that they come from Naples itself . . .'

**152** The Temperance Sweep, *c. 1876–77*. In nineteenth-century London chimney-sweeps had their parades, and for a time even made extra income from the soot they collected. 'Chimney-sweeps of the present day have lost one important source of income. The soot they so carefully collect, and have to sift from the cinders and ashes taken away from the grate at the same time, has no longer any great marketable value. It was used extensively on meadow and on wheat land, where it was especially beneficent in its effects by destroying slugs and other injurious animals.' A 'temperance' sweep who had given up intoxicating liquor was a rarity; prosperity, a large family, and respect in his neighbourhood, had ensued.

**153** London Nomades, *c. 1876–77*. In his commentary on the people in this photograph Thomson writes that 'The class of Nomades with which I propose to deal makes some show of industry. These people attend fairs, markets, and hawk cheap ornaments or useful wares from door to door. At certain seasons this class "works" regular wards, or sections of the city and suburbs. At other seasons its members migrate to the provinces, to engage in harvesting, hop-picking, or to attend fairs, where they figure as owners of "Puff and Darts", "Spin 'em rounds," and other games. Their movements, however, are so uncertain and erratic, as to render them generally unable to name a day when they will shift their camp to a new neighbourhood.'

**154** Workers on the 'Silent Highway', *c. 1876–77*. These men conducted the barges on the River Thames. While some were thieves, 'there are, undoubtedly, many most honest, hard-working, and in every sense worthy men, who hold licences from the Watermen's Company, or from the Thames Conservancy. That these men are rough and but poorly educated is a natural consequence of their calling. Never stationary in any one place, it is difficult for them to secure education for their children, and regular attendance at school would be impossible unless the child left its parents altogether. Thus there is an enormous percentage of men who cannot read at all.'

## VII CYPRUS 1878

**155** Greek monks, St Pantalemoni, *1878*. One of the most successful of the Cyprus photographs, this image comes closest to the quality Thomson achieved in his China work.

**156** A street in Larnaca, *1878*. Larnaca was the first place Thomson visited in Cyprus. He described it to the Royal Photographic Society as a 'collection of dilapidated homes, relieved by spires, towers, and minarets, and at first sight the appearance was dreary and depressing in the extreme'.

**157** A rock-cut tomb, Famagosta, 1878. An example of the powerful effects Thomson could achieve working with a natural light-source in a difficult environment.

**158** Native group, Nicosia, 1878. Thomson describes the Cypriots in Nicosia as 'a fine race of people'. By dividing the group into several smaller groups, each occupied with an activity, he has managed to achieve a dynamic and natural-seeming image.

**159** Beggars, Cyprus, 1878. Thomson did not gain familiarity with the people or environment of Cyprus. He had not developed the contacts that had been so helpful in his China work. Beggars,

however, were certain to feature in any study Thomson made of a place.

**160** A Cypriote boy, 1878. Thomson was impressed by the qualities of the Cypriots. They were generous and hospitable, the men often stood over six feet tall, and 'there was very little sickness and no physicians'.

**161** Women at a well, Levka, 1878. For the last time, Thomson calls on the experience gained in the Far East and with his *Street Life* photographs for the convincing depiction of the lives of people unfamiliar to him.

# ACKNOWLEDGMENTS

Most non-fiction books require help and support from colleagues and this book is certainly no exception. During the years the project progressed a great amount of encouragement came from England as well as the United States. In England, members of the family provided as much help as they could, particularly Hillary Thomas, who typed all of Isobel Thomson's correspondence to her husband when he was photographing in China, as well as providing what clippings had come down to her. Thanks should also be given to J. R. Derek Cameron of Edinburgh, for his sharing of information and photographs, as well as to Thomson's two granddaughters, Vivienne and Joan. Philippe Garner, a personal friend and V.P. at Sotheby's, helped by locating Thomson's original negatives at the Wellcome Institute. William Schupbach, in charge of the negatives at the Wellcome Institute, went out of his way in doing the laborious job of xeroxing each of the more than 600 prints in the collection and labelling them, a great aid in helping me to identify and place much of Thomson's work. Colin Ford, now Keeper of the new National Museum of Photography, Film, and Television, first put me in touch with the family, while John Warner, former director of the Hong Kong museum, helped with his enthusiasm and support; one of the great Thomson *aficionados* of all time. Lastly Valerie Lloyd and Robert Hershkowitz provided access or suggestions to material. The Royal Geographical Society, Royal Photographic Society, The Royal Institution, all were cooperative in allowing me to do research, as were various libraries and the British Museum.

In the United States the single most important person in this project was Robert Sobieszek, Director of Collections at the George Eastman House, who provided me with encouragement from the beginning and helped to mount the first major travelling exhibition ever to be devoted to John Thomson. He also read the manuscript and made a number of valuable suggestions. Roy Flukinger, another long supporter of the project, provided valuable information from the Gernsheim collection. Helmut Gernsheim also added suggestions. Many others offered their help or advice at different times: Beaumont Newhall, Clifford Ackley, Pierre Apraxine and Lee Marks of the Gilman Collection, Richard Pare and Lori Gross at the Canadian Center for Architecture, Keith McElroy in Tucson, Julia Van Haaften, Alan Jutzi, Ben Maddow, Robert Weinstein, Robert Koch, Charles Wood, and Willie Schaeffer. Also Gail Buckland, Clark Worswick, Arthur Ollman, Daniel Wolf, Sean Thackery and Sally Robertson, and Elliot Parker. Among American institutions, two visits to the Essex Institute were especially helpful to me. A special thanks to my wife Mus, daughters Shannon, and Lauren, for putting up with this project for so long (several years longer than Lauren's even been around). A very special thank-you to Bill Cartwright, longtime friend, who first brought me in touch with Thomson, and with that single action changed my life as much as anything had changed it in the past. And another to Jim McCrary who did the impossible, taught me enough about word processing to allow me to get this information assembled in time for deadlines.

Finally, a special thanks to John Thomson. You worked to have your negatives preserved. You have provided me with one of the richest experiences of my life and for that I am grateful, and only hope that in return I have served you well.

*Photographic Acknowledgments*

Collection Centre Canadien d'Architecture/Canadian Centre for Architecture, Montreal, 139; International Museum of Photography at George Eastman House, Rochester, 6, 16, 63, 66, 69, 70, 71, 73, 75, 76, 140–154; Collection Robert Koch 155–161. All other photographs are reproduced from the collection of the author.

# CHRONOLOGY

1837  14 June: John Thomson born in Edinburgh, the son of William Thomson, a tobacconist, and Isabella Newlands.

1861  Thomson's first visit to Singapore.

1862  Leaves England to live in the Far East. Ten months in Penang and Province Wellesley.

1863  Moves to Singapore.

1864  Visits Ceylon and India from Singapore. October: elected to Bengal Photographic Society. November: photographs the cyclones in India.

1865  Sells the Singapore studio, possibly to a European photographer named Sachtler. 28 September: arrives in Bangkok. Photographs the King of Siam and a ceremony with the King's eldest son. Remains in Siam for six months.

1866  27 January: leaves Siam to travel to Laos and Cambodia. Photographs the ruins at Angkor Wat. Photographs the King of Cambodia. Visits Saigon. Returns to Siam. May: visits Singapore en route for England. Back in Edinburgh, joins the Royal Ethnographical Society. Is elected a fellow of the Royal Geographical Society. Lectures on Cambodia before the British Association.

1867  Meets his future wife Isobel Petrie at a lecture he gives in Edinburgh. Publishes his first book, an album, *The Antiquities of Cambodia*. Lectures to the Royal Ethnographical Society and publishes an article in their journal. July: returns to the Far East, to Singapore and then Saigon to photograph the Chinese living there.

1868  Settles in Hong Kong to begin work on his project of photographing the Chinese in China. Establishes contact with *The China Magazine*, takes photographs and writers articles for them. Makes photographic prints for *The Ever Victorious Army*. Severs connections with *The China Magazine*. Sets up a makeshift studio in the Commercial Bank building. Brings his two Chinese assistants from Singapore to help him to run the studio. Isobel Petrie arrives in Hong Kong. 19 November: Marries Isobel.

1869  The couple visit Canton where Thomson makes an important series of photographs of the city and its people. Several sent to *The British Journal of Photography*. First child born. Assumes responsibility for the debts of his brother William. Photographs the visit to Hong Kong of Prince Alfred, Duke of Edinburgh. *The Visit of His Royal Highness the Duke of Edinburgh to Hongkong in 1869* published with text by the Rev. Beach and seven original photographs by Thomson.

1870  23 June: Isobel Thomson leaves for England, pregnant with her second child. En route, she picks up Thomson's brother William in Singapore. Thomson travels up the North Pearl River. Publishes illustrated book, *Views on the North River*, in Hong Kong. Studio put up for sale in preparation for extensive travel in China. Foochow, travels in the Foochow region (1870–71).

1871  In Amoy (March), Formosa (April), and then returns to Hong Kong. Visits Shanghai (August), arrives Peking (September). After three months returns to Shanghai to explore the Yangtze River.

1872  Travels up the Yangtze River. Revisits Ningpo and Snowy Valley (April). Returns to Hong Kong. Leaves for England.

1873  Lives with his family in the London suburb of Brixton. Works on the production of *Foochow and the River Min*, published by subscription.

Lectures at the Royal Geographical Society on his Formosa travels. Publishes *Illustrations of China and Its People* (1873–4), in four volumes.

1875  Publishes *The Straits of Malacca, Indo-China, and China*. Contributes three parts to Walter Woodbury's *Treasure Spots of the World*. Three lectures in Liverpool: 'The Traveller in China'. Is awarded *Medaille de 2ᵉ classe* at the Congress International des Sciences Geographiques in Paris.

1876  Translates three books: *Spain*, by Baron Ch. D'Avillier, Gaston Tissandier's *A History and Handbook of Photography*, and Grandville's edited version of *Public and Private Life of Animals*, published 1877. Thomson's book *The Land and People of China* published by the Society for the Promotion of Christian Knowledge.

1877  Collaborates (1876–7) with Adolphe Smith on a monthly series of photographs in twelve installments, on the London poor: *Street Life in London*, published from February 1877 to January 1878.

1878  *Street Life in London* published in book form. Thomson's sixth child born. Travels to Cyprus to take photographs for a book on England's most recent possession.

1879  *Through Cyprus with the Camera in the Autumn of 1878* published in London. Thomson elected a member of Royal Photographic Society. *Street Life in London* re-published in an abridged version as *Street Incidents*.

1881  Establishes a portrait studio at 78 Buckingham Palace Road, London. Exhibits in annual show of the Royal Photographic Society various photographs including a number taken of the Royal Family. Receives a Royal Warrant.

1883[?]  Moves his portrait studio to 70A Grosvenor Street.

1884  Completes a series of photographs to illustrate the two volumes of *A Description of the Works of Art Forming the Collection of Alfred de Rothschild*.

1885  Exhibits in the Royal Photographic Society competition.

1886  Becomes an instructor of explorers at the Royal Geographical Society, giving lessons in his portrait studio. Receives a gold medal from Queen Victoria for his travels in China.

1889  Highest awards received at Paris Exhibition.

1891  Resigns from the Royal Photographic Society.

1897  Is invited (among others) to record the Fancy Dress Ball for the Diamond Jubilee, held at Devonshire House on 2 July. A book was published two years later.

1898  Publishes *Through China with a Camera* (reprinted 1899).

1900  *Illustrations of China and Its People* reprinted in an abridged single-volume edition. Publishes a small paperbound book on the home-scenes of John Bunyan.

1908  Receives a French award for exploration in Cambodia.

1917  Honorary life fellow of the Royal Geographical Society.

1919  Approaches Henry (later Sir Henry) Wellcome in London about his acquiring the collection of glass plate negatives for his library.

1921  October: Death of John Thomson at the age of eighty-four.

**1** Thomson, *The Straits of Malacca, Indo-China, and China*, p. 8.

**2** ibid., p. 10.

**3** ibid., p. 14.

**4** See E. K. Laird, *The Rambles of a Globe Trotter*, London, Chapman and Hall, 1875. Vol. 2, Appendix, p. 359.

**5** Thomson, *The Straits of Malacca, Indo-China, and China*, p. 62.

**6** Thomson, *The Antiquities of Cambodia, I Journey Across Siam to Cambodia*. Edinburgh, Edmonston and Douglas, 1867

**7** Thomson, *The Straits of Malacca, Indo-China, and China*, p. 79.

**8** ibid., pp. 91–92.

**9** ibid., pp. 94.

**10** *The China Magazine*, August 1868, p. 18.

**11** Thomson, *The Straits of Malacca, Indo-China, and China*, p. 118.

**12** ibid., p.119.

**13** 'Notes of a Journey Through Siam to the Ruins of Cambodia', unpublished article submitted to the Royal Geographical Society, 1866, pp. 1–2.

**14** Thomson, *The Straits of Malacca, Indo-China, and China*, p. 132.

**15** ibid., p. 133.

**16** ibid., p. 134.

**17** *Journal of the Royal Geographical Society*, London, vol. 2, 1893, p. 211. Quoted in the discussion section after a paper delivered on Annam, Cochin China, and Cambodia.

**18** *The China Magazine*. Article by Thomson, 'The Cambodian Ruins', part one, August 1868, p. 19.

**19** Thomson, *The Straits of Malacca, Indo-China, and China*, p. 98.

**20** 'Notes of a Journey Through Siam to the Ruins of Cambodia', unpublished article submitted Royal Geographical Society, 1866, p. 8.

**21** George Thomson, (mis-attribution), 'Notes on Cambodia and its Races', *Royal Ethnographic Society of London Journal*, 1867, pp. 246–52.

**22** *The British Journal of Photography*, review published 7 September 1866, p. 431.

**23** *The Antiquities of Cambodia*. Edinburgh, Edmonston and Douglas, 1867

**24** *The China Magazine*, Hong Kong, 1868, pp. 60–62.

**25** Thomson, *The Straits of Malacca, Indo-China, and China*, pp. 174–75.

**26** *The China Magazine*, 'An Anamese Chief', pp. 150–51.

**27** ibid., 'A Chinese House at Cholon', pp. 166–67.

**28** Clark Worswick, *Imperial China*, New York 1978, p. 141.

**29** Thomson, *Photographic Album accompanying 'The Ever Victorious Army'*, Hong Kong, July 1868.

**30** Clark Worswick, ibid.

**31** *The British Journal of Photography*, 24 September 1869, p. 463.

**32** Rev. William Beach, *The Visit of His Royal Highness the Duke of Edinburgh to Hongkong in 1869*. Noronha and Sons, Hong Kong.

**33** Isobel Thomson, unpublished letter to her husband dated 9 July 1871.

**34** Thomson, *The Straits of Malacca, Indo-China, and China*, p. 225.

**35** Thomson, *Views on the North River*, published by Noronha and Sons, Hong Kong, 1870.

**36** Thomsom, *Foochow and the River Min*, London, 1873. Text-introduction.

**37** Thomson, *The Straits of Malacca, Indo-China, and China*, pp. 370–71.

**38** ibid., p.360.

**39** ibid., p. 363.

**40** ibid., p. 364.

**41** ibid., p. 364.

**42** ibid., p. 367.

**43** Doolittle's book was published by Sampson Low in 1868. It may have been Doolittle who provided Thomson with an introduction to the publisher Sampson Low when the photographer returned to London in 1872. Most of Thomson's books, as well as his various translations, were done for Sampson Low.

**44** *The Chinese Recorder and Missionary Journal*, March 1871, p. 307.

**45** Thomson, *The Straits of Malacca, Indo-China, and China*, p. 384.

**46** ibid., p. 388.

**47** ibid., p. 391.

**48** ibid., p. 396.

**49** ibid., p. 316.

**50** 'Notes of a Journey in Southern Formosa', read before the Royal Geographical Society, 10 March 1873. Published in *Journal of the Royal Geographical Society*, vol. 43, pp. 97–107.

**51** E. K. Laird, *The Rambles of a Globe Trotter*, London 1875, vol. 1, p. 242.

**52** Thomson, *The Straits of Malacca, Indo-China, and China*, p. 399.

**53** ibid., p. 495.

**54** ibid., p. 496.

**55** ibid., pp. 498–99.

**56** ibid., pp. 496–97.

**57** ibid., p. 498.

**58** ibid., p. 499.

**59** ibid., p. 501.

**60** ibid., p. 503.

**61** ibid., pp. 510–11.

**62** Thomson, *Illustrations of China and Its People*, Vol. 4, plate VII, quoted in text on 'Chinese Houses'.

**63** Isobel Thomson, unpublished letter to her husband dated 17 March 1872.

**64** Isobel Thomson, unpublished letter to her husband dated 17 February 1872.

**65** Thomson, *The Straits of Malacca, Indo-China, and China*, pp. 431–32.

**66** ibid., p. 437.

**67** ibid., pp. 446–47.

**68** ibid., p. 450.

**69** ibid., p. 452–53.

**70** ibid., p. 455.

**71** ibid., pp. 456–58.

**72** Thomson's negatives are preserved at the Wellcome Institute for Medical Science, London. They are numbered up to 1,200, including the work in Cyprus, although only about six hundred remain extant. They include sections on Cambodia, Siam, and China.

**73** Clark Worswick in *Imperial China* (p. 142) writes that: 'there is an odd postscript to Thomson's departure from China. Ironically, few of the negatives that he took with him were ever printed, except as the original material from which his book illustrations were made. But the negatives he left behind in Hong Kong were printed with relative frequency by both Rusfeldt and Floyd.'

**74** 'In the production of these prints, the old system of silver printing, which is so liable to fade, has been discarded, and in its stead I have adopted the Autotype Carbon process, the pictures being produced in the same material as that used in water-colour painting. The tint is chosen to match as nearly as possible the warm colour of the common photograph.' Thomson in the Introduction to *Foochow and the River Min*, 1873.

**75** The translation was of *Public and Private Life of Animals*, London, 1877 (list of publications, p. 11).

**76** *Pall Mall Gazette*, 11 November 1874.

**77** *The Saturday Review*, 20 February 1875.

**78** An unidentified Liverpool newspaper, 12 February 1875.

**79** Smith and Thomson (mis-spelled Thompson), *Street Life in London*, Benjamin Blom, Inc., New York and London, 1969. Publisher's preface.

**80** Unidentified newspaper review passed down through John Thomson's family.

**81** Account of Thomson's Cyprus visit quoted from a review published in *The British Journal of Photography*, 20 November 1878, pp. 20–22.

**82** Exhibits listed in *The British Photographic Journal*, 10 October 1881.

**83** Colin Ford, *Happy and Glorious*, National

Portrait Gallery, London, 1977, pp. 60–61.

**84** Bevis Hillier, *Victorian Studio Photographs*, Boston, Godine, 1975, p. 26.

**85** Letter from Thomson to the Secretary of the Royal Geographical Society, 12 June 1875.

**86** Letter from Thomson to the Secretary of the Royal Geographical Society, dated 25 January 1886.

**87** Letter from Thomson to the Secretary of the Royal Geographical Society, dated 28 December 1886.

**88** Article in *Journal of the Royal Geographical Society*, 1891, entitled 'Photography and Exploration'. Vol. 13, pp. 669–75.

**89** The half-tone process came into common use in the 1890s. It offered two advantages over earlier printing processes. The photographs could be printed together with words on the same page, and it was far less costly than any of the previous processes. The half-tone is printed through a screen. The finer the screen, the better the quality of the reproduction. It is still the most commonly used method of reproduction today.

**90** Letter from Thomson to the Secretary of the Royal Geographical Society, dated 7 November 1917.

**91** Letters from the Secretary of the Royal Geographical Society, dated 8 and 14 November 1917.

**92** *The British Journal of Photography*, 'Practical Photography in Tropical Regions', 10 August 1866, p. 380.

**93** ibid., 17 August 1866, p. 393.

**94** ibid., 24 August 1866, p. 404.

**95** ibid., 5 October 1866, p. 473.

**96** ibid., 12 October 1866, p. 487.

**97** ibid., 'Hong Kong Photographers', 29 November 1872, p. 509.

**98** Unsigned (John Thomson) article: 'Three pictures in Wong-nei-chung', *The China Magazine*, August 1868, pp. 52–56.

**99** Kuo Hsi, *An Essay on Landscape Painting*, London, John Murray, 1959, p. 36.

**100** Thomson, 'Three pictures in Wong-nei-chung', *The China Magazine*, August 1886, p. 54.

**101** Thomson, *The Straits of Malacca, Indo-China, and China*, p. 332–33.

**102** Thomson's footnote, p. 167, in Gaston Tissandier, *A History and Handbook of Photography*.

**103** Notice in unidentified Edinburgh newspaper, undated, probably *c.* 1869, in possession of Thomson's descendants.

**104** Thomson, *Illustrations of China and Its People*. Introduction to Volume I. The fear Thomson wrote about was not limited to Europeans. Many of the most successful Chinese photographers hired European assistants to work with their foreign clients. The Englishman D. K. Griffith, the photographer Afong's assistant, commented that 'the native artist has little support from his countryman, and from this cause none are to be found away from foreign settlements. Some few enterprising Cantonese have tried to push business in a few of the large towns of the interior, but were obliged to withdraw from the hostilities of the natives . . . In my own case I have had my chair torn to pieces on the road, my coolies beaten, and my camera broken . . in the case of a Chinaman *he would have fared much worse*. (Clark Worswick, op. cit., p. 143)

**105** Thomson, *The Straits of Malacca, Indo-China, and China*, p. 509.

# BIBLIOGRAPHY

## BOOKS BY JOHN THOMSON

*The Antiquities of Cambodia; a series of photographs taken on the spot, with letterpress description*, Edinburgh, Edmonston and Douglas, 1867. Contains sixteen albumen prints including two three-part panoramas.

*Views on the North River*, Hong Kong, Noronha and Sons, 1870. Contains seven *cartes de visite* of people and eighteen views, small format.

*Foochow and the River Min*, London, Autotype Company, 1873. Contains eighty carbon prints of Foochow and the River Min. Thomson's most beautiful work and one of the rarest of 19th-century books. Three complete copies; two contain the eighty listed prints. The third, Thomson's copy, contains an additional thirty carbon prints of Formosa.

*Illustrations of China and Its People, a series of two hundred photographs with letterpress description of the places and people represented*. Four volumes, London. Sampson Low, Marston, Low, and Searle, 1873–74. The photographs are reproduced by the collotype (Albertype) process. A condensed version with one hundred photographs was printed in 1900. Reprinted as *China and Its People in Early Photographs*, New York, Dover Publications, 1982.

*The Straits of Malacca, Indo-China, and China, or Ten Years' Travels, Adventures and Residence Abroad*, London, Sampson Low, Marston, Low, and Searle, 1875. Another edition, New York, Harper and Brothers, 1875. With sixty-eight woodcuts from the author's sketches and photographs. The book was also translated into French and published under the title: *Dix ans de Voyages dans la Chine et l'Indo-Chine*, Paris, Librairie Hachette, 1877, with 128 woodcuts, of which not all appear to be by Thomson. Also: *L'Indo-Chine et la Chine, recits de voyages*. Paris, Librairie Hachette, 1885, a condensed second edition.

*The Land and People of China; a short account of the Geography, Religion, Social Life, Arts, Industries, and Government of China and its People*, London, Society for the Promotion of Christian Knowledge, New York, Pott, Young and Co., 1876.

*Through Cyprus with the Camera in the Autumn of 1878*. Two volumes, London, Sampson Low, Marston, Searle and Rivington, 1879. Contains sixty permanent prints made by both the Woodburytype Co. and Autotype Co. Reprinted (1 vol.), London, Trigraph, 1985.

*Through China with a Camera*, Westminster, A. Constable and Co., 1898. Second edition: Harper and Co., New York and London, 1899. Reissued: San Francisco, Chinese Materials Center, 1974. Contains nearly one hundred half-tone reproductions from Thomson's work.

*Thomson's Souvenir of Singapore*. Album with twelve photographs.

## COLLABORATIONS, TRANSLATIONS, AND BOOKS BY OTHER AUTHORS CONTAINING THOMSON'S WORK

Andrew Wilson, *The Ever Victorious Army. A History of the Chinese Campaign under Lieutenant Gordon*, London, Blackwood, 1868. Compiled by John Thomson. Contains twenty photographs including *cartes de visite*. *Photographic Album accompanying 'The Ever Victorious Army'*, preface by John Thomson, Hong Kong, 1868. Contains twenty-two prints including *cartes de visite*. Both these volumes were the work of an unidentified photographer in 1863. Thomson probably made the copy-negatives and the prints bound into the books.

Rev. William Beach, *The Visit of His Royal Highness the Duke of Edinburgh to Hongkong*. Hong Kong, Noronha and Sons, 1869; London, Smith, Elder and Co., 1869. Contains seven photographs plus a two-part foldout panorama. Thomson is credited as the photographer in the preface.

Three translations by Thomson: Baron Ch. D'Avillier, *Spain*, London, Sampson Low, Marston, Low, and Searle, 1876; reprinted 1881 by Bickers and Son. Grandville, *Public and Private Life of Animals*. Adapted from the French of Balzac, Droz, Jules Janin, E. Lemoine, A. de Musset, George Sand, etc. London, Sampson Low, Marston, Low, and Searle, 1877. Gaston Tissandier, *A History and Handbook of Photography*, London, Sampson Low, Marston, Low, and Searle, 1876; New York, Scoville Manufacturing Co., 1877. The second edition came out almost immediately after the first.

J. Thomson and Adolphe Smith, *Street Life in London*, London, Sampson Low, Marston, Searle, and Rivington, 1878. Contains thirty-seven photographs done in Woodburytype. Issued in twelve equal parts, 1st February 1877 to January 1878, followed by publication as a whole. Reissued 1969, New York, Benjamin Blom. Reissued 1973, Wakefield, Yorks, EP Publishing.

J. Thomson and Adolphe Smith, *Street Incidents*, London, Sampson Low, Marston, Searle and Rivington, 1879. Abridged version of *Street Life in London* containing twenty-one photographs.

Alfred de Rothschild, *A Description of the Works of Art Forming the Collection of Alfred de Rothschild*. Charles Davis, compiler. 1884. Two volumes. Thomson provided some two hundred illustrations, all mounted photographs of the artworks and furnishings.

*Devonshire House Fancy Dress Ball, 2 July 1897*. A collection of portraits in costume, of which a number are by Thomson. Hammersmith, privately printed for the Committee, 1899. The book was made to be presented to the Duchess of Devonshire.

John Thomson and Sidney Robjohns, *Bunyan Home Scenes*. Bedford, John Thomson, 1900. A thirty-two page booklet illustrated with halftones by Thomson and Robjohns.

## BOOKS CONTAINING REPRODUCTIONS OF THOMSON'S WORK

Anna Leonowens, *The English Governess at the Siamese Court*, Boston, James. R. Osgood and Co., 1871. All the woodcut reproductions are from Thomson's photographs.

—, *Romance of the Harem*, Boston, James R. Osgood, 1873.

W.H. Medhurst, *The Foreigner in Far Cathay*, New York, Scribner, Armstrong, 1873.

Benjamin Robbins Curtis, *Dottings round the circle, 1876*, Boston, James R. Osgood, 1876.

Charles H. Eden, *China, Historical and Descriptive*, London, Marcus Ward and Co., 1880. Contains a few wood-engravings made from Thomson's photographs.

*The World, Its Cities and People*, London, Cassell and Co., *c.* 1880 Part of a series. The volume incorporating China has a number of wood-engravings from Thomson's photographs.

Alexander Hosie, *Three Years in Western China*, London, George Philip and Son, 1890. Contains two Thomson illustrations.

W.A.P. Martin *A Cycle of Cathay, or China, South and North with personal reminiscences*, New York 1896. Contains several half-tone illustrations by Thomson.

E.H. Parker, *John Chinaman*, London, John Murray, 1901. Contains a few Thomson half-tone reproductions.

Charles Buckley, *An Anecdotal History of Old Times in Singapore*, Singapore, Fraser and Neave, 1902. Some of the half-tone illustrations from 'old photographs' are reproductions of Thomson's work.

## BIOGRAPHY

*Our Contemporaries. A Biographical Repertoire of Men and Women of the Day, 1897–1898*, London, Klene and Co. Biographical note on Thomson, p. 117.

## SELECTED ARTICLES BY JOHN THOMSON

'Notes of a Journey Through Siam to the Ruins of Cambodia.' Unpublished manuscript in the Royal Geographical Society files. Handwritten and submitted by Thomson in 1866 on his trip to Cambodia. Edinburgh, August 1866.

'Practical Photography in Tropical Regions' in *The British Journal of Photography*, 10 August 1866 – 11 January 1867.

'Enlargements from Small Negatives' in *The British Journal of Photography*, January 4–11, 1867. Two parts.

G. Thomson (should read J. Thomson), 'Notes on Cambodia and its Races' in *Royal Ethnographical Society of London Journal*, 1867, pp. 246–52. Included are two reproductions from Thomson photographs. This paper has not previously been attributed to Thomson because of the incorrect initial. Thomson read it before the Society on 9 July 1867.

Contributions to *The China Magazine*, 1868: 'The Cambodian Ruins', part one, August 1868, pp. 17–19; part two, September 1868, pp. 80–82. 'An Anamese Village', pp. 123–24. 'An Anamese Chief', pp. 150–151. 'Anamese Scholar', pp. 180–81. 'A Chinese House at Cholon', pp. 166–67. 'A Morning Walk in Cochin China', pp. 60–62. 'Hak-kas', pp. 134–36. 'Three Pictures in Wong-nei-chung', August 1868, pp. 52–56.

*Vocabulary and Handbook of the Chinese Language*, Section 27. 'Photographic Chemicals and Apparatus'. Translation of terms from English to Chinese, *c.* 1870.

'A visit to Yuan-Foo Monastery' in *The Chinese Recorder and Missionary Journal*, March 1871, pp. 296–99.

'The Antiquities of Cambodia', Article IX in *Journal of the North-China Branch of the Royal Asiatic Society*, pp. 197–204. Paper read to the Society on 11 January (?1872).

'Hong Kong Photographers' in *The British Journal of Photography*, 29 November 1872; 13 December 1872. Two parts, p. 569, 591–92.

'Notes of a Journey in Southern Formosa' in *Journal of the Royal Geographical Society*, vol. 43, p. 97–107. Paper read on 10 March 1873.

Contributions to *Treasure Spots of the World* (Walter Woodbury, ed.): 'Bangkok, Capital of Siam', 'Amoy Harbor, China', and 'On the Merced, Yosemite Valley'. London, Ward, Lock and Tyler, 1875.

'Proverbial Photographic Philosophy' in *The British Journal Photographic Almanac and Photographer's Daily Companion*, 1875, p. 128.

'Gelatino-Bromide Plates' in *The British Journal Photographic Almanac*, 1880, p. 54.

'A Panoramic Lantern', *The Photographic News*, 17 December 1880, pp. 608–9.

'Exploration with the Camera' in *The British Journal of Photography*, 12 June 1885, pp. 372–73.

'Photography and Exploration, *Journal of the Royal Geographical Society*, New Series, vol. 13, 1891, pp. 669–75. Paper read on 24 August 1891.

'Geographical Photography' in *Scottish Geographical Magazine*, 1907, pp. 16–19. In this article Thomson gives the dates of his residence abroad between 1860 and 1872.

## RELATED READING

Beers, Burton F., *China in Old Photographs, 1860–1910*, New York 1978.

Bishop, Mrs. J.F., *The Yangtze Valley and Beyond*, London 1899.

Buckland, Gail, *Reality Recorded; Early Documentary Photography*, Greenwich, Conn., 1974.

Buckley, C., *An Anecdotal History of Old Times in Singapore*. Two vols., Singapore 1902.

Capa, Cornell, ed., *Behind the Great Wall of China; photographs from 1870 to the present*, New York 1972.

Carrington, G., *Foreigners in Formosa, 1841–1874*, San Francisco (Chinese Materials Center) 1977.

Doolittle, Rev. Justus, *Social Life of the Chinese; a daguerreotype of daily life in China*, London 1868.

Duns, J., *Memoirs of Li Hung Chang*, Boston 1913.

Eden, Charles H., *China Historical and Descriptive*, 2nd edn., London 1880.

Forbes, Archibald, *Chinese Gordon: a succinct record of his life*, London 1884.

Forbes, Robert B., *Personal reminiscences*, 2nd edn., Boston 1882.

Ford, Colin, ed., *Happy and Glorious*, London (National Portrait Gallery) 1977.

Gernsheim, Helmut, *The History of Photography*, London, New York 1969.

Goodrich, L., and N. Cameron, *The Face of China, 1860–1912*, New York 1978.

Greenwood, James, *The Seven Curses of London*, Boston 1869.

Hake, A.E., *The Story of Chinese Gordon*, New York 1884.

Hillier, Bevis, *Victorian Studio Photographs*, Boston 1875.

Hsi, Kuo, *An Essay on Landscape Painting*, London 1935.

Laird, E.K., *The Rambles of a Globe Trotter in Australasia, Japan, China, Java, India and Cashmere*. Two vols., London 1875.

Mabie, Henry C., *In brightest Asia*, Boston 1891.

Mannix, W., ed., *Memoirs of Li Hung Chang*, Boston 1913.

Martin, W.A.P., *A Cycle of Cathay*, New York 1896.

—, *The Siege in Peking*, New York 1900.

Mayhew, Henry, *London Labour and London Poor*. Four vols., London 1851.

Norman, C.B., *Tonkin, or France in the Far East*, London 1884.

Pumpelly, Raphael, *Across America and Asia; notes of a five years' journey around the world and of residence in Arizona, Japan and China*, 5th rev. edn., New York 1871.

Seaman, L., *Life in Victorian London*, London 1973.

*Shanghai, 1843–1893. The Model Settlement, its birth, its youth, its jubilee*, Shanghai 1893.

Speer, William, *The oldest and the newest empire: China and the United States*, Hartford 1871.

Warner, John, ed., *China, the Land and its People; early photographs by John Thomson*, Hong Kong 1977.

—, *Fragrant Harbour, Early Photographs of Hong Kong*, Hong Kong 1976.

Worswick, Clark, and Jonathan Spence, *Imperial China, photographs 1850–1912*, New York 1978.

# INDEX